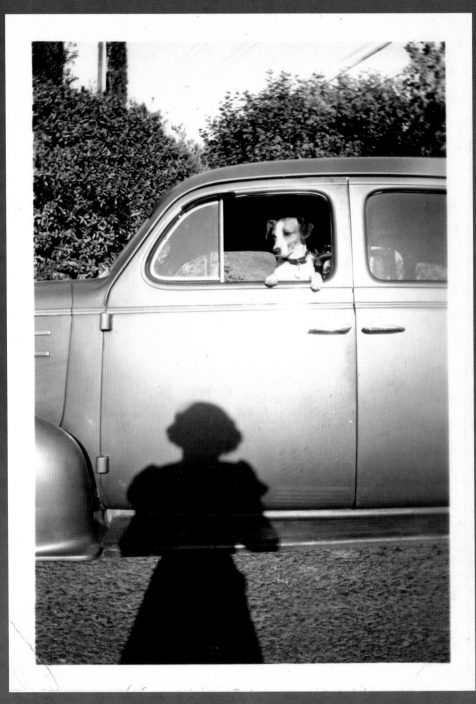

After Photography

FRED RITCHIN

W. W. Norton & Company

After Photography

Copyright © 2009 by Fred Ritchin

All rights reserved

Printed in China

First Edition

Manufacturing by South China Printing Co., Ltd.

Book design by John Bernstein Design, Inc.

Library of Congress Cataloging-in-Publication Data

Ritchin, Fred.

 After photography / Fred Ritchin.

 p. cm.

 ISBN 978-0-393-05024-0 (hardcover)

1. Photography—Digital techniques. 2. Photography—Social aspects.

3. Digital electronics—Social aspects. I. Title.

 TR267.R57 2008

 775—dc22

 2008019178

Frontispiece credit: Anonymous, c. 1938.

W.W. Norton & Company, Inc.

500 Fifth Avenue, New York, NY 10110

www.wwnorton.com

W.W. Norton & Company Ltd.,

Castle House, 75/76 Wells Street, London, W1T 3QT

1 2 3 4 5 6 7 8 9 0

To Carole, Ariel, Ezra

FIG. 1: Heather Ackroyd and Dan Harvey, *Sunbathers*, 2000.
The artists are investigating the capacity of living grass to record complex photographic images
through the production of chlorophyll. Genetics researchers developed a grass that keeps
its green color longer, allowing the artists to maintain the visibility of the image over a longer
period of time as the grass dries.

Preface

We have entered the digital age. And the digital age has entered us. We are no longer the same people we once were. For better and for worse.

We no longer think, talk, read, listen, see the same way. Nor do we write, photograph, or even make love the same way.

It is inevitable. The changes in media, especially media as pervasive as the digital, require that we live differently, with shifting perceptions and expectations.

Our cosmos is different, as is our sense of time. Our sense of community is different, as is our sense of ourselves. Rendered virtual, we have become the stuff of our own dreams.

If the world is mediated differently, then the world is different.

MySpace, YouTube. Second Life. All are welcome.

It's 8:17 now. Not a quarter past eight. Not a little past the first light. We live in the abstracted integers of the digital age.

Marshall McLuhan once remarked: "One thing about which fish know exactly nothing is water"—they do not know that the water is wet because they have no experience of dry. Once immersed in the media, despite all its images and sounds and words, how can we know what it is doing to us?

From television we now know that war can be entertainment, and that stardom is worth almost anything, no matter how humiliating. Most of all, we know that an alternate world can be put onto a screen. And it wants us to reside there.

We are not so much traveling as emigrating.

The planet once was thought of as flat, but Columbus did not fall off. Now the world is flat again, on the television screen, or the computer screen —except that we do not fall off: we enter it, and it enters us. We become "users," and it uses us. Meanwhile, our world, or what is now called RL (real life), is reduced to a reference point.

We cannot be living through a revolution in media and expect it to be primarily a revolution in shopping, mistaking the new hardware and soft-

ware for the new world. This revolution, despite all the hype, is still largely invisible (Gil Scott-Heron was right — the "revolution will not be televised."). But it's already in our heads, our bodies, and soon will be in our hearts. Some of it, I hope, is in this book — linear, analog, and palpable.

————————

For those who do not think that the melting of Antarctica is important, or the disappearance of some 25 percent of animal and plant species by 2050, or the genetic manipulation of our food supply and of our children, or the accelerating violence and abject poverty that have become a global terror and despair, this book can be read as a speculation on change that may have limited use when applied to the stock market or to inventing a Hollywood blockbuster. For those, however, who are attentive to the emerging and potential catastrophes on our planet, this book offers ways of thinking about photography and allied media that may enlarge our capacity to explore and perhaps even ameliorate a fragile universe.

This book makes no attempt at prophecy. It is rather an attempt to acknowledge the rapidly evolving present for what it is and what it might become, while engaging one of the less violent strategies for social change still extant: media.

Simultaneously, it considers how at very fundamental levels our media, in the digital environment, will profoundly and permanently change us — our worldview, our concept of soul and art, our sense of possibility. We are busily reinventing media under the guise of what is essentially a marketing term, the "digital revolution," not daring to admit, in these perilous times, that what we are really reinventing is ourselves.

From digital images to mobile phones to the World Wide Web, media have become, in their easy transcendence of previous limitations of time and space, nearly messianic for us. They replace and sublimate RL with VR (virtual reality) while waiting for AI (artificial intelligence) to maximize its potentials. (Acronyms, like those of global corporations, are both easily digestible and effective disguises.) In the interim, we are deluged by torrents of imagery that enable "branding," transforming objects into desire, and creating a map of the world that refers increasingly to itself as it mutates into something self-serving and, at times, rapacious.

What paradise does the proliferation of new media promise us? Is a byte from an Apple better than it once was? Or will it too be met by a sudden expulsion?

———————

Photography, freezing and slicing the visible into discrete chunks, has been a major player in a delineation of the real and, as numerous critics have asserted, in an insidious distortion of our vision of it. As one of the most universal of media, it is also an expansive filter through which to glimpse the transition from analog to digital. While the chasm rapidly widens between pre- and post-digital media—over 90 percent of cameras sold now are digital—some of their radically differing, and overlapping, assumptions on the nature of existence begin to emerge.

The history of media is not a linear narrative following a neat progression. It is a chaos of possibilities that emerge and recede, back up and move forward, crisscrossing one another. Each medium filters the world according to its own characteristics, so that essential ambiguities are lost in the overbearing vortex of message. In self-defense, all one can do is to look frenetically everywhere at once, hoping that being open to multiple perspectives, like a cubist, will allow an approximation of the essentials. Propitiously, digital media are particularly good at this.

If developed intelligently, the new imaging strategies that will emerge from the digital revolution can stimulate new approaches while transcending many of analog photography's limitations. The humanistic potentials for all emerging media need to be maximized thoughtfully and quickly, at the beginning of the digital transition, particularly considering the extensive efforts by commercial and governmental interests to exploit and tame emerging media for their own advantage.

These are not technologies that are out of reach of many in more affluent societies, as a printing press or a television broadcasting studio had been. For example, some 250 billion digital photos were made in 2007, and nearly a billion camera phones were said to be in use. A head of the global news agency Reuters, looking beyond its usual professional corps to solicit photos and videos from amateurs, asked, "What if everybody in the world were my stringers?" An unknown photographer, after only four hours of

work using software, created a short video of his self-portraits that has, as of this writing, attracted more than eight million viewers online.

The changes in scale are enormous. Web 2.0 and its offspring—what might be called Photography 2.0—acknowledge the massive amounts of input from anyone with access, not just a professional elite. The production of content and its publication are now considered to be the right of anyone technologically enabled, bypassing conventional editorial and curatorial filters. New software is being developed to take advantage of the vast numbers of photographs online that will allow the completion of a scene using other people's pictures or, even more ambitiously, 3-dimensional photographic fly-throughs of sites from throughout the planet.

But is this enormous expansion making the world a better place? Or are we becoming ever more submerged by information, opinion, and imagery, and increasingly narcissistic? And what of the billions with no access to such advanced technologies, and for whom physical survival is the predominant concern? Fewer than 4 percent of Africans are connected to the Web, for example.

At the moment there is less appreciation for the quiescent and barely liminal; the preference is for the incandescent and explicit. We appear to be on a mission to wallpaper our sightlines with deracinated images of so little value that they render us numb while simultaneously telling us that we can now see.

Although photography's evolution can be charted, analyzed, and discussed, the will to utilize such knowledge to devise new strategies of understanding, to select a better option from various looming futures, is always in short supply. Given the major dilemmas facing humanity and the planet, the harnessing of media to help us comprehend our transitional universe and to intervene in its evolution is less a luxury than an urgent requirement of citizenship. As photography is transformed into a variety of emergent media strategies and becomes partially integrated into an increasingly sophisticated multimedia, we should be looking to create more useful, exploratory images, not just the flamboyant, shocking ones.

The deconstruction offered by media analysis insists on the requisite reconstruction; otherwise, all is vanity.

In no way do I mean to downplay the digital divide; the exigencies of survival dwarf any extensive consideration of media for an enormous part of the planet's population. But in a morally responsive world those with greater material resources need to engage others in the necessary conversations as to how to use their wealth. How forcefully and profoundly these discussions are joined and shaped, including those on the future of media, will be significant in determining the destiny of our increasingly intertwined planet.

Whatever we eventually choose, the new media that will surface, with or without our intervention, will transform us. Why? Because that is what media do and because, whether we are aware of it or not, we want them to.

Just think: if we could have begun a similar conversation early on about the nascent technology of the automobile, the planet's oceans might not be warming, the seasons might not have become unmoored, and the world would not now be calling the sound of glaciers cracking and breaking "art."

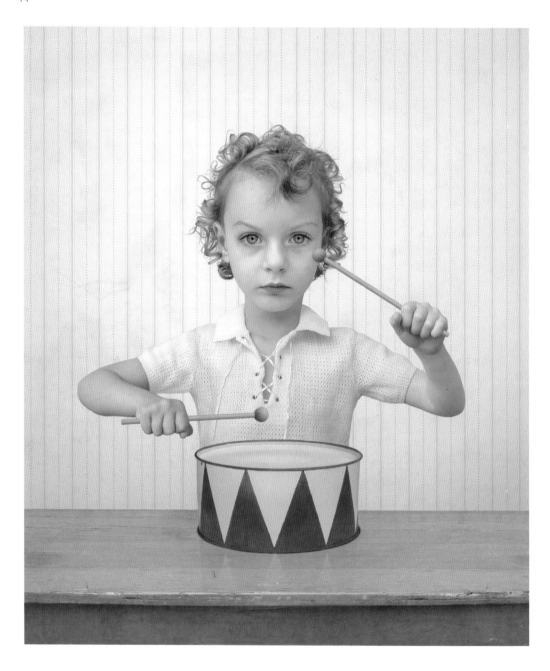

FIG. 2 · *The Drummer*, 2004, by Loretta Lux.

I
Into the Digital

"But why not just kill the photo, there and then?"
"Because she might want to look at it again. Because it meant
something to her. Something? A great deal? Everything?"

—Penelope Lively, *The Photograph* (2003)

———————————

Photography, as we have known it, is both ending and enlarging, with an evolving medium hidden inside it as in a Trojan horse, camouflaged, for the moment, as if it were nearly identical: its doppelgänger, only better.

Like all media, photography is a reflection of the societies that have spawned and embraced it. It can also be a powerful instigator, in both obvious and highly subtle ways, for societal and personal change. The process is dialectical, evolutionary, and largely unconscious, opening new possibilities while others are defused.

Digital photography has been configured as a seamless, more efficient repetition of the past, easier to sell to the apprehensive consumer even as it is celebrated as part of the "digital revolution" (a term that has joined the lexicon of consumer branding). Its name is intended to express massive change while paradoxically citing a medium that dates from the mechanical age. A comforting ambiguity results that, not coincidentally, abnegates our own responsibility for what we have invented.

A string of misnomers is conceived to contextualize and undercut sensitivity to the actual revolution that is only alluded to by "digital." We are given terms from nature and from the utilitarian everyday—apple, mouse, web, blackberry, windows, lap top, desk top, word, personal assistant, fire fox—to describe an environment that has, as of yet, no taste, no smell,[1] and where touch is reduced to clicking and typing and sight is continually framed by yet another rectangle.

What the metaphors also hide is the remarkable self-containment of this new technological universe. "The simulated desktop that the Macintosh

presented came to be far more than a user-friendly gimmick for marketing computers to the inexperienced," wrote MIT psychologist Sherry Turkle in describing her surprise at getting her first Macintosh. "It also introduced a way of thinking that put a premium on surface manipulation and working in ignorance of the underlying mechanism.... With the Macintosh, personal computers began to present themselves as opposed and even hostile to the traditional modernist expectation that one could take a technology, open the hood, and see inside. The distinctiveness of the Macintosh was precisely that it did not encourage such fantasies; it made the computer screen a world unto itself."

It is a world where the human often feels at a disadvantage, where the machine is considered smart and the human sometimes stupid. Banging the machine in frustration will accomplish nothing; it has better things in store for you. Or, as Umberto Eco noted of the Macintosh and what he characterized as its Catholic roots: "It is cheerful, friendly, conciliatory, it tells the faithful how they must proceed step by step to reach — if not the Kingdom of Heaven — the moment in which their document is printed. It is catechistic: the essence of revelation is dealt with via simple formulae and sumptuous icons. Everyone has a right to salvation." (In a similar vein, Eco argued that MS-DOS could be seen as Protestant and Windows as representing an "Anglican-style schism.")[2] The typewriter, considerably more transparent, made no such claims.

The computer also promises a secular *über*environment in which "reality is merely a convenient measure of complexity," as Pixar's Alvy Ray Smith once put it, to be simulated by computer graphics and ultimately transcended. Induced to sign on, to purchase hardware and software, we become "users," a moniker embracing both computer devotees and drug addicts. (In Web statistics we are also known by the dubious but commercially valuable sobriquet "unique users.")

The mimetic disguise of the computer, with its "paint" programs and Web "pages," minimizes digital media's profound departures from its predecessors. Based on distinct segments, calculated choices, binary strategies, and on bytes rather than atoms, digital media work off a representational model that, while able to simulate analog media, eventually will be more transformative than the perspectival changes of the Renaissance or the experimental arts of the past century. Digital media leverage abstraction, nonlinearity, asynchronicity, the dance of code over texture, multiple authors,

and most important the circumvention of nature as we have known it, while redefining space and time. It stimulates other logics and ultimately new philosophies of life, moving from the authority of the Newtonian to the probability of the quantum, and from the visualization of the phenotype to a preference for the coded genotype.

Digital media translate everything into data, waiting for an author or an audience (or a machine) to reconstitute it. Images can be output as music or music turned into text, or created by an algorithm, or transformed by an anonymous and far-flung chain of spectators. A synthesizer makes music that sounds almost like it's coming from a flute, but it can also combine the sounds of a frog and a goose, and add a random function that precipitates a mix to create the voices of new beings—the digital inhabits the land of in-between, and beyond. Similarly, a photograph may be considered a menu to be touched or clicked, or simulated (although the scene depicted may have never occurred, and possibly never could), or its o's and 1's may be transmogrified into anything else at all.

Sections, segments, and steps are the stuff of the digital; analog media reference (are analogous to) continuity and flow. Digital involves coded signifiers, data that can be easily played with, abstracted from their source; analog emanates from wind and wood and trees, the world of the palpable. Digital is based on an architecture of infinitely repeatable abstractions in which the original and its copy are the same; analog ages and rots, diminishing over generations, changing its sound, its look, its smell. In the analog world the photograph of the photograph is always one generation removed, fuzzier, not the same; the digital copy of the digital photograph is indistinguishable so that "original" loses its meaning.

Like a novel, and our earthly lives, a vinyl record was created with the intention that it be experienced within the logic of a beginning proceeding to an end; a music CD or iPod is made to be resequenced, shuffled, and rethought. In digital media, nonlinear and interactive, no two people will necessarily read the same words in a book, listen to the same music, or experience a film or photo essay in the same sequence.

Cause and effect, even life and death, flicker nostalgically in the rearview mirror that is now the twentieth century. Immodestly, we envision the immortality of being able to give postmortem interviews or of composing while literally decomposing long after death.

INTO THE DIGITAL

REMAPPING CONCEPULIYNG OF TIME

When the world was created in seven days, as the story goes, the process did not begin on day four, rest on day seven, and then skip back to day two. Light was separated from darkness before the animals were created. But in the digital story of creation not only can the sequence be reshuffled at will, or randomly, the story can be cross-referenced, mutated, linked, laid over with numerous other media, responded to in "real time," and evolved in an infinite number of ways that have little to do with an everyday sense of darkness, light, water or breath—or of a logical God. Creation is reconstituted, open for re-creation, linked, perhaps, to the speed of a butterfly's wings over Hong Kong or to the score of a football game in São Paulo.

Similarly, a digital watch does not have hands mimicking the diurnal movements from light to darkness as the sun rises and sets (twilight is not a digital concept), but refers self-referentially to its own more abstracted world of integers. In the transition to the digital every creation is reconfigured, made more pliant, primed for human manipulation—potentially becoming the ultimate consumer choice.

Likewise, photography in the digital environment involves the reconfiguration of the image into a mosaic of millions of changeable pixels, not a continuous tone imprint of visible reality. Rather than a quote from appearances, it serves as an initial recording, a preliminary script, which may precede a quick and easy reshuffling. The digital photographer—and all who come after her—potentially plays a postmodern visual disc jockey.

At the next frontier, code triumphs over appearance. Phenotype, the stuff of photography, once trumped genotype (in the "image of God"). In the information age it is the DNA that has been crowned humanity's essential arbiter. (What is the sex act if not an exchange of information?) One day soon we will ask of the image: "From where do those blue eyes come?" expecting that the answer will be conveyed in code.

Moreover, the photographic act, once requiring the presence of a seer and the seen, the distillation and creation of aura, the focus not only of lens but of one's intuitive mind, evolves into one more quick and omnipresent communication strategy, casually enacted using telephones and personal digital assistants, Web cams and satellites. Added to a plethora of text messages and e-mails, it contributes mightily to a condition that former Microsoft executive Linda Stone called "continuous partial attention." One may wonder about the dialectical role of attention deficit disorder and other

psychiatric maladies. To what extent are they symptoms, and to what extent do they cause some of the frenetic digital multitasking strategies?

"The great divide—between the reality of temporal and spatial distances and the distancing of various video-graphic and info-graphic representations—has ended," wrote cultural theorist Paul Virilio in 1984. "The direct observation of visible phenomena gives way to a tele-observation in which the observer has no immediate contact with the observed reality." Like the modern soldier, one eye on a small screen showing what is happening miles away, and the other concentrated on the battlefield just ahead, we too live in multiple spaces, talking to and seeing images from distant friends and acquaintances while walking down the street, the experiences merging.

Painting was posited to have preceded, inspired, and then been threatened by photography in the nineteenth century—the handmade versus the mechanical. In the twenty-first century photography of the digital kind—wired, instantaneous, automatic, malleable, a component of a larger multimedia—may eventually turn out to have a more distant relationship with the film-and-chemicals variety that came before it.

This is not to suggest that there has ever been only one kind of photography. Since early in its history there have been a whole slew of strategies, ranging from phantasmagoric "spirit" photography to the blandest mug shots. It has been used in a utilitarian way to document, in a transcendent way to create art, and as a vital hybrid of the two. Despite the variety of approaches, photography has achieved the paradoxical credibility of a subjective, interpretive medium that has simultaneously been deemed reliable and ultimately useful as a societal and personal arbiter.

Its perceived credibility, to whatever extent it exists, has been a useful function, especially as evidence of one sort or another. But its perceived credibility has also been purposefully misused to manipulate the public since the medium's inception for political and commercial goals. The introduction of digital photography, noted for its nearly effortless malleability, provides a propitious moment to ask whether this evidentiary role can and should be retained, or even expanded. Certainly there is a substantial number of potential witnesses: by the year 2010 it is expected that we will be producing half-a-trillion photographs annually.

For those who think of digital media as simply providing more efficient tools, what we are witnessing today is an evolution in media. This is

the more reassuring, business-as-usual stance, probably held by the major-ity. For those who see the digital as comprising a markedly different environ-ment than the analog, what we are currently observing is no less than a revolution. This latter view is considerably more accurate.

All emergent media borrow heavily from previous media at first, primarily because it takes time to summon the energy and imagination for a dramatic reinvention. (In 1964, McLuhan argued that "the content of any medium is another medium.") Early film looked like theater depicted on a screen (see D. W. Griffith's *Birth of a Nation*, for example). Early television looked like a visualization of radio with men in white shirts and ties, newly apparent to the public, reading the news from behind microphones. Early photography self-consciously and somewhat insecurely imitated the textures of painting, as in Pictorialism.

We should be suspicious of the easy melding of photography into digital photography, focusing on initial similarities. In a sense, it is some-what like continuing to think of the automobile as a horseless carriage. Even now the speedy, multi-ton, climate-controlled, gas-guzzling vehicles depend-ent upon computer chips and equipped with GPS and ABS, DVD and MP3 are advertised as being run by a more naturalistic "horsepower" (one current commercial alludes to 263 horses). The metaphor of the horseless carriage, even a century later, manages to minimize the manifold ways in which the automobile long ago transcended its beginnings.

Horses kept things mostly local, constrained by the biological; auto-mobiles, like cyborgs, did not. The paving of vast stretches encircling the planet, the growth of suburbs, as well as the displacement and degradation of the extended family can be attributed in considerable measure to the auto-mobile. The proliferation of malls, countless deaths in high-speed accidents, and the enduring obsession with oil have little to do with horses. Would anyone have bothered to invade Iraq for hay? And whatever unpleasantness a horse leaves behind is trivial compared to the smog, lung diseases, and hugely destructive perils of climate change.

The automobile also eventually heightened our sense of control, and perhaps even more importantly our sense of entitlement. Enhanced expecta-tions of power and of mobility came from the automobile and its motorized descendants—family, work, leisure, and war can all happen at a distance, day or night, and in all kinds of weather. A new 24/7 mobility over a vast

network of roads became the conceptual metaphor for what was earlier called the "information superhighway." (Now it has been reformulated as the more centralized Web, like "horseless carriage" a more naturalistic reference, but one that also has overtones we choose to ignore of being captured and devoured.) The Internet can claim partial descent from a planetary road system, with the fantasy fulfillment of no stoplights, tolls, or gas pumps as people zip from one Web address to another.

Similarly, the mentality of automobile-obsessed cultures had earlier helped to spawn the rapid-fire, semiconscious zapping from one television channel to another (remote control in hand, we are always in the passing lane) and the joystick-controlled navigation of video games. At high speeds, the external world had become increasingly remote and inconsequential behind the windshield. Virtual reality could not be far behind.

Like the automobile, the photograph created new realities. Part of the problem in distinguishing them is realizing that for many of us the world is largely envisioned, even in the absence of a camera, as photographic.

"My view of the world was a photographic view, like I believe that it is for almost everybody, no?" sculptor Alberto Giacometti stated over forty years ago. "One never sees things, one always sees them through a screen." The multitudes of photographers now intensely staring not at the surrounding world, nor at their loved ones being wed or graduating, but at their camera backs or cell phones searching for an image on the small screens, or summoning the past as an archival image on these same screens, is symptomatic of the image's primacy over the existence it is supposed to depict. It is as if we have banished the actual experience and instead flattened it into a small rectangle, preferring its commodification as a picture show. It is not because it makes it more immediately "real" that we prefer the image, but because it makes it more unreal, an unreality in which we hope to find a transcendent immortality, a higher, less finite, reality.

We are also changed, turned into potential image. Even before the ubiquity of a billion cell phone cameras, we were already in rehearsal for the pose, the look, and a diminished sense of privacy. "In a YouTube world, one's home is no longer one's private retreat: it's just a container for the webcam," as the *New York Times* recently put it. Wars, sports events, weddings, graduations, and even funerals are staged. Advertisements promise a picture-perfect vacation. Actress Ellen Barkin complained, upon her separation from billion-

aire Ronald Perelman, that "You don't spend years with someone and they're just Photoshopped out of your life."[3] Young people are continually imaging and re-imaging themselves for a better MySpace or Facebook profile. One teenager described his date to me as being "sufficiently photogenic."

Photographing well trumps a more ethereal beauty; a variegated existence is suppressed for an ever more exigent two-dimensional photographic currency. In his novel *White Noise,* Don DeLillo limns the photographic disconnect as well as anyone has ever done:

> Several days later Murray asked me about a tourist attraction known as the most photographed barn in America. We drove twenty-two miles into the country around Farmington. There were meadows and apple orchards. White fences trailed through the rolling fields. Soon the signs started appearing. THE MOST PHOTOGRAPHED BARN IN AMERICA. We counted five signs before we reached the site. There were forty cars and a tour bus in the makeshift lot. We walked along a cowpath to the slightly elevated spot set aside for viewing and photographing. All the people had cameras; some had tripods, telephoto lenses, filter kits. A man in a booth sold postcards and slides—pictures of the barn taken from the elevated spot. We stood near a grove of trees and watched the photographers. Murray maintained a prolonged silence, occasionally scrawling some notes in a little book.
> "No one sees the barn," he said finally.
> A long silence followed.
> "Once you've seen the signs about the barn, it becomes impossible to see the barn."
> He fell silent once more. People with cameras left the elevated site, replaced at once by others.
> "We're not here to capture an image, we're here to maintain one. Every photograph reinforces the aura. Can you feel it, Jack? An accumulation of nameless energies."
> There was an extended silence. The man in the booth sold postcards and slides.
> "Being here is a kind of spiritual surrender. We see only what the others see. The thousands who were here in the past, those who will come in the future. We've agreed to be part of a collective perception. This literally colors our vision. A religious experience in a way, like all tourism."
> Another silence ensued.
> "They are taking pictures of taking pictures," he said.
> He did not speak for a while. We listened to the incessant clicking of shutter release buttons, the rustling crank of levers that advanced the film.
> "What was the barn like before it was photographed?" he said. "What

did it look like, how was it different from other barns, how was it similar to other barns? We can't answer these questions because we've read the signs, seen the people snapping the pictures. We can't get outside the aura. We're part of the aura. We're here, we're now."

He seemed immensely pleased by this.

The aura DeLillo describes has, if anything, expanded, and photography's primary task has become not only to maintain the aura but also to enlarge it. When Susan Sontag wrote in the 1970s, "A photograph is not only an image (as a painting is an image), an interpretation of the real; it is also a trace, something directly stenciled off the real, like a footprint or a death mask," the "real" she was referring to was the scene itself, not its simulation.

Where then is the "real" now? Increasingly we are looking at photographs of the map that refers to no territory: the pictures of pictures, the photo opportunities in which politicians and celebrities have their managers stage a scene as if it had actually happened, the photo illustrations that magazines adroitly set up to prove a point, the advertisements for products too glossy to exist, the media filters that reduce life to a shorthand of shock and voyeurism. They are invariably done with a sense of superiority, as if by capturing the image we somehow own the experience. A 1990s Kodak advertising slogan, "Let the memories begin," became another ploy to obscure the repression of the present.

"Consider the United States, where everything is transformed into images; only images exist and are produced and are consumed," the French theorist Roland Barthes commented in 1981. Earlier in the century the German poet Rainer Maria Rilke had argued, "Now is emerging from out of America pure undifferentiated things, mere things of appearance, sham articles....A house in the American understanding, an American apple or an American vine has nothing in common with the house, the fruit, or the grape that had been adopted in the hopes and thoughts of our forefathers." In the globalized marketplace both image and sham are spreading, intertwined.

Once the world has been photographed it is never again the same. (This is where Eve and the Apple come in.)

Once the images begin to replace the world, photography loses much of its reason for being.

Into the vortex, then, comes the digital.

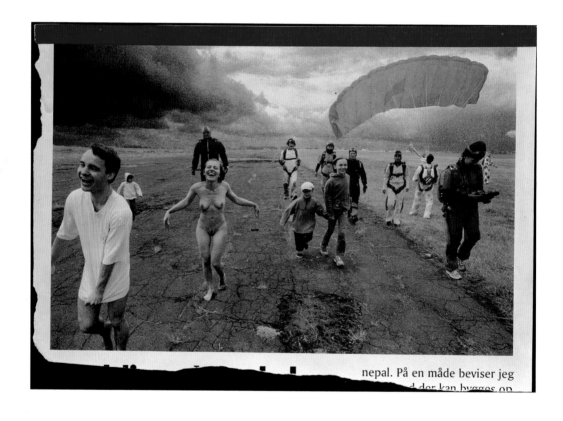

nepal. På en måde beviser jeg
d der kan bygges op

FIG. 3 · *Nepal,* 2003, From Polish artist Zbigniew Libera's series, *Positives.*

2
Of Pixels and Paradox

Already, one would say that human cloning is on its way to becoming, for a part of the contemporary public, an operation as simple as having one's portrait taken by a photographer in the previous century.

—Paul Virilio, *The Information Bomb* (1998)

After a lecture I gave in the 1990s on some of the ways in which photographs were being manipulated with a computer, a woman in the audience stood and responded: That's exactly what we're doing in genetics. Except while you're working with the images, we're working with the DNA.

While those in media have been modifying the eye or skin color in photographs, changing textures or modifying body types, geneticists have been experimenting with strategies to change the actual physical person. Whether aware of it or not, those manipulating photographs are preparing the way for fundamental personal and societal changes.

The more than two decades of frequent alteration of photographs in the press have made genetic manipulation more palpable, immanent, and perhaps even inevitable. If one can repeatedly show brown eyes turning blue, lips and breasts enlarging, and any and all putative "flaws" disappearing, the process seems less scary or remote. If we, like our jeans and our cars, can transition from a solid physicality into the allure of image, then we too become more likely candidates for manipulation.

Our celebrities are already easy prey. As one who was, during the past decade, offered Mel Gibson's body to replace my own by an editor of a major magazine, I can attest to the insinuating seduction of becoming image, even someone else's. After first having refused any image alteration at all of my body I was asked, "What are your ground rules?" "For what?" I asked. "For manipulating your image." I had not thought about any ground rules, but I felt I should be generous: "You can change my tie, or make my hair shorter," I replied. It

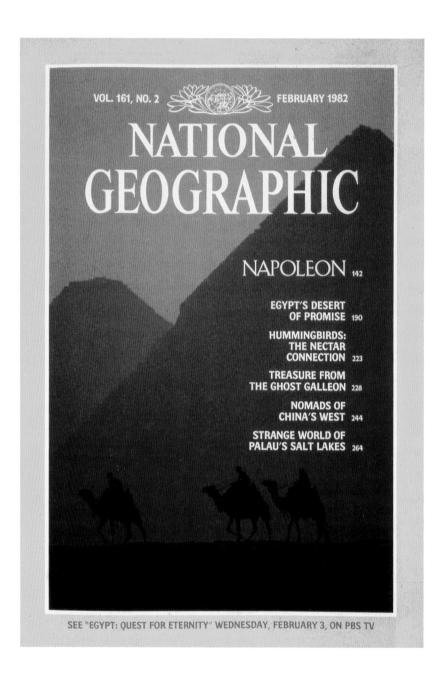

FIG. 4 · The digital era in photography can be said to have begun
with this manipulated 1982 cover.

was then that I was offered Gibson's body and rejected it. I had a queasy feeling that by doing so I might have forestalled the publication of another writer's article on image ethics, for which this composite was apparently needed.

But a photographer was sent to make my portrait. However, he told me that the photo would be manipulated later. I asked him if he knew how the editors would modify his photograph. He did not. Watching his assistant set up lights, the lens pointed at me, I felt that however I would choose to present myself would be meaningless; the photograph would later be changed by someone who had never even met me. And for the first time I saw a photographer as no more than a paid researcher looking for images for someone else to re-present. The new post-photographic process had diminished both the professional photographer and his subject—we were, like so much else these days, part of a larger system controlled elsewhere.

Now it can be possible as well for an art director or editor on another continent to virtually look through a viewfinder to consult on the framing, or to review the images as they are uploaded even while the assignment is in progress. In the days of film one would have had to be physically on site to be able to micromanage the photographer; the photographer's autonomy was somewhat more impervious.

If I had to pick a date when the digital era came to photography, it would be 1982. It was then that *National Geographic*'s staff modified a horizontal photograph of the pyramids of Giza and made it vertical, suitable for the magazine's February cover. They electronically moved a section of the photograph depicting one of the pyramids to a position partially behind another pyramid, rather than next to it. It was a banal change—after all, the original photograph was an already romanticized version of the scene that excluded the garbage, tourist buses, and souvenir hawkers—but it opened the digital door. Robert E. Gilka, then *Geographic*'s director of photography, said the introduction of such technique was "like limited nuclear warfare. There ain't none." Interviewed two years after the cover's publication, the magazine's editor-in-chief, Wilbur E. Garrett, was more sanguine, referring to the image modification as merely the retroactive repositioning of the photographer a few feet to one side so as to get another point of view.[4]

Unintentionally, the rather conservative color magazine had introduced time travel to photography. When I later explained this to an older

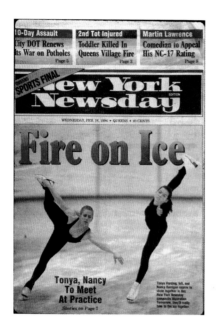

French photographer, Edouard Boubat, he seemed anxious, imagining someone in the future tempted to alter his black-and-white photographs for another point of view. ("They will only do this to color, no?") Perhaps he was wondering why he had waited hours for a scene to unfold in the street when someone could simply fabricate a similar image. In the French context, more supportive of the moral rights of the author than the American legal system, based on copyright, such a possibility can be even more distasteful.

Geographic's rationale, contravening or even transcending the presence of the author, is reminiscent of the Grammy award–winning "duets" between Natalie Cole and her long-dead father, Nat King Cole, recorded in the 1990s, or an animated film made posthumously from László Moholy-Nagy's still photograms. Some of these are meant as tributes, while others are circumventions. Will anyone animate one of the classics of landscape photography, Ansel Adams's *Moonrise, Hernandez, New Mexico,* bringing the image to daybreak? The fractional second when the image was recorded is made to expand; the famous "decisive moment" of Henri Cartier-Bresson can occur more easily, and just as decisively, decades after the image was taken. Authorship becomes malleable, even an unintended posthumous collaboration.

If one can reach into the past why not photograph the future? On the front page of the newspaper *Newsday,* feuding Olympic skaters Tonya Harding and Nancy Kerrigan were shown at an anticipated meeting on the ice as if it were already the next day. "Fire on Ice, Tonya, Nancy to Meet at Practice," read the February 16, 1994, front page, with a smaller-type explanation of how the image was composited so that the two athletes "appear to skate together." Photographic time, rather than the fixed moment of a privileged encounter

FIG. 5: This 1994 image may be the first published "future" news photograph.

between observer and subject, is restructured. The photographer's role, unsurprisingly, becomes less consequential.

That same year a *Time* magazine cover image—a significantly darkened, blurred version of a mug shot of O.J. Simpson upon the occasion of his arrest on suspicion of having committed a double murder—was described by the magazine's editor in a letter to readers the following week as merely an attempt to lift "a common police mug shot to the level of art, with no sacrifice to truth." Widely viewed as racist—why darken a celebrity's skin tone upon his arrest, but not when he is selling Hertz rental cars on television?—the ability to revise a key historical document almost simultaneously with its creation was an exercise that the magazine's editors, at that time, undoubtedly would have criticized anybody else for undertaking. It is difficult to imagine anyone similarly tampering with Abraham Zapruder's amateur film of the John F. Kennedy assassination when it surfaced, although decades later filmmaker Oliver Stone did exactly that.

Similarly, a news photograph of a Swedish plane crash appeared in Finnish newspapers, even though there was no photographer present and no camera. After talking to eyewitnesses, the image was composited (and was later said to be rather accurate according to video footage that was uncovered

OF PIXELS AND PARADOX

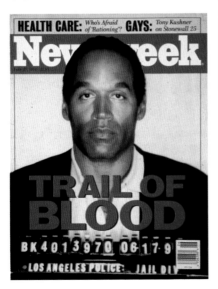 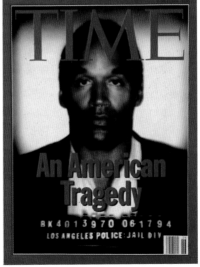

FIG. 6: The two newsweeklies appeared on the same day, *Newsweek* with a Los Angeles Police Department mug shot and *Time* with a manipulated version of it.

of the scene). Imagine then the famous Clinton-Lewinsky tryst being retroactively "photographed" according to one of their accounts, presumably Lewinsky's. The media might finally have been able to stop obsessing about what had happened and, as a result, the U.S. government might then have been able to proceed with other more important business. Does the photograph still require a photographer, or even a camera?

While placing facts and their own *raison d'être* as authoritative sources into question, these corporate entities were also unconsciously playing the role of an avant-garde, pioneering new forms of imaging considerably ahead of most artists and documentarians. Their unintentional playfulness, while destructive, can also be seen as inspiring new, as of yet unrealized, potentials.

In 1984, two years after the *National Geographic* cover had been manipulated, I found myself in Boston working with a technician to create an illustration for an article on new photographic possibilities. We manipulated a color photograph of the New York City skyline using a very costly and complex Scitex system, adding an image of the Eiffel Tower, Transamerica Pyramid, and Statue of Liberty, turning on lights in an office building, creating a traffic jam around the newly arrived Statue of Liberty, and moving a taller Empire State Building a few blocks uptown. Later that day I flew back to New York and, riding in a taxi and looking at the same skyline, I had a sensation reminiscent of a God complex, as if I had actually been able to move tall buildings. For me, photography had irrevocably been changed. For today's generation raised on Photoshop, the experience would probably seem mundane.

When, as a college freshman, I had first watched a piece of exposed paper in a chemical bath mysteriously turn into a photograph, the encounter seemed magical, a kind of alchemy. Now, in the nascent digital era, the photograph was already extant and the magic was in modifying it. No longer was it the slow emergence of the "trace" or "footprint" that was "directly stenciled off the real," as Sontag had put it, which was captivating, but the manipulation of the images themselves.

A few years after the skyline manipulation, sitting on a New York City subway and looking at the photographs posted throughout the car, particularly those above the passengers across from me, I began to doubt that what they represented actually existed. Was the man photographed speaking at the podium ever there? Did he ever exist? What of the people depicted in busi-

ness suits, in a taxi, or on a picnic? Were they complete fantasies? The question for me was not whether the image had adequately and accurately interpreted the person or the scene depicted but whether in fact the person or the scene had even existed.

I began to sweat, unsure as to whether this entire system of referents was functioning. Seeing certainly was not believing, and the photographs seemed to represent openings to an alternative universe synthesized according to discordant goals, which I could only assume were commercial and subversive.[5] Two decades later my response seems hopelessly naïve.

Certainly, photographs were retouched and staged since the beginning of the medium's history, Hippolyte Bayard's 1840 faked *Self-Portrait as a Drowned Man* serving as a very early example. But the frequency of the occurrences and the fact that image alteration can be accomplished by nearly anyone with basic computer skills has triggered mounting societal skepticism. According to a 2005 Consumer Reports WebWatch national poll, 30 percent of Internet users said they had little or no trust in news sites to use pictures that had not been altered. Given that such sites are the flagships for photography as a documentary medium, one can hardly claim a generalized confidence in the medium's ability to cause the reader "to confront in it the wakening of intractable reality," as Roland Barthes put it at the end of *Camera Lucida.*

If photography's stenographic function is doubted, its recording fidelity no longer a given, then using it to give credibility to the stage-directed dictates of leaders and celebrities or constraining it to the generic images that make up journalistic shorthand (solemn leader, grieving widow, starving child, fiery explosion, etc.) will make its purpose transparently ceremonial. If documentary photographs cannot be trusted at least as a quotation from appearances, then photography will have lost its currency as a useful if highly imperfect societal arbiter of occurrences, including the accidental and the spontaneous, and have become a mere symbol of spin.

A generalized skepticism, of course, can also be advantageous. Photography will have a chance to mature as a language, not relying so heavily upon its stenographic function but upon its expanded linguistic fluency. Its role becomes that of a less proximate signifier like words, paintings, or drawings, but with the background duality of its surviving role as direct trace. Its author, rather than being ignored or circumvented as the one who merely

holds the camera, can emerge as central, with a point of view like other creators. And those in power will not be as able to use photography to "prove" what the medium will no longer be able to confirm.

Why stage an event when few will believe its depiction anyway? For example, a photographer known for his risk-taking recounted how, early in the digital era, he had passed around to his friends a dummy version of a forthcoming book featuring his photographs of models posing somewhat perilously on the tops of buildings and bridges, at times in high winds. The reaction of those who saw it was to compliment him on being extremely adept, but with software—much to his chagrin no one would believe that either he or the models had been foolish enough to take the risks depicted.

Now when I sit on the New York City subway I no longer even imagine that the imagery refers to anything that exists. I think of the "photographs" not as referents but as "desirents." Each image exists to make me want to find out something that is probably useless, to purchase the product described no matter how unnecessary, or to brand it so it will seem familiar each time I see the image or name again. There is no relationship for me, the viewer, with an actuality that exists independently of the intended transaction. There is not even any room to dream.

Sontag admonished: "To photograph is to appropriate the thing photographed. It means putting oneself into a certain relation to the world that feels like knowledge—and, therefore, like power." In the digital realm, where each image is a malleable mosaic, the distance is magnified. The photograph, no longer automatically a recording mechanism, is not as able to "appropriate the thing photographed" as much as to simulate it. In the age of image, the relation to the world it offers may not be knowledge or power but something like conceit.

––––––––––

What is appropriated is often someone else's photograph, one of several postmodern strategies to which the digital lends itself. Numerous photographers have become embroiled over disputes not only when others use their photographs without permission but also when they change them. For example, Susan Meiselas, who covered the Nicaraguan revolution nearly thirty years ago, was trying to protect the historical contextualization of one of her photo-

graphs that has become iconic—a man throwing a Molotov cocktail—after she found that a painter, Joy Garnett, had used the image as the basis for one of her own works in a series entitled "Riot." (Garnett defines herself as a painter for whom "all of my paintings are based on photographs" that she finds, many on the Internet.)

Feeling that Meiselas should not be able to exercise proprietary control over the uses of her own photograph, Garnett went public with the conflict on the Internet. Many sided with Garnett in what was soon called "Joywar," putting up mirror sites to support her in case her own site would be shut down, as well as creating and publishing even more derivative imagery. Meiselas, who has long found it difficult to establish a point of view in mainstream media, was marginalized again, this time judged to be too controlling and old school by denizens of the Web.

They appeared together to publicly discuss the issue, and then published their remarks in *Harper's* magazine. Garnett, who is also arts editor of the journal *Cultural Politics,* cited provocative questions raised by Internet posts: "Does the author of a documentary photograph—a document whose mission is, in part, to provide the public with a record of events of social and historical value—have the right to control the content of this document for all time? Should artists be allowed to decide who can comment on their work and how? Can copyright law, as it stands, function in any way except as a gag order?"

Meiselas responded by warning that "technology allows us to do many things, but that does not mean we must do them. Indeed, it seems to me that if history is working against context, then we must, as artists, work all the harder to reclaim that context. We owe this debt of specificity not just to one another but to our subjects, with whom we have an implicit contract." The author, who risked her life to witness the Sandinista revolution (not "riot," as Garnett contextualized it), found that all she could do, in the age of mass appropriation, was plead her case. Garnett did promise to credit the photo along with her painting.

"If God died in the nineteenth century, according to Nietzsche," wrote Paul Virilio, "what is the bet that the victim of the twentieth century will not turn out to be the *creator,* the author, this heresy of the historical materialism of this century of the machines?" In fact, what happened to

Meiselas's photograph has happened to countless others. The "content provider" is often just that.

Some of the most historically significant photographs are being remade by artists who reconfigure the images or place themselves within them. Polish artist Zbigniew Libera, for example, has taken well-known images of suffering, such as of a concentration camp, the Vietnamese girl fleeing from a napalm attack, or the death of Che Guevara, and modified them to show smiling prisoners behind barbed wire, a nude Caucasian woman smiling near a man in a hang-glider suit, or an apparently resurrected Che rising from his deathbed. History becomes fluid, with a happier ending just around the corner. In his 1994 series of forty manipulated images that he calls "Man Without Qualities," Matthias Wähner, a German artist, inserted himself into famous photographs such as that of President John F. Kennedy in a motorcade or, again, the young girl fleeing a napalm attack on a Vietnamese road. The past is revised and questioned, and some of history's iconic images are made to seem silly.

Given the increasing manipulation of the past, Barthes's famous observation from another era now seems nostalgic, even hopeful: "One day, quite some time ago, I happened on a photograph of Napoleon's youngest brother, Jerome, taken in 1852. And I realized then, with an amazement I have not been able to lessen since: 'I am looking at eyes that looked at the Emperor.'"

Families are also revising their photographic histories, retouching albums, removing ex-spouses. Looking at these albums, children may have difficulty knowing who was actually present at their parents' wedding, or what their parents were wearing at their own. Why buy an expensive dress when an "image stylist" can add it to the photograph later? One commercial service, by selecting from a variety of photographs, promises group portraits in which "We combine the best expressions into a single 'perfect portrait.'"

Increasingly, much of the photographic process will occur after the shutter is released. The photograph becomes the initial research, an image draft, as vulnerable to modification as it has always been to recontextualization.

In recognition of the new characteristics of digital media, the concept of copyright has already become more nuanced (and perhaps more realistic) with the new licensing system Creative Commons. As the non-profit's

Web site suggests, "You can use CC to change your copyright terms from 'All Rights Reserved' to 'Some Rights Reserved.'" Choices can be made by the initial author concerning whether the work should be copied, distributed, displayed, or performed with a specific credit, whether derivative works can be made from it, whether it can be used only non-commercially, and so on. In the fluid digital environment copyright may be for some too static and all-inclusive a concept.

———————

There have been numerous recent high-profile cases where photographs have been changed. For example, a few years ago the *Los Angeles Times* fired photographer Brian Walski, who had composited two photographs from the war in Iraq to get what he thought was a better image. A foreground image of a British soldier from one frame was composited with the background of another, depicting seated Iraqi civilians. But he was given away by the repetition in the image of a few of the people in the background, although not until the work had been published in several newspapers. The *Times* then examined his previous photographs and, despite finding no evidence of any manipulation, quarantined them so that they could be republished only with approval from the senior photographic staff. Other news organizations have also recently fired photographers, as well as an editor, for the digital manipulation of photographs to make what the photographer considered to be a stronger point.

Walski's alteration, which was largely innocuous in the information it conveyed, can be argued to hardly have been as significant as those engaged in by photographers who, on a daily basis, legitimize the staging of yet another photo opportunity as an authentically occurring event. There is a generalized preference in news media to publish actual photographs of artificial events, rather than the other way around. In Walski's case it may have been particularly frightening that it was the unsupervised photographer in the field who was making the modifications.

There is considerable competition among photographers to make the most exciting photograph (if not the most exploratory one) so as to have it published back home. If readers do not see the photographs then what is the point of the photographer risking his or her life in battle or even doing the

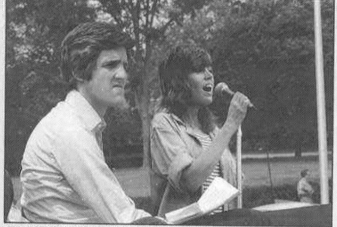

Fonda Speaks To Vietnam Veterans At Anti-War Rally

Actress And Anti-War Activist Jane Fonda Speaks to a crowd of Vietnam Veterans as Activist and former Vietnam Vet John Kerry (LEFT) listens and prepares to speak next concerning the war in Vietnam (AP Photo)

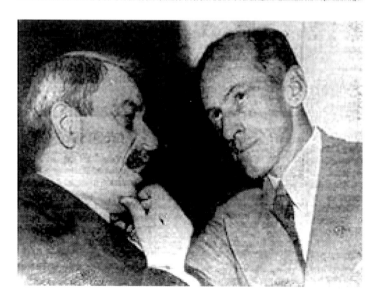

FIG. 7: Both images were fabricated to discredit politicians: Massachusetts senator John Kerry falsely shown with Jane Fonda in a 2004 composite (top); Maryland's senator Millard Tydings similarly depicted in 1950 with Earl Browder, former head of the U.S. Communist Party.

job? David Rees, a University of Missouri journalism professor, suggested that one motivation for such alterations in today's image world might be that "movies are perfect, so we have this expectation that journalism should be perfect as well."

In the increasingly stylized press, concerned for its own survival, fearful of readers' sensibilities, competing with "reality" television and surrounded by a never-ending stream of well-groomed advertising, the raw, visceral, upsetting photographs are often refused and, partially as a result, never made. (After once publishing a group of war photographs in a magazine where I was on staff, I was admonished by the publication's advertising department for not having been helpful in creating "a good environment for advertising.") Photographers in pursuit of the authentic often find themselves using their own money, along with grants, to work on self-defined multiyear projects.

It is not, however, only the professionals who reconstruct imagery for the press. During the 2004 presidential campaign, an image of candidate John Kerry and one of actress Jane ("Hanoi Jane") Fonda were composited to make it appear that they once were together at an antiwar rally during the Vietnam War. Published on a conservative Web site, with a fake Associated Press credit, the image was made simply by downloading a photo of each from the Corbis photo agency site. The composite was then picked up and published by mainstream newspaper editors who, thinking it was an actual photograph, were now able, and sometimes all too eager, to picture Kerry's early radical leanings.

Similarly manipulated imagery playing on voters' suspicions and fears could significantly influence future elections, particularly if published in the days just before the voting. A 1950 composite of the former leader of the U.S. Communist Party, Earl Browder, meeting with Senator Millard E. Tydings of Maryland, circulated by the staff of the virulently anti-communist senator Joseph McCarthy, is thought to have been not only a factor contributing to Tydings's unsuccessful bid for reelection (he lost by 40,000 votes) but a warning to other politicians not to tangle with McCarthy. Even though it was labeled a photo-composite, few readers understood the term.

Another much more recent controversy over a possible photo-composite concerned a smiling U.S. Marine with two boys making a thumbs-up

gesture and holding a sign that read, "LCpl Boudreaux killed my dad, th(en) he knocked up my sister!" It provoked outrage, including protests by the Council on American-Islamic Relations, which asked for a Pentagon investigation. But another version read "LCpl Boudreaux saved my dad, th(en) he rescued my sister!" A third version on the Internet, with two other boys, read, "I'm safer in Iraq then [sic] with Michael Jackson!"

In 2004 an investigation was conducted by the commander of the U.S. Marine Forces Reserve. According to information received in 2007 through the Freedom of Information Act, "Several other versions of this photograph — with different quotes — surfaced on the internet following this initial photograph ["LCpl Boudreaux killed my dad..."]. After extensive analysis of these photographs by Federal authorities, however, there was insufficient evidence to conclusively show whether any of these photographs were 'original' or whether they actually contained the words alleged. In other words, investigators were unable to determine whether or not these photographs had been digitally altered." If the military could not figure it out, what hope is there for anyone else?

Perhaps the most interesting site that concerns itself with digital manipulations of photographs is an instructional Swedish Web site that shows the multiple alterations to lips, eyes, teeth, breasts, nose, waist, cheek shadows, jawline, facial creases, hips, hair, and clothing that typically occur to make an ordinarily attractive young woman slickly glossed for magazines. "How I Became Perfect" allows the reader to click on each physical feature and see the changes that were implemented to transform her image for commercial consumption. The viewer, for example, can find out about her eyes and brows: "The whites of the eyes are made as white as chalk, and the irises are given a bright blue colour. The eyebrows are moved higher up and made less straggly. The eyelashes are lengthened and the entire photo is given a lighter, softer glow." (This is reminiscent of Richard Avedon's analog retouching of pinkish tear ducts, removing them in order to whiten his models' eyes.) By imparting a modicum of media literacy, the site may allay the insecurities of some readers.

Many of these modifications of the photograph were the inventions of large corporations, thought of as authoritative. Some, like the Walski composite and the fake Kerry-Fonda image, were created by individuals, both

professional and amateur. The actual photograph, for a variety of reasons, had been judged insufficient for their purposes. Each had to be manipulated or, according to the more positive spin, "enhanced."

There have also been frauds published in scientific journals—slight changes in the look of a cell, for example—that have been difficult or impossible to detect. At the *Journal of Cell Biology,* 1 percent of the submissions recently were judged fraudulent. Editors now routinely use Photoshop software to search for compositing or other changes—a part of the image that has been doubled; an extraneous line indicating that a segment comes from another image. It is not a foolproof method but it does catch some of the fakes.[6]

Dr. Hani Farid, an applied mathematician at Dartmouth College, has recently developed algorithms to analyze whether parts of an image have different illumination sources than the rest or to see if extra pixels have been generated by either enlarging sections or rotating them as ways of finding photographs that have been altered. Interest in the new field of digital forensics, according to Farid, has come from editors at scientific journals, eBay customers, and the F.B.I., among others. Whether it will eventually prove practical to analyze the masses of images that circulate daily, or how difficult it will be to detect all the modifications, will take time to sort out.

It would be interesting to provide such software to interested readers, just as cashiers have machines to find fraudulent paper money. One could imagine bloggers—in the United States there are already twelve million— taking up an aggressive watchdog role as a public service. (The somewhat crude digital alterations by a Reuters freelance photographer in Lebanon during the 2006 conflict with Israel—he added smoke to one photo to increase the sense of devastation over Beirut and flares to an Israeli F-16 in another, which were miscaptioned as missiles—were uncovered by the blogging community.) The atmosphere, however, could degenerate into that of a witch-hunt, where accusations fly and every photograph is thought to be guilty until proven innocent.

While waiting for any technical watchdog to develop, the lack of universal, transparent standards in photojournalism, particularly in magazines, despite nearly twenty-five years' experience with such manipulations, is disconcerting. For example:

Mag Runs Doctored Photo of Martha Stewart
By THE ASSOCIATED PRESS
Published: March 2, 2005
Filed at 3:52 p.m. ET

NEW YORK (AP)—Martha Stewart, who is about to get out of prison, seems to have undergone a makeover on the cover of the latest *Newsweek*.

Stewart's face was placed on someone else's body for the cover story "Martha's Last Laugh," making the 63-year-old look terrific after five months behind bars.

Editors at *Newsweek* said there was nothing wrong with the "photo illustration," which was identified as such inside the magazine.

"Anybody who knows the story and is familiar with Martha's current situation would know this particular picture" was an illustration and not a photograph, said assistant managing editor Lynn Staley.

Photo illustrations are a fairly common practice.

Newsweek's cover headline read: "Martha's Last Laugh: After Prison, She's Thinner, Wealthier & Ready for Prime Time." Celebrity images have often been retouched, but now it's possible to "borrow" someone else's body to make the point. Why diet or exercise?

If one is rich and powerful, in the world of image it can be a sign of prestige to be given someone else's body. (It is reminiscent of Neal Stephenson's novel *Snow Crash,* where in the "metaverse," now cyberspace, the poorer denizens have black-and-white avatars while the richer get color.) But considering that such image manipulations frequently happen to women, the motivations can simply be misogynistic. Body replacement happened to Oprah Winfrey on the cover of the mainstream *TV Guide* (Ann-Margret's body) and to Hillary Clinton on the cover of the much more provocative *Spy* magazine (shown as if a dominatrix in leather and chains). Rosanna Arquette had her T-shirt adorned with the *Playboy* bunny logo on that magazine's cover without her permission, while she disagreed with the company's philosophy.

More recently, in 2006 CBS television news anchor Katie Couric lost a virtual twenty pounds or so in a slimmed-down image that the network published in one of its magazines (some digital cameras now offer a similar slimming function that can be used as one takes portraits). Daryl Hannah not only lost weight, she lost her body in a composited photograph on the

cover of *Spy* that dressed her in a Jackie O–style pillbox hat and suit (similar to the one the president's wife had worn on the day he was assassinated) and had her sporting someone else's bare midriff, while the magazine posed the provocative question, "The next Mrs. John F. Kennedy Jr.?"

Some time after I published a long article in the *New York Times Magazine* on the coming digital revolution in photography and film in 1984,[7] a senior editor told me that I was prohibited from writing again on issues of new technologies. Why? Because according to their calculation this article turned out to be four years prescient and the editors deemed it unfair to force the reader to contemplate anything more than six months into the future. Now, almost a quarter-century later, we are only beginning to grapple with many of the implications of the digital revolution.

———————

The alteration of the phenotype, modifying body parts and exchanging them among the people depicted, is symptomatic of the transition from a focus on the visible human, illuminated by the play of light and shadow, to experimenting with his coded being, or DNA. These media strategies begin to acknowledge the evolution of humanity from sentient beings to social signifiers. Once conceived of as the embodiment of thought and feeling, people are now assigned, through the lens of mass media, to global importance as information and image.

The widespread use in affluent societies of graphic software, video games, camera phones, and digital cameras has accelerated playing with code-based images — synthetic football players, computer-generated characters in films, composited portraits — as a prelude to modifying code-based humans. In a recent *New York Times* column, David Brooks wrote: "A Harris poll suggested that more than 40 percent of Americans would use genetic engineering to upgrade their children mentally and physically. If you get social acceptance at that level, then everybody has to do it or their kids will be left behind." More specifically, "British couples can create babies through in vitro fertilization to help cure sick siblings, Britain's highest appeal court ruled Thursday, rejecting a challenge from an anti-abortion group. The Law Lords backed a 2003 Court of Appeal ruling that some couples undergoing the fertility treatment could have their embryos screened to find tissue

matches for seriously ill children."

Not only are bytes, unlike chemistry and film, not palpably physical but they become insistent metaphors for a depiction of reality as informational. While photography is conventionally thought of as depicting the present to be seen as the past, we have also, unbeknownst to ourselves, been making coded images of the future—our own as transformed humans, or what some are calling, with justification, "post-humans."

Our genotypes will soon be viewed as part of our résumé, perhaps preventing us from getting certain jobs, health insurance, or even being accepted in marriage. For one thousand dollars by mail, an individual's genome can now be charted and analyzed, including proclivities for diseases. Much of the staff of *Vanity Fair* took DNA tests for a special issue on Africa to chart their ancestral pool; results were published on the masthead. The "replicant" in *Blade Runner*, assured of her humanity by the snapshots she possessed of herself as a child, was doubly deceived: the photos were manipulated, as was she. Her situation begins to forecast our own in the age of the digital photograph and the cyborg.

In the interim, digital photography will shower us with photographs of chimeras, creating a menu of possibilities for change, some helpful and others as psychically destructive as the cold cookie-cutter imagery that has already tyrannized the susceptible on nearly every magazine cover featuring a young, thin, and heavily retouched woman. In an age where twins have already been born seven years apart due to frozen embryos stored by fertility clinics, it will not be enough to just focus on appearances. Image-portraits will undoubtedly be made that reflect the kinds of chromosomes we each possess, using new strategies to make not only our bodies but also our genotypes visually explicit. Dating services might provide images that approximate the look of children who could result from their suggestions for partners, while simultaneously making potential couples anxious as to the health risks of their having a family together based on the combinations of their DNA. Realistic-looking imagery of imagined species, coming from an eventual genetic image generator, will suggest the possibilities of merging into more hybrid beings ourselves, just as artists have long been doing in a more intuitive way.

Some of these virtual experiments have begun, including the extraordinary synthetic multiplayer world of *Spore*, created by Will Wright, where

people will be able to choose body parts to create their own creatures. More prosaically, there is also a Miss Digital World competition—Ilana, one of the entries in 2004, was described as having been born in São Paulo, being 5′11″, and having "velvety" skin and a polygon count of 195,000. Meanwhile, there is also the new field of synthetic biology, a real life experiment, where engineers go beyond tinkering with one or two genes and try to rewire the genetic circuitry of living organisms, even the entire genetic code. One strategy already being pursued is the modification of microbes so as to generate inexpensive petroleum out of plant waste, and there is discussion about eventually designing whole organisms from scratch. Given the possibilities for massive, wholesale change as to the character and quality of life, there should be much for digital photography to visualize and address.

And just as there are extensive similarities among the DNA of humans and other organisms, so too in the digital environment the various media can share code and be output as hybrids or as each other. I remember a Mondrian painting output as music by Kevin Walker, at the time a New York University graduate student, who worked out a system allowing the viewer to "play" the colored geometric objects in the jazz-influenced painter's imagery. One can imagine the "tones" of music and of image commingling as code, and then output as either one, or as a different medium entirely. Jaron Lanier, the virtual reality pioneer, envisioned playing an organ so that the musical tones translate into a virtual castle that one could then inhabit.

Ansel Adams, the great photographer, began as a classical pianist. When I asked him why he had been using, at that time, Polaroid film with its short tonal range as opposed to conventional film, he remarked that the harpsichord has a more limited number of tones than a piano but still makes beautiful music. His "Zone System" in photography, organizing tones from black to white in steps as one would organize sound on a piano keyboard, was influential in determining a conceptual architecture of the photograph. It also predicts, in a sense, the discrete integer-based tonalities of the digital.

Then there is artist David Rokeby, who in the late 1980s came up with his *Very Nervous System* (so many of the more innovative works began at the cusp of the digital revolution, before many of its features became pervasive enough to seem routine). The protagonist moves his or her body in space and the cameras "see" it, translating the image into data and then outputting

it as music that causes the protagonist to again move his body, almost as if dancing, so as to produce more music (or sound). Movements are analyzed "dynamically and historically," so it may be that one kind of movement will not cause a similar sound to be produced (therefore making it unlike a piano). The camera, inputting the visual, ends up by making a kind of music. To Rokeby, the state produced is "almost shamanistic," so that "after 15 minutes in the installation people often feel an afterimage of the experience, feeling directly involved in the random actions of the street."

Imagine, then, filming a demonstration and bringing it home as a musical recording based upon what the camera saw. How would it be to evaluate the intensity and success of a demonstration by the sounds produced from imagery? Or, as students at NYU attempted, asking a dancer to create her own music from within the system. In this case the dancer found that her movements became contorted as she attempted to get the right sound; she was used to dancing to the music, not creating it as she danced. The students achieved a more serendipitous result aiming a camera at the street below and having the taxis, bicyclists, pedestrians unknowingly create, à la John Cage, a kind of music, or what one might call a "sound photograph," one of many eventual kinds of "writing with light."

These "accidents" become a continuation of one of photography's strongest suits—its ability to see in ways that humans cannot, and to find emerging rhythms of life that people may sense but cannot focus upon. As such, these results serve as a partial antidote to the medium's servile function as both illustration and "proof" of preexisting points of view. Here the human has less control over the photographic process and is surprised by it.

FIG. 8: Visuals are translated into sound in David Rokeby's "Very Nervous System."

As Garry Winogrand used to say, "I photograph to see what things look like when they are photographed."

As in the sciences, the very act of observing can fundamentally change an outcome, and so can also fundamentally change us. Inventing new media, whether eyeglasses or computers or digital cameras, to better explore the world has the unintended consequence of rendering that world in which the inventions were made passé. The new inventions allow, and ultimately force, the world in which they were invented to change. And the planet that these media were meant to explore is no longer the same for the very simple reason that these media observe it.

Media create for us a different world and, as a result, we require evolving media. "Our fine arts were developed, their types and uses were established, in times very different from the present, by men whose power of action upon things was insignificant in comparison with ours," poet and essayist Paul Valéry wrote in 1931. "But the amazing growth of our techniques, the adaptability and precision they have attained, the ideas and habits they are creating, make it a certainty that profound changes are impending in the ancient craft of the Beautiful....For the last twenty years neither matter nor space nor time has been what it was from time immemorial."

Like the arts, news media also fundamentally shape the world that they are made out to represent—and may even replace it. As many theorists have explained ("the medium is the message") watching the war in Iraq on television is, in large measure, watching television, not the war. A televised war requires different strategies—simplified ideologies, a visually coherent narrative, a telegenic president, horror viewed as spectacle—than does one reported in print with its closer adherence to cause and effect. A "permanent war on terror" transcends the limitations of a book but is exemplary as an anxiety-producing drama to fill many television seasons and sell untold billions of dollars' worth of reassuring and diverting advertising. The attacks on September 11 kicked off the series; few seem intent on ending it. As a televised drama it serves its purpose well.

Photography is generally perceived as resolving ambiguities (for example, that when a horse gallops there is a moment when all four feet are off the ground, as Eadweard Muybridge's photographs famously demonstrated in 1878) rather than promoting them. Yet it can also become a filter

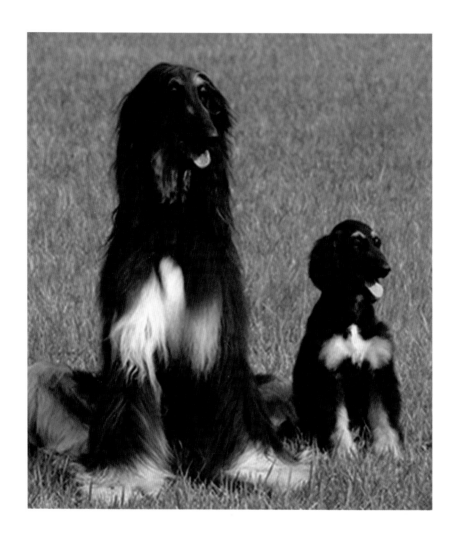

FIG. 9: Snuppy, on the right, is an identical twin of an adult male Afghan hound.
He was born to a surrogate mother, herself a Labrador retriever.
Photo by Hwang Woo Suk/Seoul National University/AP.

that, in combination with its accompanying caption, attempts to collapse overlapping realities, often unfairly, into a singular state. Knowing that a horse gallops with all four legs off the ground at one time means that we live in a world that is less mysterious, less intuitive, in which the camera, not people, becomes the arbiter. Using the camera only to provide answers and not questions is to underestimate what the camera can do.

Over a century later, as one of the founders of Doctors Without Borders put it, "Without photography, massacres would not exist." Otherwise, no one, especially politicians, would pay attention. A human eyewitness's account lacks the perceived objectivity and portability of the photograph. As a result, massacre survivors are victimized twice, by subjective, hating people and by the so-called objective machine trumping their viability as witnesses to their own victimization. And if one day people believe neither the validation of the photograph nor the eyewitness testimony, then we will live self-absorbed in a world where there are no massacres, at least no credible ones.

A superficial irony in this information age is that so many of these massive changes go unnoticed as the staggering overload of information makes them all that much harder to detect; the tragedy is that so many of these are fundamental transformations that are difficult if not impossible to undo. For example, as Bill McKibben recently wrote in *Enough,* once we start modifying the gene pool we have caused revolutionary change that cannot be undone (as has already happened in the genetic modification of food sources; much the same can be said of the planet's climate). Once genetic manipulation begins in humans, what will be done with those whose genes have been modified—forbid them from having children? Will their children still be considered "natural," or humans with an asterix? Will it be a version of the post-human who wins the races, comes up with the new theorems, and leads the planet? Will the unmanipulated humans then be labeled organic, as we now call certain foods? Or, as the cyberpunk novelist William Gibson has asked, are we not already beginning to approximate a cyborg once we have had the first synthetic vaccine injected, as nearly all of us have had?

Among the many consequences of this malleable gene pool most certainly will be the pursuit of image, with a concomitant loss of perspective: "In a world in which everyone is smart, good-looking and pleasant, everyone will be fit to perform in hit movies, but no one will be fit to review them," wrote David Brooks in the *New York Times.*

It is a potentially calamitous pursuit. Did the millions of romanticized and appropriately beautiful images of nature that serve as an image archive, on calendars, in textbooks and magazines, on the Internet and elsewhere, help us to ignore the realities of environmental destruction? Might this proliferation of celebratory imagery turn out to be a facade that has served to disconnect us from the disappearance of the natural? We can always make more images, since in the digital realm they can be synthesized ad infinitum whether or not the putative subject continues to exist.

In our acquisitive mode, it may be fool's gold that we have attained. Transforming the world into photographic currency substitutes a "sense of the universal equality of things," wrote Walter Benjamin in the 1930s. He argued "Every day the urge grows stronger to get hold of an object at very close range by way of its likeness, its reproduction." But, Benjamin continued, "reproduction as offered by picture magazines and newsreels differs from the image seen by the unarmed eye. Uniqueness and permanence are as closely linked in the latter as are transitory and reproducibility in the former. To pry an object from its shell, to destroy its aura, is the mark of a perception whose

FIG. 10: My Twinn is a company that promises, upon receiving the appropriate digital photographs, to make a "just-like-me doll created to look like the special child in your life."

'sense of the universal equality of things' has increased to such a degree that it extracts it even from a unique object by means of reproduction." The more than three billion photographs that Photobucket claims are available online at the user-generated site, or the more than three billion video clips that market research firms say are served up monthly on YouTube, are more than able, by sheer volume alone, to "pry an object from its shell," as well as eliminate any aura of the original or a sense of uniqueness.

In a university classroom I often ask students if there is anything in the room, other than the students themselves, which is one-of-a-kind and not mass-produced; we can usually count many dozens of rectangular shapes—desks, computers, books, pads, blackboard, screens, windows, doors, etc.—yet we rarely ever come up with more than one or two custom-designed pieces of jewelry as the only unique objects in the room. It is often the first time the students realize that for much of their lives they are surrounded almost exclusively by the non-original, which many find reassuring. After all, who wants a one-of-a-kind car, and who does not want to bond in the consumerist ethos of nearly infinite replication?

Photography itself is, in this context, an appropriately shaped medium with which to communicate. The plethora of rectangular photographic images that reinforce the generic and mass reproduced as a means to consumer acceptance diminishes our sense of the possible and the sublime. They insidiously and casually substitute easily reproducible image-friendly paradigms—the synthetic human, the paradise-like environment—for the rawness of existence. Accustomed to relying on the photograph as trace, we hardly know (or want to know) to what extent and how quickly we are leading ourselves down such an essentially compromised path.

In the digital image world the universal equality of things also lends itself to easy categorization under the most banal keywords in the ever-growing archives of o's and 1's. The photograph, no longer visible on paper or film, generally requires that keywords be assigned in order for the image to be quickly retrieved—an experience quite different than perusing prints. By assigning keywords, the ambiguity of the photograph is often arbitrarily concretized, the photograph's multiple meanings denied, reifying the challenging mysteriousness of existence that the photograph can sometimes evoke. "Sunsets" and "babies" become keywords that belie any remaining

complexity in the image; "sexy" is a keyword that is frequently assigned as a ploy in search of a larger audience, a form of consumer branding. As of now there is very little sense of play in keywording, of a poetic dissonance between the word and the image.

Eventually the assigning of keywords will become more subtle, and other strategies will be widely employed to find a digital photograph— geo-tagging, matching image algorithms, various ways of linking from other images and image fragments, etc. A more intuitive associative retrieval system, like Vannevar Bush's visionary memex ("a device in which an individual stores all his books, records, and communications, and which is mechanized so that it may be consulted with exceeding speed and flexibility. It is an enlarged intimate supplement to his memory."), first broadly outlined in the July 1945 issue of *Atlantic Monthly*, would be particularly helpful if it could treat photographs in the digital environment with more subtlety as neither generic nor confined by the information in their captions.

Meanwhile, photographic prints are sold for booming prices at auctions from what is beginning to resemble a photographic graveyard. Earlier this decade the *New York Times* reported that some 98 percent of the Bettmann photographic archive, personally owned by Bill Gates, was taken from its file cabinets in Manhattan and buried in a refrigerated Pennsylvania limestone mine for safekeeping, as the prints were deteriorating. Only the more commercially popular images from among the 17 million going into storage had been digitized (it was said to be too expensive to scan all the rest) and would remain generally available. The collection, a great paper-based idiosyncratic cultural legacy containing some of the most riveting news and documentary photographs of the twentieth century—which grew from a cache of photographs brought to the United States in 1935 by Otto Bettmann during the Nazis' rise to power—was rendered much less accessible. A readily salable version of history—Einstein sticking out his tongue, for example—was kept in circulation as a digital file. Prints become the collector's domain; for reproduction in today's media, digital files are generally preferred.

The moldering photographs, palpable testimony to time's passing, are refrigerated and remote. The original photograph, its presence in time and space, yellowing and with all the markings on the back, is disallowed.

The mechanically reproduced photograph attains a new status as a scarce and at times unique object, with a preciousness more like a painting: one of only three known prints of Edward Steichen's *The Pond-Moonlight* sold in 2006 for $2.9 million. The scanned and smoothed digital images enter an eternal present in which they are distributable over wires and through the air, ephemeral, omnipresent, never decaying, gratuitously bestowing a facile attempt at immortality.

Certainly, the aging of the digital photograph is not the same as a software engineer's offer to program a paper-like "browning" according to the computer's clock. The digital, as we shall see, offers a much more dynamic version of time than that.

And why not? Even one of the great constants, the speed of light, has changed. In 1999, on the cusp of the millennium, this article, "Physicists Slow Speed of Light," appeared in the *Harvard University Gazette*:

> Light, which normally travels the 240,000 miles from the Moon to Earth in less than two seconds, has been slowed to the speed of a minivan in rush-hour traffic—38 miles an hour.
>
> An entirely new state of matter, first observed four years ago, has made this possible. When atoms become packed super-closely together at super-low temperatures and super-high vacuum, they lose their identity as individual particles and act like a single super-atom with characteristics similar to a laser.
>
> Such an exotic medium can be engineered to slow a light beam 20 million–fold from 186,282 miles a second to a pokey 38 miles an hour.
>
> "In this odd state of matter, light takes on a more human dimension; you can almost touch it," says Lene Hau, a Harvard University physicist.

In the past few years speeds have been slowed down even more. "In a quantum mechanical sleight of hand," the *New York Times* reported in 2007, "Harvard physicists have shown that they can not only bring a pulse of light, the fleetest of nature's particles, to a complete halt, but also resuscitate the light at a different location and let it continue on its way."

The word "photography," coming from the Greek, means writing or drawing with light. If the light changes the writing should as well.

FIG. 11: The Trevi Fountain according to "Photo Tourism," a software that assembles
photographs showing multiple perspectives of the same scene from the Web.

3
From Zero to One

A way of certifying experience, taking photographs is also a way of refusing it—by limiting experience to a search for the photogenic, by converting experience into an image, a souvenir. Travel becomes a strategy for accumulating photographs.... Most tourists feel compelled to put the camera between themselves and whatever is remarkable that they encounter. Unsure of other responses, they take a picture.

—Susan Sontag, *On Photography* (1977)

The new malleability of the photograph in the digital environment both exacerbates the issues that Sontag singled out and, intriguingly, renders them partially moot. As the digital destabilizes the photograph as a faitfhul recording of the visible, its new flexibility opens it up to other approaches that previously may have been quickly rejected or deemed impossible.

Does travel have to become "a strategy for accumulating photographs," as Sontag states, even among the photographically inclined? From the perspective of profound technological change, it would be particularly defeatist were we to feel compelled to remain within the limitations of what might now be called the previous medium. While advertising agencies and fashion publications have eagerly embraced a pixelated photography, few artists and documentarians have seriously investigated new possibilities and integrated them into their working strategies. The new medium remains, for the most part, quiescent, its potentials hardly articulated, let alone realized. As Jocelyne Benzakin, a gallery owner and photo agent, said in 2000, "I realize the power of a computer program like Photoshop...but haven't seen anybody who has taken photography to a different level with it, a different place, the way, say, Jimi Hendrix completely changed the guitar."

But photography can, and will, be transformed. An example: For the tourist Sontag writes about, one of the great advantages, so far unexpressed,

of digital imaging is the ability to have oneself "photographed" at one's destination *before* leaving for vacation. Just as *Newsday* showed the two ice-skaters meeting the next day, it would be remarkably simple for a would-be traveler to place his or her own portrait in front of an image of any tourist trap—there are none that remain unphotographed—and create a "future travelogue."

Would this be cheating? Upon arrival, the traveler could then improvise and skip the tourist attractions (the photographs that "certify" his or her presence at the de rigueur sites having been already created). Instead, the visitor might try to experience foreignness more intimately, walking around, talking to people, following intuitions, smells, sounds, sights, using a camera to explore what is intriguingly new, without feeling required to repetitively depict the already-known. Tourist photographs would be acknowledged for what they usually are: personalized postcards repeating clichés. (Pedro Meyer, a Mexican photographer, would teach workshops by having his students first buy local tourist postcards and then go and photograph the same scene, with extraordinarily different results.)

Even more important, the tourist has a chance to evolve into a traveler, an appellation that now seems reserved for the nineteenth century. "Traveler" acknowledges a voyage into the unknown rather than a sampling of the overly exposed. The tour guides telling where to stand for the best photograph, rating each vantage point, could be discarded or, better yet, never produced. There would be less chance of a "Most Photographed Barn in America"; instead, each place of interest could be separately visited and discovered, without the experience already having been so thoroughly appropriated by the camera—although it might require disregarding photo Web sites until after the trip. (In 1984 while visiting Havana, I saw no photographs in the streets attempting to sell anything. Unlike in a competitive capitalist country, products did not need to be advertised, emphasized, signified. I walked without the attempted seduction of image. Finally, I saw a few photographs—individuals' portraits, quietly hung over a photographer's studio where they seemed to belong.)

Unclogging a part of Paris, tourists would not be found standing en masse in front of the Eiffel Tower waiting for a spouse or passerby to release the shutter. That picture would already have been made in a kiosk at the airport, if not at home, a task that might become routine, like packing a pass-

port. Initially, the images could be put in the mail upon arrival, or timed to be sent as an e-mail, with the requisite phrases: "Having a great time. Wish you were here." (See Georges Perec's fascinating rumination on the few generic sentences that constitute the backs of nearly all postcards.) Avoiding the chain restaurants, stores, and hotels as much as possible, the adventure (not the "memories") may begin. And each image could be labeled "future photograph," just to let one's correspondents in on the anti-tourist strategy.

The originality and spontaneity of experience is at stake, with a chance to be revived. Already equipped with "future photographs," not needing to add to the blizzard of imagery already existing, the individual is freer, less pressured to frame and preserve every precious moment. If the traveler wants to share the trip with friends via a user-generated Web site, images can be almost instantaneously uploaded. The pressure then on the traveler, given the competition of the billions of photographs already uploaded by others (fotolog.com, for example, claims that its members upload 500,000 new photos daily and over two billion images are viewed monthly), would be to find and photograph the idiosyncratic, not the predictable. And, as many are finding out, it may be better to wait and share the photographs upon one's return rather than be bombarded by e-mails from the curious.

There is also new software being developed to help in an ironic pursuit of the "perfect" picture. "Scene Completion Using Millions of Photographs," from Carnegie Mellon University, allows the hurried photographer to later have pieces of an image filled in with fragments automatically searched for from among other people's online photographs of the same scene (perhaps someone's head had inconveniently passed in front of the lens, or an ex-spouse had to be removed). It is a system of collage drawn from numerous authors who had visited at different times that will certainly befuddle historians looking to the photograph for any certainty as to what things were like. The software will also borrow captions from previous authors to more fully, if not always accurately, describe what one did not know one was looking at.

Another project, from the University of Washington developed by Noah Snavely, Steven M. Seitz and Richard Szeliski (the latter from Microsoft Research), is aptly called "Photo Tourism." A predecessor to "Photosynth," described later, the software finds photographs of the same site and presents them on-screen in a cubist array, according to the perspective from which

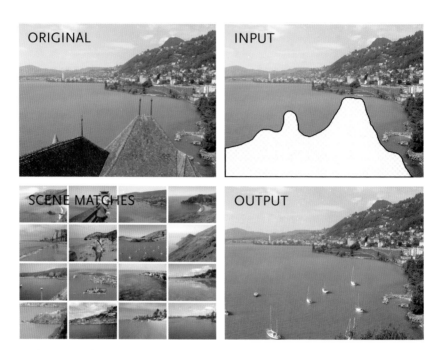

each was made. Any photograph can be enlarged, the viewer can search for close-ups of its segments that were made by others, and caption information can again be automatically exchanged among similar photographs. It also bills itself as a way to find photographs without being entirely dependent upon keyword searches.

And, of course, Google Earth and other such programs already allow compelling views from a satellite in outer space, seen through the metaphor of a three-dimensional planet on which we all live. Although still in its infancy, the possibilities represented by Google Earth are enormous for another form of travel photography that combines aerial overlays, geo-mapping, sound and video, allowing readers to follow a safari as it happens, for example, contextualized by a bird's eye view of multiple events that may be occurring simultaneously. Or one can descend for a closer look from the virtual sky for more urgent projects such as the Darfur overlay created by the United States Holocaust Memorial Museum. It allows a viewer to see at a glance the villages that have been destroyed and then view testimonies of those under

FIG. 12: "Scene Completion" allows the filling in of parts of one photograph by fragments from other photographs of the same scene that the software finds online. Images by James Hays and Alexei A. Efros/Carnegie Mellon University.

attack (it is the first project of the Museum's "Genocide Prevention Mapping Initiative").

Or, when combined with Gigapan, a billion-pixel panoramic photograph being developed at Carnegie Mellon University by a team lead by Randy Sargent and Illah Nourbakhsh, such mapping programs provide possibilities to deeply explore various scenes by immersing oneself in the high-resolution images.[8] The viewer can enter the extraordinarily detailed panoramic of an outdoor market, a political rally or sporting event, zooming in, finding and framing as well as annotating their own snapshots from within the vast array of pixels for others to click on and follow. In the future those exploring the image may also be able to listen to specific conversations or enter the buildings depicted. There are intriguing potentials for ways to enter evolving arenas in different cultures that, given the complexity of the panoramic, is not so much controlled by a photographer's persuasive point of view as investigated by the viewer.

The digital photograph, potentially more fluid than the paper or film-based variety, offers an experience to its readers that may better resonate with the open-ended, initial encounter. Rather than explicitly defining circumstances, such imaging strategies may leave much more to the reader's own curiosity as to what and how to explore, as well as a sense of the arbitrariness of the image. Encyclopedic in terms of possibility, ephemeral on the screen, offering enormous numbers of perspectives and combinations of media, updated continually and often featuring in part the viewer's own pictures, these new digital imaging strategies do not as readily provide a concretizing object the way that conventional photography does.

Rather than being perceived essentially as a reproduction, the digital photograph may be seen as representing a point of view that is more synthetic and impressionistic, capable of melding with other imagery or of creating variegated copies that may grow, as derivative works, further apart. These images may ultimately infringe less on the uniqueness of that which they purport to depict, just as a one-of-a-kind painting may emphasize the singularity of existence rather than diminish it.

The following image generations become responses to the previous work rather than copies, and the original is overlapped and contested by later improvisations. On YouTube, for example, videos often inspire response

videos, forming an ongoing and sometimes quite critical commentary. There are also threads on Flickr where others are invited to manipulate an initial image and post the results on the site. ("This is my wife. Go crazy, have fun, and let's see some of her alter-egos.")

Certainly pixel-based photographs can be effortlessly reproduced through exact copies of the code, but the digital space encourages play and a potentially subversive reconfiguring of the map that would otherwise both define and suppress the territory. In Walter Benjamin's 1936 essay, "The Work of Art in the Age of Mechanical Reproduction," he argued that the many reproductions being made "substitutes a plurality of copies for a unique existence," diminishing the aura of the original. Douglas Davis, in a digital-era response six decades later, asserted: "Here is where the aura resides—not in the thing itself but in the originality of the moment when we see, hear, read, repeat, revise."[9] Now the icon is transmogrified and, in a sense, resurrected.

Evidently, the medium's relationship to memory is affected as well. If photographs will be frequently altered and reappropriated, with faces changed and different meanings assigned (such as what happened to Meiselas's photograph of the "Molotov Man"), their relationship to memory is more pliable, provoking a variety of thoughts and reminiscences as well as confusions. In the digital arena one cannot with any certainty look at a photograph and say, "So that is how it was." This can be liberating, responding to some of Plato's famous concerns about writing: "For this invention will produce forgetfulness in the minds of those who learn to use it, because they will not practice their memory."

John Berger, when he wrote about photography in its analog incarnation thirty years ago, saw a more substantive connection: "What served in place of the photograph before the camera's invention? The expected answer is the engraving, the drawing, the painting. The more revealing answer might be memory. What photographs do out there in space was previously done within reflection." But we now need a new question: "What served in place of the *digital* photograph before the camera's invention?" The answer might be more playful, having more to do with conversation, even speculation. The past would be recreated, rethought and reinvented, the process more resembling an oral tradition where divergent views of the community are taken into account.

Just as the novel, poetry, and the memoir have explored the permutations of memory, so too might the digital photograph evoke a more complex past. Rather than a singular, inarguable reference point that is thought to be truer than human recollection, it can serve as an element in a web of other supporting and contradictory imagery, sounds and texts, a menu of possible interpretations, a malleable dreamscape and memory magnet. In a digital environment a photograph can be easily linked to newspaper headlines of that day, locally or globally, to weather reports, to diaries and appointment books, to photos and texts written by others in one's family or anybody else. Most important, others can also link to it, amplifying and contravening what its initial author claimed it represented, a central tenet of Web 2.0. Holistically, the photograph sprouts electronic roots and branches and is, in turn, entwined by other media.

The photograph of that beautiful red robin perched on an old oak tree was made, should one want to know, the same day that the president announced there were no weapons of mass destruction to be found in Iraq. (Perhaps, in this case, one would not want to know.) Or perhaps looking at that photograph of a red robin the viewer, moved, would decide to vote for a different candidate. The juxtaposition of its simple elegance with governmental machinations invites new reflections. And a photograph of a beautiful red robin perched on an old oak tree would be seen for what it always was —inextricably linked to the political.

The photographic frame would then move beyond an excerpt from a visible reality, radiating outward, connecting to ideas, events and images that were previously thought of as external. The photographer, cognizant that framing both does and does not exclude the rest of the world, could then try to be more present, aware, less confident that it is the camera that will "remember." And as author and viewers grapple over time with the photograph's meanings, creating new links and interpretations, it will become evident that the photographic process necessarily involves an ensuing contextualization. Rather than encouraging forgetfulness, the photograph might invite too much remembering.

For example, "Spellbinder," a new approach to melding the visible and invisible from the University of Edinburgh in Scotland, allows people to photograph sites with their cell phone cameras, to send in the photographs

to a database and, in return, quickly receive a new photograph containing virtual art that has been specifically made for that site overlaid onto the initial image. An afterimage can be thought of as entwining the actual as offline and online worlds overlap.

Imagine, then, if a visual database was used that allowed the photographer to see what had existed at the photographed site before—the dense forest that preceded the country club's manicured golf course, or the site of the horrific Triangle shirtwaist factory fire where seamstresses were locked in and burned or jumped to death that is now a nondescript building in lower Manhattan. The work in the 1990s by Shimon Attie, an artist who projected photographs of pre-Holocaust Berlin onto contemporary buildings there, would be particularly relevant. The past enters into a conversation with the present about the future, and each perception can be both amplified and contradicted, its authority less inviolate.

Of course, a danger exists that this conversation with the past could become obsessive. For example, there is a scene in the Wim Wenders movie

FIG. 13: Linienstrasse 137: Slide projection of 1920 police raid on Jewish residents, Berlin, 1992, by Shimon Attie.

Until the End of the World where the protagonist Claire Tourneur, played by Wenders's wife, Solveig Dommartin, is obsessed with viewing a videotape of her dreams. The visual fragments bring back much of the pain and sadness that she once felt as a child. Finally, her small machine runs out of batteries and, like an addict, she will do nearly anything to replace them. Images of her own subconscious become more precious to her than anything from the present, and she quickly evolves into a technological "user," hooked on videotapes of her uncovered memories.

As in the case of Claire Tourneur, despite an apparently enormous capacity for digital storage, this abundance should not be viewed as a blanket invitation to a continuous pursuit and offloading of all the minutiae of existence. (It is hoped that we will not all turn out to be closet pharaohs seeking immortalization in our digital pyramids.) Few can cope with the unending waves of reflection and pseudo-reflection that permeate the Web, including its blogs. Or one day all too soon we will mourn the analog, a single photograph on paper seeming refreshingly modest by comparison.

Given the enormous build-up of technologically inspired possibilities it may, in fact, be a suitable moment to consider invoking photographic modesty. Only twenty years after photography's advent, poet and critic Charles Baudelaire did so when he rather harshly criticized the medium as being soulless, as offering little more than a stenographic service and a memory aid: "Photography must, therefore, return to its true duty, which is that of handmaid of the arts and sciences, but their very humble handmaid, like printing and shorthand, which have neither created nor supplemented literature. Let photography quickly enrich the traveller's album, and restore to his eyes the precision his memory may lack. . . . But if once it be allowed to impinge on the sphere of the intangible and the imaginary, on anything that has value solely because man adds something to it from his soul, then woe betide us!"

Although the battle still simmers, there are few today who would question photography as an art form where, in the confrontation with emergent realities, even "the intangible and the imaginary" can be made palpable. And now, by rearranging pixels, modifying images by algorithms according to the rise and fall of the stock market or changing their colors based on casualty

counts, having photographs converse with the viewer or each other, sending them over the Internet to hundreds of family and friends just minutes after a baby's birth, hooking cameras up to one's blood pressure readings, using them to keep track of everyone in a neighborhood, or employing them to realistically depict a virtual world or to virtually depict a realistic one—many more strategies both inform and transform photography. To what extent this will reflect and amplify the human soul—or diminish it—is to be seen.

But it is not an entirely bad idea to have certain kinds of journalistic and documentary photography remain, if this is even still possible, Baudelaire's "humble handmaid." To aggressively abandon the documentary photograph as a credible recording device while exploring a host of new digitally inspired possibilities would be, at least in the short term, irresponsible. It would be unconscionable to force people into constant debates over whether a massacre depicted in some far-off country actually happened, owing to a generalized attack on photographic evidence. Or, due to an exaggerated sense of photographic possibility, to continually have to question whether that is an actual child who is being abused or a man being brutally beaten. Will those who suffer, actually suffer, take any solace from the debate over the free-floating ambiguities of photographic meaning? The photograph's irrelevance as documentary witness, should it come to pass, would handicap a democracy's capacity to function due to a dearth of credible evidence. The growing inability of many governments and citizens to assimilate and respond to nonlocal events, from global climate change to the mass killings in Darfur, suggests that the kinds and amounts of imagery available are already contributing to a cynical breakdown in governance.

It can be tempting to seamlessly fabricate imagery, even in pursuit of what one sees as the greater good, but once the medium's role as recording witness is deeply compromised those in power have an even greater advantage. It becomes all too easy to deny accusations of governmental wrongdoing by blaming the manipulation of the photographic or videotaped testimony, or to falsely indicate the existence of key evidence—weapons of mass destruction?—where none existed. Entire chapters of history could become newly contentious at the most basic levels. A fabricated Tiananmen Square? Holocaust? September 11? The moon landing? The future is even more problematic.

For example, digital imaging's impact on child pornography is already one of these problems, one that Congress was quick to realize in passing the Child Pornography Prevention Act of 1996. While child pornography previously had been defined as using actual children, and the legal system had attempted to protect them from harm, this act addressed "new photographic and computer imaging technologies [that] make it possible to produce by electronic, mechanical, or other means, visual depictions of what appear to be children engaging in sexually explicit conduct that are virtually indistinguishable to the unsuspecting viewer from unretouched photographic images of actual children engaging in sexually explicit conduct." Congress also warned against digital imaging systems that can "produce visual depictions of child sexual activity designed to satisfy the preferences of individual child molesters, pedophiles, and pornography collectors; and...alter innocent pictures of children to create visual depictions of those children engaging in sexual conduct."

The act was overturned by the Ninth Circuit Court of Appeals, a decision supported by the Supreme Court, because it was viewed by the courts as overbroad, banning imagery that was neither obscene nor using actual children. But as Justice Clarence Thomas pointed out, "technology may evolve to the point where it becomes impossible to enforce actual child pornography laws because the Government cannot prove that certain pornographic images are of real children." Congress and the courts continue to struggle with these issues.[10] As the world of the virtual becomes an essential starting point for the photographic, a direct connection to actual people and events may emerge as the old-fashioned exception. And, as is often the case, the bustling business of pornography may be a perverse leader showing the way.

It may be useful now to limit the manipulation of the documentary photograph when being used in the responsible press and to make these parameters easily understandable for all readers. Perhaps, given the billions of photographs now available on the Web, the frame of the manipulated photograph should be made thicker or thinner for easier identification, or apply some other device that the publishing industry feels will signal the difference. The extent of the modification could be explained in text hidden within the digital frame for the interested reader to retrieve with the cursor. With the easy exchange of photographs over the Internet, taking them out

from one context and inserting them into another in a matter of seconds, certain kinds of permanent identification may serve both the author's and the subject's interests.

In 1994, after the manipulation of the photograph of O. J. Simpson on the cover of *Time* magazine came to light, a student group at New York University and I worked together to propose a "not-a-lens" icon to be placed to the bottom right of a manipulated photograph. Presuming that the lens, more than the photographer or other aspects of the photographic process, was the key element not to be tampered with, we felt that this symbol—a small circle inside a square, representing a lens, with a diagonal line running through it— could be used internationally to caution the reader. While certain publications and media groups did adopt it at the time, such as the American Society of Media Photographers, a nature photographer, and the Italian magazine *Airone,* most refused, finding either that their own ad hoc systems were sufficient or that marking a manipulated photograph would give the reader the impression that those unmarked were somehow "true." And not everyone has ever agreed whether, for example, taking out an image detail such as a wire or wall outlet is a manipulation that should be brought to the reader's attention.

Nor is there sufficient vocabulary to deal with the issues of imagery. For some publications a "photo illustration" is an actual photograph taken to illustrate a preconceived idea: for example, having a dozen short people smile to "show" that short people have more fun. For others a photo-illustration is the altering of a photograph that already exists to demonstrate another point —such as significantly darkening and blurring O. J. Simpson's face, a modi- fication that for many would not be obvious. The reader is left to wonder, and to doubt.[11]

The result is that, despite frequent manipulations over a quarter- century and considerable reader confusion, there is little willingness within the publishing community to pursue a unified, easy-to-understand policy. While many publications, particularly newspapers, have recently adopted more stringent policies concerning the digital manipulation of photographs, the reader usually has no simple way to understand what these standards are, even in the responsible press.

In fact the dilemma may be resolved quite simply, once the vocabu- lary of the image is expanded even slightly. If one thinks of a news photo-

graph as a "quotation from appearances"—not the truth but a quotation—
then just as in writing it would be impossible to change the quotation with-
out taking off the quotation marks. For a news photograph that means, other
than slight alterations such as modest color correction, darkening and light-
ening—which would be somewhat like taking out the "umhs" and "ers"
from an interview—no changes are possible. If cropping is required it
cannot be used to change the essential meaning of the photograph (for
example, by removing an important element) just as a written or spoken
quotation cannot be cut short to make the interviewee say something quite
different from what the longer quotation stated (if shortened for space or
clarity an ellipsis is used to indicate the cutting). An immensely important
aspect of the photograph is that it contains elements that are outside the
photographer's and the subject's conscious control; whatever is essential and
raw, as in an interview, cannot be summarily disposed of for the sake of a
more controlled, glittery package.

It becomes clear that media literacy, which is hardly ever taught in the
United States, would be highly useful to deal with the enormously complex
changes that are affecting nearly all mass communication strategies.
While it might not be in the interests of many advertisers, politicians and
Hollywood producers, an increased ability to read and understand rapidly
evolving media would be particularly timely. Currently I am working with
Consumer Reports WebWatch, a project of Consumers Union, to inform
readers what the relationship of the imagery on the Web may be to what is
being depicted. What are the in-house guidelines for photographs and videos
used by various Web-based publications and user-generated sites? Which can
be counted on to respect normal journalistic practice? Which have no stated
guidelines? What do the various descriptions of the image mean? What are
the various copyright, privacy and fiscal issues that emerge when one places
one's own imagery online? The goal is to help people become more sophis-
ticated consumers and producers of imagery.

There is, however, already an extensive fear that an era is over. Philip
Jones Griffiths was the photographer, writer, and designer of one of the most
innovative and devastating books on the Vietnam War, *Vietnam Inc.* (1971),
which made a sardonic, bitterly skeptical case for the U.S. military and polit-
ical effort as barely disguised barbarism. Griffiths, a former pharmacist who

spent two and a half years in Vietnam as a freelancer with only a few days of paid assignments, contextualized his imagery in ways that depicted the war as absurdly and fundamentally immoral. His subsequent 2004 book, *Agent Orange: Collateral Damage in Vietnam,* followed up with an eviscerating depiction of the enduring damage that war can inflict upon a civilian population, particularly children.

In Griffiths's pictures there are children who grow up without limbs and eyes, and with grossly distorted skulls. His photographs of the horribly deformed stillborn, preserved in a jar in a cloistered museum dedicated to the effects of Agent Orange, are among the most gruesome imaginable. His work represents what aggressive governments fear: believable, accessible, and dire, these cautionary photographs warn citizenry of the hellish consequences of armed conflict. Griffiths's work is hampered by its relatively small circulation: the mainstream press, protecting themselves, their readers, and their advertisers, generally shy away from a concerted use of such nightmarish imagery and caustic commentary.

Even such a cutting-edge photographer is fearful of the digital, feeling the credibility of his work and that of others is at stake. Interviewed by The Digital Journalist, he stated:

> The real problem with digital is there is no reason to believe photographs any more. In a sense, you could easily postulate and say photography was a shooting star of the twentieth century. It came and went in 100 years... faking pictures is just so easy. Let's hope that there will be a reaction to that. And we will go back to taking real pictures on real film and people will say, yes, this is real, this really happened.

Griffiths's conflation of the older technology with reality and the newer one with fantasy is a widespread and unfortunate belief. If left unchallenged, one of our most effective reportorial media will be dissipated in the popular imagination while the potentials of the emerging media are undercut. Our universe would be foreshortened, making it easier to deny and circumvent that which cannot be personally experienced, particularly that which is painful and deserves our attention.

The adoption of the digital may be an appropriate juncture in which to suggest that photographs can be thought of, like writing, as nonfictional

and fictional (which is not at all the same as analog and digital). Fact-based, respecting context, carefully captioned, these "nonfictional" photographs, while always interpretive, can establish the existence of a visible reality for the duration of a fractional second. In certain cases they may be able to do no more than that. But the mechanical-age capacity for recording the visible may have to be guarded dearly in a chaotic world where clashing and often unyielding points of view make it difficult to agree on the most pivotal of facts. Rather than at the end of a gun, it makes sense for the photograph to continue to be one arbitrator of what actually happened.

There is, however, considerable temptation to wait and see what happens with the newer digital technologies without constraining their use. Experimentation, artistic freedom, even market forces are formidable reasons to leave them alone. But there are other, perhaps deeper motivations among many to refrain from any intervention, including a sense that disbelief is the only antidote to a spiraling chaos that none of us can do anything about. It is an attitude that invites a widespread disconnection from any reportorial medium.

Undoubtedly some would welcome filmmaker Wim Wenders's vision of the future as deliverance: "The digitized picture has broken the relationship between picture and reality once and for all. We are entering an era when no one will be able to say whether a picture is true or false. They are all becoming beautiful and extraordinary, and with each passing day they belong increasingly to the world of advertising. Their beauty, like their truth, is slipping away from us. Soon, they will really end up making us blind."[12]

ORIGINAL

DETAIL

FIG. 14: Chris Jordan, *Plastic Bottles*, 2007. The 5 by 10-foot digitally constructed image depicts two million plastic beverage bottles, the number used in the United States every five minutes.

4
Mosaic Connections

There are things known and there are things unknown, and in between are the doors of perception.

—Aldous Huxley

In 1978 John Szarkowski, then director of photography at the Museum of Modern Art, curated a photographic exhibition titled "Mirrors and Windows." Trying to make sense of U.S. photography since 1960, the exhibition's premise was that most photographs fall into one of two categories: the "mirror" photograph tells us more about the photographer, the "window" photograph more about the world. "This thesis suggests that there is a fundamental dichotomy in contemporary photography between those who think of photography as a means of self-expression and those who think of it as a means of exploration," Szarkowski wrote. (Some of the most interesting images exhibited overlapped, categorized as both mirror and window; they were shown in a separate room.)

The exhibition argued that the camera's mechanical recording of the external world did not guarantee that the photograph's subject was not, in fact, the photographer. As Szarkowski also pointed out in an essay about Walker Evans's famed 1930s photographs that had defined a large chunk of the Depression-era United States: "It is difficult to know now with certainty whether Evans recorded the America of his youth, or invented it. Beyond doubt, the accepted myth of our recent past is in some measure the creation of this photographer, whose work has persuaded us of the validity of a new set of clues and symbols bearing on the question of who we are. Whether that work and its judgment was fact or artifice, or half of each, it is now part of our history." Or, as Ruby Fields Darley pointed out to *New York Times* reporter Howell Raines four decades later about Evans's photographs of her Alabama sharecropper family, "'These pictures are a scandal on the family,' she said. 'How they got Daddy's picture without a shirt on and barefooted, I'll never know.'"

Yet Ms. Darley, who was only eight years old in the photographs, also said, "I know it's all of us and that's the way we looked back then. But just to take our lives now and compare it to that life back then, it seems a dream. It seems like it just didn't happen to me." The photograph may be wrong in certain respects, but it's also difficult to refute. In Szarkowski's classification system, Evans's work could be construed as a "window" onto this world, but it could equally be thought of as a "mirror" to this ascetic New Englander's obsessions. A comparison with James Agee's much more raucous and sexual accompanying text in *Let Us Now Praise Famous Men* highlights the error of believing the photograph—any photograph—as absolute truth in depicting its putative subject.

But beyond mirrors and windows there is another analogy to the photograph that was not realized in the 1970s. In the digital environment a new kind of photograph emerges, neither mirror nor window but a mosaic. It allows for multiple pathways leading to new avenues of exploration—a hypertext. Like Alice's mirror, the hypertextual photograph can lead to the other side, whether to explore a social situation or to create an image poem. The photograph is no longer a tangible object, a rectangle resembling a painting,[13] but an ephemeral image made of tiles.

This begins the paradigm shift into another medium, or more precisely into an interactive, networked multimedia, which distances itself from conventional photography. The "digital photograph" output on desktop printers is not indicative of the shift, being for the most part an attempt to more efficiently produce or simulate what already exists. Digital photography, as we know it now, temporarily disguises the more revolutionary potential of the photograph as not only mirrors and windows, static rectangles, but also as a potentially interactive mosaic that becomes part of a larger array of linked, dynamic media. Each image, whether from a digital camera or scanned, not only can be reconfigured in a variety of ways as the values of each pixel are changed, but each of these same pixels can be configured to serve as "doors of perception," leading to new avenues of exploration.

On the screen, each photograph can be "image mapped" so that any cluster of pixels, or the entire image, could be linked to new images, texts, sounds, or any other medium. A cluster of pixels in a photograph—say a fragment representing a child's hat—can link to a soliloquy on the hat and memory, to a series of images of other hats, to a song, or to a way to buy it. An

entire photograph can similarly serve as a node, a hyperphotograph, an ambiguous, visual, uncaptioned, tantalizing segment of a developing conversation leading, if the reader is willing, to other photographs, other media, other ideas. The photograph can, of course, also be left freestanding and unlinked.

This mosaic grid also evokes an earlier mosaic tradition in which the golden calf, the concretization of the invisible as idol, is considered reprehensible. If every photograph, as part of an evolving conversation informed by the dialectics of history and culture, can be considered multivocal, with a diversity of meanings, then there is no pretense at a single reality or a single interpretation. As a result, there is no idolatry that subsumes complexity. The photograph can no longer be read according to the simplistic notion that "the camera never lies," that there is only one concretized reality.

This is not to imply that the photograph cannot also be factual but that its meanings are open to diverse interpretations. For example, the famous 1968 photograph of the summary execution of a member of the Vietcong galvanized public opinion against the war, becoming an icon for the resistance. (In Havana in 1984 I heard Fidel Castro go on at length as to the impact of this image on his understanding of the nature of that war.) Yet the photograph had other meanings, including the photographer Eddie Adams's assertion in *Time* magazine that "The general killed the Viet Cong; I killed the general with my camera. Still photographs are the most powerful weapons in the world. People believe them, but photographs do lie, even without manipulation. They are only half-truths. What the photograph didn't say was, 'What would you do if you were the general at that time and that place on that hot day, and you caught the so-called bad guy after he blew away one, two or three American soldiers?'" In fact, when in the late 1980s I interviewed Adams he had only recently been told that the general had, at the time he was photographed, just found out that his best friend's family had been massacred and the man whom he was executing was responsible.

What if the reader could have used the computer to elicit such answers, to find out the photographer's opinion of what happened, or the general's, or officials in the Vietcong? What if the photograph was allowed to be an expression not only of a primary point of view concerning arbitrary, barbaric violence but of multiple, unresolved perspectives? Or could the reader in later years have been allowed to click on the pixels representing the general, at the time the highest-ranking police officer in South Vietnam, to find out what happened

to the man "killed" by Adams's camera? (Nguyen Loan later was seriously wounded, had a leg amputated, ran a pizza restaurant in Virginia, was forced to close when his past came to light and died of cancer in 1998.) What if others, bystanders for example, added links and provided this information?

In part, this would be like the current "wikis," such as Wikipedia, the sprawling Web-based multilingual encyclopedia, where a large community collaboratively writes the texts. A key decision would be whether a photograph should be immediately contextualized on the same screen only by the photographer as its author, or whether its subjects, bystanders, and the community of readers should be invited to comment as well in a kind of "crowdsourcing." In any case the readers probably will chime in, at least linking from another Web site, hopefully with issues of substance and not the facile, repetitive responses to be found on so many message boards.

A documentary photograph has always required contextualization to evoke its intended meanings. This usually comes from a caption, a voice-over, a headline, an accompanying article, as well as the context derived from where it is shown or published. The same person crying in a photo could be suffering from dust in an eye or from hearing terrible news. The digital, unlike the analog, easily allows the photograph's ambiguity to be respected —the first reading of the visual—before it is concretized, while providing hidden amplifying information to confirm and provoke other ideas.

For example, a new photographic template for the digital environment could be devised in which information is hidden in all the four corners of the image so that those interested could make it visible by placing the cursor over each corner to create a roll-over. The bottom right corner might contain issues of authorship and copyright; the bottom left could contain the caption and amplifying comments by the photographer; the upper left could contain responses to the image by its subjects; and the upper right could give information as to how the reader can become involved, help, learn more, by providing Web addresses and other guidance.

Particularly today, given the media climate of manipulation and coercion, to record appearances without contextualizing them, or at least questioning them, is no longer conscionable. There are too many media handlers, too many staged events and expert poseurs, for the photographer to point the lens and simply record what is most probably a manipulation: the starlet looking sexy or the politician looking like a man of the people. Photography may serve

at times, recalling Baudelaire, as the "handmaid of the arts and sciences," but it does not also have to serve as an acquiescent handmaid to people in power.

It is understandable that the photograph, with its mechanical bias, was seen as such a useful arbiter of reality. It encouraged the study of discrete events and provided the means to link them in some coherent pattern (such as with psychoanalysis, surveillance, journalism, family albums). The sculptor Rodin could argue that "it is the artist who is truthful and it is photography which lies, for in reality time does not stop," but the stopping of time and the encapsulation of a scene in a convenient rectangle provided a cogent amplification and counterpoint to human recollection. At the very least, it was a useful illusion.

Yet now the camera shutter's fractional second of release comes to seem interminably long compared to the digital nanosecond (about 10 million times longer), and the paper or film photographic rectangle appears inflexible and unwieldy next to the more user-friendly screen. Just as the comparatively slow eye-to-hand painter was partially supplanted by the quicker and more efficient eye-to-finger photographer, now in the digital environment the new photography is nearly eye-to-mind. Unlike the analog version, it does not require processing and is capable of being immediately transmitted world-wide. And, like impressionist, surrealist, and cubist paintings, this emerging medium can easily transform from a realistically representational one to a medium invested in more nuanced and less visible realities.

Hypertext's multiple voices suit photography well. As George Landow of Brown University has asserted, hypertext is the obverse, activist side of deconstructionist theory, making evident the otherwise implicit collaboration between author and reader. But unlike writing, which is already understood to be subjective, the photograph has only relatively recently begun to shed its myth of mechanical objectivity. And whereas writing is thought to explain itself, in photography it is usually the caption or some other text that is used to collapse, often simplistically and unnecessarily, whatever ambiguities reside in the image. A linked, dynamic, node-like photography—a hyper-photography—based upon both literal representations and transformative metaphors, could open and amplify the image, allowing it a more vibrant, dialectical role on a multimedia platform.

In hyperphotography the photographer-communicator could become

MOSAIC CONNECTIONS

someone who uses images to activate the discussion. The hyperlinked photo essay, if located on the Web, opens itself up to connections both within the essay — to other images, text, sound, video, perhaps eventually even to smells that have been provided — and to sites on the Web that might provide divergent perspectives. As various voices are invited to shape and reshape the trajectories of the essay, each photograph could change profoundly, no longer a delicate object to be carefully handled at its edges but an image that has to be prodded to discover multiple meanings. Reading is activated as each viewer decides where to click, which avenue to pursue and how to respond, both online and off, in his or her life. The reader creates his or her own journey while collaborating with the photographer and, ultimately, transcending any single reading, any single linear pathway. Hypertext allows and even encourages two readers to take very different journeys and, evidently, to come up with very different responses.

Unlike an analog photograph where the viewer is told never to touch its center for fear of smudges, the reader is invited into the interior of the digital image: Should I click on the little boy in the corner or on the tank passing by? Does the photographer provide these options? Where will the image of the tank take me — to photographs of battle, or to a video interview of the soldiers, or to profiles of politicians in their peace conference, or to a scrap metal factory? And the little boy — will I learn about his family, about him, or about the many civilian victims of this particular conflict? Or will I, in some other logic, learn about girls? Will he talk to me? Will he or the photographer ask me to respond, perhaps by mailing a politician or observing a minute of silence? Should I, if I am an eyewitness, assert my own opinion, repudiating the image's exoticism or affirming its exigency to the facts, and have my response and my questions become part of a broadening context? Should I, in a sense, take control of the image?

Or should I, the reader, click on the image of my grandmother in the family group photograph? Will she, long dead, engage me in a conversation according to her own rules of what is permissible to talk about and how? Or should I click on the pixels forming an image of the Bible, hoping to find a family tree? Perhaps others who saw the photograph, or members of the family, will have their voices enclosed in the image, ready to emerge as I summon them. Or maybe they will not speak until I have spent sufficient time with the photograph, showing it enough respect — will I know when that is? Perhaps

other viewers would be provided with a different set of possibilities in the reading-viewing experience based upon what they had already seen before or their ability to answer a few questions, or on their family name or a random variable.

The photograph need not be available in the same ways for everyone. Images of horror, for example, might be revealed only to certain viewers, perhaps older ones. Too much laughter or loud noise in a gallery or in front of a computer might preclude the appearance of certain images or their links. Some elements might appear only after a certain period of time, to protect the subject's privacy. Or certain photographs can be made to change size or color as the news changes—images of the conflict in Iraq enlarge as the bombings diminish, for example.

To require a photographer to create links and context ad infinitum is an impossible and unnecessary task, yet for the photographer to potentially have this opportunity encourages her to work as an essayist, in parallel with the filmmaker and the novelist or metaphorically as a poet. Photography of this sort is far from a mechanical recording; it becomes a collaborative, multi-vocal interrogation of both external and internal realities in which the initial exposure is only a minimalist starting point. And the still photograph, unlike pictures in motion such as video and film, provides easily accessible nodes, menus, and image maps to other destinations. The reader can stop, reflect, and move on, as the photograph becomes a map for territories not yet found.

This is not only an information superhighway but also a meandering walk in the woods within a confluence of connected ideas and information. It can be seen whole, viewable without any captions, or the reader can summon captions if they have been provided. The reader can also pursue the smaller nodes within the larger photograph that lead elsewhere, or pursue them through the contextualizing information. Or the linkage may be more visually intuitive, beginning with the atmosphere evoked by the photograph: a feeling of darkness, or a crooked point of view, or the blurry quality of the image.

The photograph can also be a hybrid: a photo-movie with a piece of it that moves, like video, while the rest remains still; or an amalgamated photo-roman, with texts bounding from its guts; a polyphony with sounds emanating from one area while different sounds emerge from another when provoked by a reader's cursor; an unfolding image poem. Or its hues can be linked to the performance of the stock market or to the scores at a bowling alley (one bowling alley in Minneapolis was actually linked to an art project by

Shu Lea Cheang in a gallery at the Walker Art Center; the speed and direction of the ball would modify the movie, slowing, accelerating or scrambling it).

The digital environment also allows the photograph to be seen as a rectangular image that leads nowhere else except to its own contemplation by an interested viewer. It can be printed out, saved, admired, studied, mailed. This approach eventually will be displaced as the central mode for "reading" the digitally derived, hyperlinked photograph. It will be better suited to the analog photograph, which will appear to be increasingly static and concrete, nearly permanent, in comparison to the more fluid, evanescent digital image.

Sontag once argued that "photography implies that we know about the world if we accept it as the camera records it. But this is the opposite of understanding, which starts from *not* accepting the world as it looks." The hypertextual photograph, with links to other points of view both amplifying and contradicting its own, begins a process of understanding. Given the malleability of the pixel-based photo, appearance is only the starting point.

In the new mosaic of possibilities, we must also be aware that our gaze is far from the only one that counts. We too are becoming nodes and targets for a variety of vision machines, many of which we do not control. Maurice Merleau-Ponty, author of *The Visible and the Invisible,* argued for such a space where "he who looks must not himself be foreign to the world he looks at. As soon as I see, it is necessary that the vision...be doubled with a complementary vision or with another vision: myself seen from without, such as another would see me, installed in the midst of the visible." With the increasingly omnipresent security cameras one could argue that this has already happened.

Even while we have been celebrating the ascension of the photograph, the billions of images being made, the dominion of the human photographer as a singular observer may be receding into the past. In his 1990 *Techniques of the Observer,* Jonathan Crary argued that this is just what is occurring. "Computer-aided design, synthetic holography, flight simulators, computer animation, robotic image recognition, ray tracing, texture mapping, motion control, virtual environment helmets, magnetic resonance imaging, and multispectral sensors are only a few of the techniques that are relocating vision to a plane severed from a human observer." His point, doubting the eventual dominance of the mimetic arts of film, video, and photography in a

digital environment, is that "most of the historically important functions of the human eye are being supplanted by practices in which visual images no longer have any reference to the position of an observer in a 'real,' optically perceived world. If these images can be said to refer to anything, it is to millions of bits of electronic mathematical data."

It is possible to feel at certain times like the painters must have in the nineteenth century, intrigued that the hand-eye coordination they had practiced for years could be so easily transcended by photography, but also outraged and afraid of the erosion of their métier and the diminution of their milieu. The canvas, the smell of paint, the patient utilization of their bodies were being supplanted by a finger releasing a shutter, chemical baths, and a mechanical device on a tripod. Now it is not only a form of hand-eye coordination that is being supplanted but the primacy of the eye itself.

In the world of image, an embrace of new strategies—not all of them emanating from the human eye—may give us more traction to understand what is going on around us. The facile, repetitive icons that we have become used to, the medium's stylized empathy and ritualized depictions, the slick rendition of events, all should be contested by newer modes of looking and contextualizing. For example, a significant 1968 photograph of our planet from a spacecraft in outer space, "Earthrise," jumpstarted the save the earth movement. People saw that we live together on a single, solitary planet, suspended in space. This photograph complemented and contextualized the photographs from the ground, and is now the central metaphor for Google Earth.

However potentially revelatory, it should be evident that the newer strategies of image-making can also conceal and distort. One has only to think of a new, misused, and sanitized technology of seeing, the "smart bomb" photos from the first Persian Gulf war, when we were able to view on television the targeted rooftops from the sterile point of view of the same bomb that was about to destroy it; we never saw all those who were purposefully left invisible below. Later, when no weapons of mass destruction were found the second time around, in a sense there never had been any.

One letter writer at the time described the assault appearing as if the pilots were dropping "marshmallow bombs." Nearly two decades later, and after thousands of American casualties and the death and mutilation of many more Iraqis, we as a society are finally comprehending that despite the sterile imagery the bombs have always been real, and not so smart.

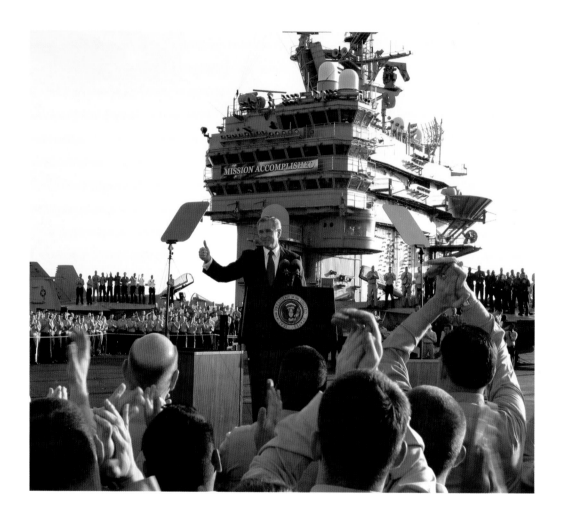

FIG. 15: On May 1, 2003, in a carefully scripted appearance, President Bush declared
"Mission Accomplished" in Iraq. The year before, one of his senior advisers, in a discussion with
journalist Ron Suskind, stated, "We're an empire now, and when we act, we create our
own reality.... We're history's actors... and you, all of you, will be left to just study what we do."
Photo by Scott Applewhite / AP.

5
Image, War, Legacy

Of all nations in the world, the United States was built in nobody's image. It was the land of the unexpected, of unbounded hope, of ideals, of quest for an unknown perfection. It is all the more unfitting that we should offer ourselves in images. And all the more fitting that the images which we make wittingly or unwittingly to sell America to the world should come back to haunt and curse us.

—Daniel J. Boorstin, *The Image: A Guide to Pseudo-Events in America* (1961)

When the World Trade Center towers were destroyed, a photograph of the raising of an American flag among the ruins easily emerged as a key, symbolic image, emulating another photograph of the raising of an American flag at Iwo Jima during World War II. (The latter image itself was of a repetition of an earlier, more spontaneous effort.) Its altogether-too-neat bookend was the toppling of the statue of Saddam Hussein in Baghdad, itself a staged event. The ascendancy of the American way was scripted, as if bereft of spontaneity. Photography, too, was hijacked, its more probing images discarded for photographs that seemed to say everything was going to be fine. Of course, everything has not been fine.

As to the hijackers, when they commandeered airplanes to destroy the World Trade Center towers on a bright September 11 morning, they also hijacked the visual language of Hollywood, using the imagery of action films that the United States had exported throughout the world. They filled the roles as anonymous villains that central casting had previously assigned in fictional films to Arabs. Soon some 3,000 workers, their families, and their friends would suffer the horrific consequences of those choices, and now we see beheadings, bombings, and poignant pleas from those kidnapped as a matter of course in the various offshoots from that apocalyptic day.

Reality imagery, or in effect an imitation of the iconic and pseudo-real, emerged with an even greater cachet. "Reality" shows continued to take over the airwaves, an ironic and sadistic limning of societal foibles turned into

voyeuristic fun. The hijackers had made their point: one had to be portrayed by media on their terms to be perceived as real, to be given the planetary stage. Everyone was a potential actor playing himself to a potential camera. Not just Patty Hearst, the wealthy heiress, amazingly caught on a bank camera during a 1974 robbery; now the cameras were omnipresent, some were controlled by the kidnappers, and all the world had become a stage. Those fomenting terror had learned the lesson that politicians and celebrities already knew: the staged reality, emanating potential and portent, was the goal if one wanted to be

taken seriously. These images, forty years after Boorstin's book *The Image* was published, had "come back to haunt and curse us" with a vengeance.

How then, as we move into the digital, does photography deal with image? How does it manage to show a president in a flight suit as someone trying to lead by wardrobe and not by logic? How does it move beyond showing the same generic imagery of war and make the virtual understood as actual? How does it picture a shining red tomato, grown and gassed to look perfect, to communicate that the fruit has no taste or texture? How does it avoid being image's accomplice and servant?

In politics the origins of the progression are evident. First a powerful person does something—let's say plays a game of touch football—and the

FIG. 16: From a fashion spread by Steven Meisel, "State of Emergency," that appeared in Italian *Vogue* in September, 2006. It did not take long for the pain of others to be reflected in the selling of merchandise.

press is drawn to it and photographs the event. Readers seem to love it. Then politicians begin to play football *in order to have the press photograph it.* Finally, the politician, even if he does not want to play football or doesn't know how, or has something more important to do, must play so that the press photographs him *as someone who plays football.* And we end up with a manufactured-by-media president.

An encounter with a touch-football-playing president, John F. Kennedy, was Richard Nixon's demise. As is now well-known, while voters appeared to favor Nixon in the 1960 radio debate with his opponent, the televised debate favored the more charismatic Kennedy. Nixon and his advisers would embark upon an image remake. "By Election Day 1968, Nixon had been so thoroughly repackaged that he became, in a sense, the first President to win the office by suicide," Michael Kelly wrote in the *New York Times Magazine* in 1993. "The man sworn in on Jan. 20, 1969, was someone the press called the New Nixon."

Here was the transcendence of image in politics: the schizoid recognition that anyone can be reconfigured as image, and that image and person need not at all be the same. Kelly quotes Nixon speechwriter and consultant Ray Price: "Voter approval for a Presidential candidate, Price argued, is not about reality but is 'a product of the particular chemistry between the voter and the image of the candidate.' He continued: 'We have to be very clear on this point: that the response is to the image, not to the man, since 99 percent of the voters have no contact with the man. It's not what's there that counts, it's what's projected—and…it's not what he projects but rather what the voter receives. It's not the man we have to change, but rather the received impression.'"

In 1971, unhappy with the public's response to Nixon as president, his staff embarked on the "RN Human Interest Story Program," which was ordered by chief of staff H. R. Haldeman in a memo to Price. The idea was to find enough warm and fuzzy moments: "A speech-department staff member culled dozens of anecdotes about Nixon from intimates and aides in a lengthy report, with each anecdote indexed according to the character trait it was meant to advertise: Repartee, Courage, Kindness, Strength in Adversity. What is most painfully obvious about these undertakings is how little the anecdotalists had to work with. Exemplifying the President's talent for Repartee was an account of Nixon silencing a New York businessman who had upbraided him over the Vietnam War by telling the man not to 'give

me any crap.' Illustrating the President's Strength in Adversity was a bald little story of how the young Congressman Nixon, falling on an icy sidewalk, still managed to keep his 2-year-old daughter, Tricia, safe in his arms."

These anecdotes prove unnecessary in an age where facts so easily degrade before spin. As Kelly already wrote fifteen years ago, "Politics is not about objective reality, but virtual reality. What happens in the political world is divorced from the real world. It exists for only the fleeting historical moment, in a magical movie of sorts, a never-ending and infinitely revisable docudrama. Strangely, the faithful understand that the movie is not true — yet also maintain that it is the only truth that really matters."

An image mistake: George H. W. Bush would play golf in the pouring rain to show that he was not, as the popular press had it, a "wimp"; his predecessor Ronald Reagan, who unlike Bush had never served in the military, wore a cowboy hat and indulged in flannel shirts, achieving macho status as the Marlboro Man. Ergo, George W. Bush arrives on an aircraft carrier in a flight suit, with a MISSION ACCOMPLISHED sign behind his head. No more golf on rainy days. A smart editor might have digitally laid the earlier image behind the later one for the reader to uncover what preceded the swagger.

One day in 1983, when visiting the White House on a work assignment, I asked my host, Michael Evans, Reagan's personal photographer, the whereabouts of the president, since I had not seen him at all. Evans's response: practicing his hockey shot so that when the U.S. Olympic team arrives at the White House later that day the president will look good on camera.

In 1980, the year that Reagan, the master of the photo opportunity, was elected, Cindy Sherman had her first major New York show of faked "film stills" in which she dressed as various femmes fatales and sultry blondes.[14] Reagan, the former movie actor, brought us trickle-down economics, and Sherman, the fake one, brought us postmodernism. Perhaps never before was the disconnect between content and image so actively affirmed. The legacy continues: As a *Time* magazine picture editor described it to me, covering politics is like "photographing Hollywood movie sets."

———————————

After the attacks of September 11, there was little imagery of actual death or of the wounded. The smell of death was everywhere in lower Manhattan, but the

photos on signs begging for information tacked to nearly every lamppost and tree were of the vibrant and living. Locals do not need photographs to "prove" the consequences of disaster; that is for those far away. The deaths became a horror made all the more incomprehensible because the images repetitively broadcast and published were both overpoweringly symbolic and insufficient.

Modernism was trumped by postmodernism, with only the signs and signifiers surviving. While there were no weapons of mass destruction, an actual war was waged to destroy them. As we now know the Iraqi government had nothing to do with the September 11 attackers, but the United States attacked as if it did. "Saddam," pronounced vituperatively like "Satan," was reduced to a playing card. Iraq was plunged into chaos and civil war while the United States attempted to bring on another uprooted signifier: "democracy."

It was a combination of amateurs and professionals who created the most interesting, varied and heartfelt media response to the attacks of September 11 in New York City itself. The photographs in the storefront exhibition "here is new york: a democracy of photographs," given later manipulations, can be seen as a form of resistance (and as an intelligent predecessor to the "user"-generated work of Web 2.0). They were printed digitally and

FIG. 17: President Ronald Reagan reacts after scoring against U.S. Olympic team goalie Bob Mason during a White House ceremony on September 29, 1983. Far left is Vice President George Bush. Reagan's personal photographer, Michael Evans, a Canadian, had spent part of that day coaching him. Photo by Ed Reinke/AP.

FIG. 18: During Thanksgiving, 2003, President Bush arrived unannounced to visit the troops and picked up a turkey that was there for decoration. This image of a beneficent leader was widely disseminated. Photo by Pablo Martinez Monsivais / AP.

hung anonymously on clotheslines, a magnet for those firemen, civilians, students, tourists, and others bewildered and in shock. The images became an impromptu album for a newly constituted family of the wounded, the long lines of viewers waiting testifying to their resonance. Interestingly, the best-selling image from the exhibition (the proceeds from the photos, which were selected by interested buyers without at first knowing who made the image, went to charity) was by Katie Day Weisberger, a student who had, a few months before the attacks, photographed the World Trade Center towers emerging from the clouds while seated in a passing airplane.

Some saw the September 11 attacks as an invitation to consider others living in their own situations of death and destruction. Why did they hate us so? But the U.S. government's inner circle, as became apparent, had other ideas. The pseudorealities were resurrected, and the realities of politics and religion that could not be contained were shunned. The president secretly flew to Iraq for Thanksgiving and was widely photographed as being there to make sure the troops were eating well, holding a turkey as a prop that was meant only for decoration. Taunting the insurgents he said, "Bring them on," and, somehow, they came.

The slower grappling with horror—its complex causes and impacts— was not media's job. Fox television made sure that the war became a reality show as well, filtered through the flag, a morality play where all points of view boiled down to the rightness of the cause. The U.S. government ordered that the caskets of dead soldiers could not be shown, as the "privacy" of families had to be respected. The publication of photos of the U.S. military dead was initially resisted and forbidden by many news organizations, condemned as politically inspired and unpatriotic. Many preferred American deaths to remain invisible.

Al Jazeera was chastised for showing deaths: "Yes, we have been showing a lot of blood, there is no denying it," said Maher Abdallah, head of International Affairs for Al Jazeera Television, at the World Editors Forum in Istanbul. "Is it civilized to kill hundreds of thousands of people to civilize them, but uncivilized to show some of those dead? Will someone explain this to me? How can you kill hundreds of thousands to civilize them, and you don't even bother to count the dead? Yet, you expect me to follow suit? When Al Jazeera shows a couple of pictures of dead and mutilated bodies, suddenly we are uncivilized."

Foreign photographers were "embedded" as a condition of access, forced to sign agreements as to what they could show. Later it was largely enormous danger that kept them from going deeper into the realities of Iraqi society. But even with an increasing number of local photographers working in Iraq, the complexities of daily life there still remain mostly invisible.

There were also new responsibilities for the digital photographers covering the news: to quickly edit their own work on their laptops fresh from the event with little time to digest what had happened, and then immediately transmit the images to the home office thousands of miles away. This makes it nearly impossible to find the time to explore what is going on with anyone, even with colleagues. And it forces photographers to interrupt their activities in the field to transmit to publications with insatiable, competitive appetites for Web updates. In previous conflicts, photographers would ship film once a week or so, often not knowing what the images looked like until months later. Uncertain of their success they had to work more intuitively and, one can argue, more expansively.

It is the soldiers with collections of personal pictures on their iPods, some traded with colleagues, who often tell a more grisly, more intimate, and more human story of fear and fascination. (One wonders, with considerable anxiety, if the people inside the towers on September 11 had been equipped with today's camera phones, would they have provided the missing, horrific visual details? And how would everyone else have dealt with them?) It was the soldiers in the prison of Abu Ghraib who most graphically showed how sadistically degrading the war had become, and how venomous a weapon the camera can be. Unlike in the Vietnam War where professionals consistently made the most compelling imagery, it is the photographs made by these soldiers that will remain indelible in our memories.

It is painfully ironic that just over a decade earlier, shortly after photography's widely celebrated 150th anniversary, the government had decided to largely ban photographers from the first Persian Gulf war, thereby creating a blind spot that would heavily contribute to the illusion that the second invasion of Iraq would be a cakewalk. Afraid of demoralizing the American people with photographs that showed the horrors that inevitably occur in battle, viewers were presented with nearly continuous simulations of possible battle strategies. Instead of humans with cameras in the field, the

FIG. 19: The best-selling photo by Katie Day Weisberger from the participatory storefront exhibition "here is new york: a democracy of photographs," which was created in response to the September 11 attacks.

"vision" of a so-called smart bomb, amoral and precise, was celebrated. (Not coincidentally, this was also the moment when the image manipulation software Photoshop had just been introduced.) In the first Iraq war, as in the next, it would be remote aerial photographs that would prove to be pivotal: imagery of massed Iraqi troops apparently convinced a hesitant Saudi government to allow U.S. troops into Saudi Arabia at the beginning of the first war; aerial imagery that Secretary of State Colin Powell certified as proving the existence of weapons of mass destruction helped to spark the second war.

The diminution of the eyewitness was not a new development: photographers and other reporters had already been excluded from recent conflicts such as those in Grenada, Panama, South Africa, Syria, and the West Bank. For example, Don McCullin, perhaps the dean of war photographers who had already been photographing armed conflicts with great distinction for sixteen years, found himself turned down by the British military when he asked to cover the 1982 war in the Falklands: "Ironically, I have just learnt through reliable sources that my application to accompany the task force was met with some enthusiasm at the Ministry of Defence, but was later turned down flat by a high-ranking military officer who, I suppose, considered my experience in war coverage a threat to the image that they would find comfortable."

After the war in Vietnam, many governments clamped down on the access allowed to photographers and other journalists, particularly those who might differ from the official point of view. The plethora of photographic books prematurely celebrating the U.S. "victory" in Iraq after the 2003 invasion pointed to the cheerleading aspect of some of the coverage. Now photographers and reporters are targeted by the combatants in Iraq and elsewhere, shot at and held hostage, as physical proximity becomes an even more risky and expensive venture. Well over one hundred journalists, most of them Iraqis and a significant number of them photographers and camera operators, have been killed in Iraq since the 2003 invasion. Simultaneously, the Pentagon was using retired generals as "message force multipliers" to deliver the administration's point of view while masquerading as media analysts. For multiple reasons, an independent point of view can require enormous courage.

The United States government also banned cameras during the first Persian Gulf war to record the return of the bodies of troops who died in the conflict, ostensibly to protect the privacy of their families. One theory is that

the decision was made to protect the first President Bush, embarrassed by the split-screen presentation of him smiling as coffins came back from the war in Panama. His son adopted the same stance in the more recent war in Iraq; the edict was ignored by a civilian with a camera who thought that her photographs would indicate the respect with which the returning dead were treated.

While it would appear that if one cannot see as a missile sees, anonymously, irresponsibly, successfully, or from the point of view of a simulation, or circumscribed as an embedded photographer, then seeing has become far too dangerous for a government intent on pursuing war. Other than a press pass that allows professionals entry to certain events—many of them photo opportunities created specifically for them—they have considerably less advantage these days over the "citizen journalists."

The professional photographer is in a quandary as governments grow savvy in contesting and creating photographic meaning, and the powerful, politicians and movie stars alike, act to control their own depictions in staged media events. Even many non-governmental organizations, like major corporations, have recently embarked on strategies to use photographs to "brand" their identities. In part because of these various constraints, the documentary photographer is placed under suspicion as a possible collaborator, open to accusations of configuring poverty or any other social issue to make it more reader-friendly and to advance specific aims. (For example, NGOs now may require that marginalized people be photographed as more active and individualized, not just sitting around in groups, as a way of countering existing media stereotypes.) While the policy is understandable, as a result the imagery can be perceived at times as illustrations of the various assigning institutions' preconceptions of the world.

Nor, evidently, is the problem just with photography. Skepticism is rampant: "Let down, perhaps, by the mainstream media, 21 percent of people under 30 say they are learning about the [2004 presidential] campaign from satirical sources like 'The Daily Show' and the late-night television monologues, up from 9 percent in 2000," according to a 2004 Pew Research Center study. In 2005 only 28 percent of those polled by Gallup had a great deal of confidence in television news and newspapers. During the same year, according to the Annenberg Public Policy Center, 65 percent of the respondents thought that most news organizations try to ignore errors or cover them

up; 79 percent thought that a media company would hesitate to carry negative stories about a corporation from which it received substantial advertising revenues. And now only 19 percent of adults between the ages of eighteen and thirty-four say they even look at a daily newspaper.

As Neil Postman wrote in *Amusing Ourselves to Death,* comparing the dystopian theories of George Orwell and Aldous Huxley: "Orwell feared that the truth would be concealed from us. Huxley feared the truth would be drowned in a sea of irrelevance." Unfortunately they both seem to have been right.

As the Vietnam War was winding down, I began a job at Time-Life Books. It was my first professional job after college and served as my introduction to publishing. The weekly *Life* magazine had folded the previous year, and Time-Life had hired a number of former magazine staffers to work in their book division. It was a hierarchy in which men held most of the top positions and women made up the great majority of researchers. It seemed that for equal-opportunity reasons they needed more men in research, so I was hired.

After a month on the Old West book series, where my first out-of-office experience was looking for photographs of Jesse James in the Pinkerton Archive with an armed guard posted outside, I was transferred to the Human Behavior series. I endured a short stint as a text researcher, where my job was to confirm every word in a manuscript without using Time-Life references. I heard the author of one of the books complaining that, due to heavy editing from above, his whole book did not retain one complete sentence that he had written.

I switched to picture research. It seemed safer. If a photograph was accepted it would be impossible to do to it what had been done to this writer. It could be cropped, and the caption could misconstrue its meaning, but within its rectangle the image would provide an alternative, perhaps even more complex voice that would reach through the formulaic filter of the Time-Life publishing model.

I was assigned to the first book in the series, *The Individual.* My initial task was to script a photo essay on the theme of the creative process. Having read some Freud, Jung, and Abraham Maslow, I came up with a multistep sequence that I hoped would describe the assigned theme. For me it seemed

almost perverse that I could be deciding all this for an international audience less than a year out of college, but my script was approved and I was asked to continue.

I would soon learn, however, that I knew nothing. Having decided that one step of the creative process could be self-discipline, the ability to focus, to practice, to be tenacious in the pursuit of one's goals, I had selected a subtle black-and-white photograph of the world-famous pianist Arthur Rubinstein, created by his daughter Eva. He was seated at the piano, his back ramrod straight, and the photograph gave the impression that he might have been sitting there for hours.

When the top editors came to look at the layouts hung on the wall for approval, they announced that Rubinstein was not creative. Therefore he could not be in the photo essay. I was incredulous. But he is one of the great pianists of our age, I responded. No classical musicians are creative, they told me. Why? Because they play someone else's music. Are any musicians creative? Only jazz musicians, they said. Why? Because only jazz musicians improvise.

Chastened, I was sent to look for photographs of jazz musicians and found an arresting black-and-white image by Larry Fink of a young black man with a trumpet in his hands, shirtless, staring up as if for inspiration. He was in his apartment, and again I had the feeling that he could have been playing for hours.

Once again the photograph was rejected. Why? It was too ambiguous. I was told that he could have been looking at an airplane going by. But he was in his apartment, I said, and there are usually ceilings in apartments. How could he be looking at an airplane? They would not budge.

I was on a deadline. I needed to find a photograph. So I found another image of two better dressed jazz musicians, both white and famous, playing in concert. It had none of the solitude, the loneliness, the passion of the two previous images I had selected. It was more ordinary—a concert photograph. But they accepted it. Why? Because they were white and not black? Because they were well known? Because the photograph was less ambiguous? Because they were not shirtless? Because the editors tired of saying no?

Whereas there are legions of writers and text editors who can agree at a minimum on grammatical rules, the editing of photography is often a slippery slope. Few agree, or can even verbalize, on what a photograph is capable of articulating. Few see photographs as more than the illustration of preexist-

ing ideas, from either the text or the editors themselves. (Veteran photographer Philip Jones Griffiths recently defined a typical editorial assignment as "we want the photographer to go to country X and illustrate our preconceptions.") There are very few courses worldwide in which one can learn picture editing. It seems so obvious that many believe anyone can do it.

Yet the choices reverberate, reinforcing stereotypes, opening up or closing discussions, accusing, or justifying a variety of attitudes. Malcolm Browne's extraordinary 1963 photograph of a Buddhist monk burning himself to death in Vietnam to protest his country's politics was banned from the *New York Times* newspaper as "not being fit for the breakfast table." Associated Press picture editor and photographer Horst Faas, the story goes, selected Nick Ut's image of children being napalmed in Vietnam even though others had refused to distribute it—the girl, photographed frontally, was naked. And Kenneth Jarecke's horrifying 1991 photograph of a burned Iraqi tank commander remained unpublished in the U.S. until it ran in a photography magazine months after the war. Its contemporaneous publication had been considered unpatriotic.

Stories abound of photographs that were never published, published with the wrong captions, or published in the wrong way. Another photo essay that I worked on, of a young couple having their first child, was accepted, laid out, and the text written. The essay extolled the joys and responsibilities of family life: It later turned out, just before the book went to press, that the man had left the family, jealous of the attention his wife was giving to their firstborn son. So the staff simply rewrote the accompanying texts (it was too late to change the photographic layout), showing how the very same photographs now indicated the inevitability of the breakup.

Not long after, I terminated my own fledgling career as a photographer, in large part because I did not want to provide imagery for others to misuse. One story should suffice. In 1976, during the presidential campaign, I thought that I had managed to delineate the archetypal photo opportunity, the pseudo-event in all its grotesqueness. Two politicians were eating lunch together at a neighborhood delicatessen in New York City. One, "Scoop" Jackson, was running for president of the United States; the other, Abe Beame, was mayor of the city. They decided to appear together behind meat sandwiches; it was lunchtime. At a table for four they sat side by side so that

FIG. 20: Arthur Rubinstein practicing in a Rome hotel room in 1969, photographed by his daughter Eva Rubinstein.

the cameras would have an uninterrupted view. There were photographers all over them. The television cameraman next to me put his foot in the jar of mustard on top of their table in pursuit of a better angle.

I ran to a spot behind the two politicians to photograph upwards and show the artificiality of the event. When I took my photograph to *Time* magazine the next day, a picture editor there was enthusiastic: she told me that it was a fine photograph and that she would consider it for publication but only if she could crop out all those extra photographers. The authority of the publication, it seems, could not be compromised. The interpretive autonomy of the photographer was another matter.

The attempt to camouflage the artificiality is shared. It is not only the power elite and their media managers but also the publications and television stations that are complicit. In a perfect world, every editor, producer, photographer, and writer would probably want unfettered access, time, intimacy, the ability to make imagery that reflects what is actually going on to the best of their ability. Perhaps there are even some who would, like a Faulkner or a Joyce, attempt to extend the reach of their medium.

But in the world where access is limited and budgets are tight, deadlines are looming and the reader-viewer is assumed to be nearly a simpleton, imagery is diluted. It tends to reiterate and provide a gloss over what we already know or, more accurately, illustrate someone's ideas of what should be going on. For example, a national newspaper put a photograph of turbaned, bearded Afghani shepherds on its front page soon after the September 11 attacks. Why? The editor in charge explained it was because they looked biblical. This editorial process, while its results are highly visible, is ultimately unseen. And the digital, with its nearly undetectable alterations, becomes a useful tool in extending the camouflage.

———————————

For better and for worse, the result of these last several decades of media manipulation is that people now sense, consciously or unconsciously, that when we watch television we are not watching anything but television, and when we look at a photograph we are primarily seeing a photograph. The lens has dimmed and a distorting mirror has been added. The medium's perceived needs are respected, often more than the world that it purports to represent.

This is what we really mean by "virtual reality," as Kelly suggested, a term that we have mistakenly assigned only to the digital. Diffracting and diffusing the multiplicities of existence, keeping things captive within its ephemeral mind-set, the analog media have been pivotal in the creation of a shadow planet.

Can emerging digital media, based as they are in the virtual, now find ways to elicit and confront the actual? And can photography, traditionally the medium of the trace, along with television news, the so-called live medium, be revitalized, absent institutional filters, in the new environment of Web 2.0, the "living" medium?

FIG. 21: From *Portrait One*, 1990, by Luc Courchesne with Paule Ducharme.

6
Beginning the Conversation

The real story becomes a conversation, in which the
author/photographer is simply the most prominent participant.

—Darcy DiNucci, *Print* magazine (1996)

———————

Photographs in their ambiguity can provoke, motivating the reader to inter-
rogate their meanings. The photograph may create enough confusion and
curiosity to stimulate the reader to solicit alternate voices, to peruse the
accompanying text, or to click on the image and go to another screen.

Digital media, in turn, promise that the viewer can pursue certain
ideas that come up in the looking and follow up on interests almost as if in
a conversation. The advantage of this form of exploration is how open-ended
it is: the photograph stimulates multiple questions as much or more than it
provides answers. If not overly constricted by a caption or accompanying
title, the photograph's odd appropriation of a fractional second and a rectan-
gular space may serve to engage the reader's curiosity.

The famous Turing Test, which is won annually by the software
program that best fools humans into thinking that there is a person on the
other end of the conversation, is a benchmark to measure the development
of the computer's artificial intelligence. For me, a type of Turing Test
involved visiting a 25,000-person computer graphics conference in Las
Vegas in 1991, at a time when digital media were less omnipresent.
Sponsored by SIGGRAPH, an international computer graphics association,
it was packed with booths displaying software and hardware and with
surrounding art projects.

One of these projects, in the "virtual reality" section, was called
Portrait One. It was a "conversation" with a fictional woman, Marie, created
by Luc Courchesne with the actress Paule Ducharme, who played the part of
Marie. People would line up to ask her questions by clicking on one of
several options. Staring straight into the screen at face-level, the character

Marie would answer in French and then pose her own questions that the viewer could respond to from a multiple-choice menu. The questions and answers could also be read in English.

Several of the women in line had discussions with her about feminism. Some of the men were trying to "score" and compared notes after each encounter. When Marie tired of the conversation (perhaps one had made a faux pas, indicating to her a lack of interest), she would turn and stare at the viewer and say, "Now, if you'll excuse me…," and the conversation would stop. But there was also a point in the conversation when she could be provoked to say, "See…I could tell you that I love you…I love you! But how does that commit me? You…you are not afraid? With me it's too easy. I can only be the impossible love, a detour which occupies the desire at no risk. When you'll turn away from me, will you dare exchange a glance with the nearby onlooker?" Turning away, it was in fact startling to notice all the people standing around with whom one would never have had a conversation as intimate as this one.

She talked, when provoked, about the Argentinean writer Adolfo Bioy Casares, about an art show that she had seen, about the vagaries of existence. She played a counting game (a favorite presumably of children). During the week, as conference attendees would ask me where I was from (question 1), what I did (question 2), and then usually walk away after leaving me a business card (being a professor at New York University was not sufficiently stimulating), I began to miss Marie.

Because of her I went ahead and read Bioy Casares's story about a conversation that turned out to be, to the protagonist's surprise, with a fictional character. With her I had one of the deepest discussions of the week. Many of the people I met at the conference making routine conversation could not have passed the Turing Test—their questions would have seemed too formulaic.

It was particularly moving at the conference when the visionary inventor Jaron Lanier, acknowledged as the pioneer of virtual reality, took partial responsibility for the first Persian Gulf war. He described it as a virtual war that had been represented to be more like a video game than a physical conflict. He wanted the audience to understand that a danger in the virtual is that it could have very powerful and destructive real-world effects, a senti-

ment that, a few years into the new millennium, already seems both noble and old-fashioned.

Then what are the constructive possibilities for virtual media? *Portrait One* comes out of Courchesne's longtime wish that portraits in a museum could talk, but it also offers itself as an interesting alternative to the standard interview. Whereas mostly one sees a video clip of someone answering a few questions, in *Portrait One* questions can be posed closer to one's own interests without having to watch an entire interview conducted by someone else.

In this case, if the viewer asks something that might be seen as inappropriate, or maladroit, there is no answer. In fact, *Portrait One* teaches more about the art of conversation and of seduction, as well as of the personalities of the interviewee and interviewer, than linear interviews usually do.

In Marseilles, Courchesne did another interactive project on multiple computers with a group of eight people who already knew one another and, in the absence of a live interlocutor, they could be seen conversing from one screen to the next. In this project the viewer was unable to ask an older woman for a favorite recipe without first inquiring about her and her family. Information is not a consumer right but to be earned through the manner in which one seeks it, even in the virtual world.

Imagine, then, the possibility of having such a "conversation" with a deceased relative or friend in which the style of the conversation is as important as its content. If the question is inappropriate, the recorded person need not answer. Another kind of knowledge is learning what one cannot ask, at least not so directly. The frustration may help a person to learn about the conversational codes of previous generations and to be sensitized to the mores of other cultures.

The difficulty in adapting to other conversational codes has become a major problem in Iraq for U.S. soldiers who needed to learn, among other issues, that by coming directly to the point one is perceived as being rude. The nascent "serious game" movement tries to explore such political and cultural issues, featuring a popular United Nations video game *Food Force* which aims at helping people understand the tactics of humanitarian relief efforts, or MTV's *Darfur is Dying*, in which a central idea is trying to escape from the Janjaweed, or *America's Army*, a government recruiting tool with more than 4 million people having completed an online, simulated "basic training."

The inability to get what one desires on the computer, as in *Portrait One,* also confounds an otherwise simplistic sense of interactivity in which there is a menu of choices but no resistance, coming out of a singularly direct, consumerist American culture. No one can always get what he or she wants, even from a computer. Umberto Eco's perceived "salvation," in fact, may not always be waiting.

Sometimes there is a small window of opportunity when it is possible to experiment with a new media model before it is back to business as usual. It's as if the habitués of agreed-upon form are distracted momentarily by the unknown, and for an instant the formulaic loses its ritualized status.

In 1994–95 I was asked by the New York Times corporation to create a model of the future multimedia newspaper. The idea was to familiarize those working on the editorial side with the emerging potentials of multimedia, a rare opportunity to be proactive before the ascension of the Web.

A group of senior editors would meet every six weeks or so with us (I worked with Chris Vail, a photojournalist beginning a second career as a multimedia producer, who handled all the technical issues) to look at different sections of a single day's newspaper as we created them. From a longtime print perspective, their initial response was at times skeptical. For example, the argument was made, upon being presented with a photo and voice-over essay, that it was not the *New York Times* if the reader was not told how long the essay would continue; there had to be easily recognizable boundaries, as on the page.

By the end of the year we were all much more interested in newer digital possibilities. We introduced a function allowing the reader to immediately see articles from newspapers worldwide on the same subject to provide contrasting points of view. We developed a way to listen to music from a concert being reviewed, as well as a REMEMBER button that readers could click to see a photo of an aging singing group change to an image of them in their prime. (We thought this would particularly interest younger readers who might never have heard of them.) There was a photo accompanying an obituary on the actor John Candy that the reader could click that then transformed into a short scene from one of his movies. We had a bilin-

gual studio visit with an artist and a virtual tour of the interior of a house for sale (the viewer could listen to the piano).

The general intent was to utilize the emerging media for better journalism, not for gimmickry. We tried to emphasize and broaden first-person reporting and multiple perspectives, to allow the reader to immediately compare the critic's perspective with a recorded version of the performance, to create a word-picture-sound hybrid so that media would complement one another. We wanted things to be seen or heard when it was important, not just because it could be done. And we wanted the interested reader to be able to learn more about certain subjects when desired, but not to be initially overwhelmed by a massive amount of information.

Ultimately, aware of the declining interest in newspapers by younger people (the average reader of a daily newspaper in the U.S. is now fifty-five and rising, according to a 2008 *New Yorker* article), we wanted the multimedia version not to simply repurpose the print newspaper but to reinvent it as another medium entirely. Our intent was to help the *New York Times* find its way not just in the newspaper business, but in the much larger business of global knowledge.

Then the Web, with all its Web *pages,* became the nearly universal presentation vehicle; print media were repurposed and installed much as if they were still on paper. Our somewhat idiosyncratic project served as a tease to what was possible, but the Web more efficiently began to standardize the formula.

In an attempt to move the paradigm forward, at the end of 1995 I proposed to an editor of the newly born *New York Times on the Web,* Kevin McKenna, a project to create a photojournalism that would be responsive to world events, readers' concerns, and the exploration of the Web for more complex and pertinent communication.[15] Why do the same thing one can do on paper when the digital offered so many new possibilities?

"Bosnia: Uncertain Paths to Peace" was a Web site presented by the *New York Times* for three months in the summer of 1996. After four years of horrific bloodshed among Serbs, Croats, and Muslims, and the signing of the Dayton Peace Accords, the idea was to create a photo essay that departed

from the usual shockingly graphic violence of war to one that used imagery to describe the tentative making of peace. The intent was also to take advantage of the new strategies made possible by the Web—nonlinear narratives, discussion groups, contextualizing information, panoramic imaging, the photographer's reflective voice—rather than imitating a print-based essay.

From the very beginning it was evident that the photographer Gilles Peress, a Frenchman living in New York who had worked extensively in Bosnia, needed to be centrally involved in the creation of such a project rather than simply hand over his imagery for others to select as is often the case in print media. My many years of working as a picture editor were insufficient for the multilinear, multimedia editing required. I could not simply select the "best" images and string them together, bemoaning the imagery that had to be left out due to lack of space, because in fact the Web allowed an enormous quantity of images to be used which could be made accessible to the most interested readers. The photographer had to articulate the multiple meanings of each image as a way of deciding upon accompanying texts and images, and to strategize possible linkages to photographs and media on the other screens that would make up the site.

As the eyewitness who was aware not only of what was within each frame but of that which remained outside it, both spatially and temporally, the photographer had an ongoing and pivotal role even after the actual photography was accomplished. Peress, fortunately, was someone who viewed his role as not only that of a photographer but an author in the largest sense of the world. It would take two months to edit and build the site— longer than to photograph the essay; several hours for a viewer to go through it; and the photographer remarked afterward that the process was equivalent to making three books or one feature film. By comparison, he edited and sequenced an eight-page essay of these same photographs for the *New York Times Magazine* in about two and a half days. Even though the photographs were made with film (in 1996 digital cameras did not have the requisite resolution for serious journalistic work), scans turned them into a part of the digital environment.

In this need to interrogate every image for possible meanings there was a sharper sense of my own distance, as editor, from the events and people being depicted and, concurrently, a heightened desire to understand

them. I wanted to know the people that were photographed as individuals rather than as symbols; furthermore, with all the nonlinear, multimedia possibilities of the Web, generic imagery of a suffering mother or wounded combatant would not propel the narrative. In fact, such simplistic imagery would squelch it.

A photograph of a dead man on the ground that I had selected from uncaptioned contact sheets while the photographer was still in Sarajevo turned out to be, to my surprise, an actor playing dead: the shooting of a feature film on the siege of Sarajevo had commenced only four days after the shelling had stopped. The multiple meanings of the photographs were often not at all apparent. Ultimately, as in the case of Schrödinger's cat, it was

possible either to collapse each photograph's potential meanings into one that could be called a defining caption, or to sustain the ambiguities in the presentation so as to provoke new thinking, not only about each image but also about the larger conflict in Bosnia.

Peress and I worked with some four hundred small photos on the walls of his loft, with differently colored lines connecting the various images, playing a kind of four-dimensional chess as we pondered how to structure the photo essay. If the reader clicks on this image near the window, where

FIG. 22: The opening screen of the nonlinear photo essay, "Bosnia: Uncertain Paths to Peace," photographs by Gilles Peress, published by the *New York Times on the Web* in 1996.

would it take him or her? To the image on the other side of the room? What if a reader clicked on the image but only on the person on the left; where would it lead? Why would a reader want to become involved in such a new form of reading? How interactive could (and should) the experience be? When would we lose a reader's interest?

Looking at the photographs of Muslims returning to their own neighborhoods and Serbs moving away, as they responded to well-intentioned United Nations directives and to sinister rumors about potential genocide, we decided that the metaphor of the journalist should be the operative strategy for navigating the essay. Just like the journalist who arrives at the Sarajevo airport not knowing where to go, what specific story to explore, the reader would be required to click on images without knowing where they lead. Unlike a book or magazine, there was no way of quickly flipping forward to assess and select a path. Each click of the cursor would put a reader on another screen with new perspectives and unknown possibilities.

In our construction, readers would be required to size up the information presented, then take trips and side trips through photographs, text, sound, and video, with the option of extricating themselves at any time from Peress's essay to go to one of fourteen forums and participate in various discussions, as well as to consult maps, a bibliography, or a glossary. There would be a copy of the Dayton Peace Accords and links to large numbers of other sites and other archival material provided by the *Times* and National Public Radio.

The navigational devices for each screen, in these early days of the Web, were exhaustively discussed as we aimed for simplicity, short download times (most people then had telephone modems), and the capability to explore aspects of the narrative with greater complexity. It took three weeks for a group of us to agree on the rather simple trio of buttons PREVIOUS/MORE/NEXT, allowing the interested reader to pursue more depth at specific places in the narrative. We also decided, without telling the reader, that clicking on a photo would link to the same screen as if MORE had been selected; the idea was that choosing a photo indicated sufficient interest so that the reader should be shown more than the linear narrative would provide. Most important, two screens of a couple of dozen small photographs each were provided as grids—one compiled from the screens

concerning Sarajevo and the other from screens dealing with the surrounding suburbs—that would allow the reader to decisively reject any linearity by clicking on an image to leap to any other part of the reportage. The uncaptioned photographs that made up the grid were meant to encourage a more intuitive, visual reading. Any confusion that resulted for the reader seemed minimal compared to the actual chaos in Bosnia.

The photography was discussed and reevaluated in Web terms—we could present a 360-degree navigable panorama; we could use complex images which link to different destinations; we could scroll up and down or sideways (hiding pictures beyond the border of the screen); we could create collages, and so on.

We decided to pair Peress's photographs with his own written text and recorded voice to add other points of view. His emotional reactions and philosophical questions would help to contextualize and extend the imagery beyond what the typical identifying captions could accomplish. ("The sniper's world is a cubist virtual reality where both killer and victim have mapped out space in a game of life and death, and where ten centimeters of unthought potential are met by the crack of the gun. When the sniper is 'on,' the air vibrates, the sound of a shot can come at any time, and the street changes its form from a positive space to a negative one, more defined by its outlines than by its center. And now that war is gone, you can visit the other side of the mirror from which he was looking at you.")

The newness of the medium required that we discuss nearly every decision at length, lost in a new and emerging language. And we tried to be ambitious. Rather than publish the conventional photographs of war, sensationalizing victimization and emphasizing the grotesquerie of violence, we preferred photographs that would strive to understand the problematic and possibility of peace. We were attempting to ask how people who viciously killed one another for years might live together, and provided forums for readers to discuss strategies for resolution.

The idea was to challenge some previous limitations of storytelling without completely losing the reader's interest. The essay opened, for example, with an uncaptioned photograph that was, in fact, a rephotographed snapshot of a Muslim family in which the face of each family member had been erased by a drill bit; the disfigured snapshot was all that was left when

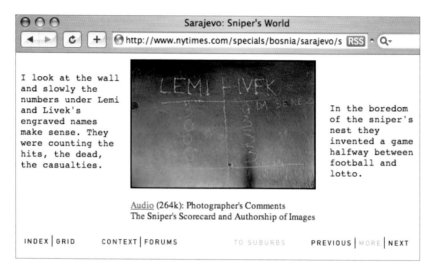

this family returned home after four years of conflict. Then the reader had to choose, intuitively clicking on one of two photographs that would take him either to Sarajevo or to its suburbs, unsure of what each choice entailed.

The photo essay allowed the viewer, at one point, to navigate through a 360-degree panoramic showing a Serbian cemetery filled with empty holes where bodies once were—the caskets were being dug up by relatives afraid that the dead might soon be desecrated by vengeful enemies. The idea was to recreate some of the eerily disconnected feeling of what it was to stand in the middle of that cemetery, where many of the relatives, fueled by alcohol, were unburying family members. It enabled the viewer to look around and get closer to the dirt and the empty graves as if he or she had been provided with a periscope rather than a fixed view.

Rather than circumvent a photographer freshly back from extraordinarily intense experiences and who was highly invested in his own work, Peress was given center stage. And rather than produce the site primarily relying on the authority of the *New York Times,* by acknowledging and encouraging a conversation among photographer, subject, and reader we could be seen as undermining it. By the newspaper's willingness to engage its readers in such a relatively open and unresolved fashion, the online project demonstrated the *Times*'s self-confidence. Two hundred thousand e-mail

FIG. 23: Screens internal to the nonlinear essay, "Bosnia: Uncertain Paths to Peace," contained photographer Peress's writings and occasionally his voice.

messages were sent out announcing the site, and although readers outside the United States at that time had to pay a subscription fee to access the online newspaper, the *Times* made this project free to anyone with Internet access who might want to participate.

Some of our hopes for the project were not realized. The complexity of experiences available to the reader were not nearly as great as we had initially wanted (we were prepared to use hundreds more photographs), but we had to weigh that against the fact that this site was already much more complex than possibly any photojournalistic foray previously attempted in any medium. We had wanted to automatically keep track of a reader's movements so that some mixing of pathways through the essay could take place based upon previous choices. For example, a reader who continually chose photos depicting Serbs might be given more photos representing Serbs or maybe would be required to look at more images that showed Muslims. We also wanted each reader to be able to pause and then to reenter the site at another time depending upon what had already been seen. (One reader told me that it took her four hours to go through the site.) But these options would have involved too many demands upon the *Times* servers in 1996.

I also had wanted to engage the viewer's history of choices as a primary navigational determinant, so that if a reader clicked on a picture showing someone from the Muslim community, then later she might be surprised to be prohibited from selecting pictures of Serbs (the computer might temporarily freeze, for example). In a much milder way this could have reminded the viewer of what had happened to the inhabitants of Sarajevo who were continually being hemmed in and at times assaulted or murdered not only over their own ethnicity but also according to their previous choices of friends and neighbors. Here the viewer would risk only an ocular occlusion.

In the end it was the discussion groups that proved the most volatile and the most painfully revelatory. Four computer terminals were set up at the United Nations in New York and two at The Hague to expand the discussion with those who normally might not have had Internet access then (another center planned for Sarajevo University encountered problems and was slow to go online). Yet the discussion groups were quickly dominated by some of the most racist and vitriolic comments ever to appear in the *New York Times*. There were fourteen forums with differing subjects (introduced by UN

Ambassador Madeleine Albright, CNN's Christiane Amanpour, human rights leader Aryeh Neier, among others), many of which were dominated largely by pro-Serbian commentators abroad who felt their cause was being vilified by the conventional media; someone suggested, accusing the *Times* of a pro-Muslim slant, that the newspaper must be owned by Saudi Arabia. The discussion groups, despite entreaties for civility by former *Times* foreign editor Bernard Gwertzman, were so rampantly hostile that a reader could learn more from them than from any news report as to how extensive, irrational, and personal the contested claims could be.

At least a couple of commentators felt that the project succeeded in important ways. In *Print* magazine, Darcy DiNucci wrote: "Clumsy as today's low-bandwidth presentations must be in some particulars, the site indeed pioneers a new form of journalism. Visitors cannot simply sit and let the news wash over them; instead, they are challenged to find the path that engages them, look deeper into its context, and formulate and articulate a response. The real story becomes a conversation, in which the author/photographer is simply the most prominent participant." Joe Goia, writing in the online journal *Salon,* cited "the McLuhanesque consequences of photography freed from the confines of material reproduction." He responded to the relative insubstantiality of the screen-based photographs: "They seem barely more permanent than the moments they presume to record. Quick to load, the photos present themselves with the ease and weight of dreams."

While all reading is a conversation between the reader and the author, the hyperlinked nonlinear narrative is more similar to the oral tradition. Those in a conversation pick up on different ideas and follow them in whatever ways interest them and they feel are appropriate, assuming that the others involved in the conversation can and will follow. The Web had shown itself capable of a conversation among a variety of authorities; for this project a discussion was provoked by the singular voice of a photographer within the boundaries of a news organization. The interpretation of the news was made more overt, and the requirement on the part of the reader to digest and reinterpret these interpretations, acting as what Barthes called the "active reader," was reinforced. No longer was the continuum from subject to reporter to editor to reader conceived as if in a straight line; the Web allowed, and promoted, a more zigzag approach.

In 1997 the *New York Times* nominated "Bosnia: Uncertain Paths to Peace" for a Pulitzer Prize in public service. But despite the increasing interest in the "digital revolution," the Pulitzer committee immediately rejected this project. Why? It had not been produced on paper. The following year, inspired in part by this project, the Pulitzer committee decided to consider Web sites for the prize in public service if they were associated with print projects from traditional media outlets. Stand-alone sites, however, were not admissible. It would take nearly another decade for a variety of online media such as databases, interactive graphics and streaming video, published online but still with a print component, to be ruled eligible for a Pulitzer. The connection to the tangible, analog medium was difficult to relinquish.

Journalism schools across the country are now focused on "convergence"—the need to impart skills to students in multiple media techniques (video, photography, writing, sound, new media)—in order to meet the needs of a multiplatform industry. But they miss the essential point: stories will not be told in the same way. The power relationships among author, subject, and reader will evolve, as will the filters, and the linear narrative, based on the authority of a single voice, is up for grabs in an increasingly nonlinear, decentralized media environment.

While advancing literary devices such as footnotes, annotations, and multiple chapter endings (as in the novel *The French Lieutenant's Woman*), hypertext takes advantage of the digital environment's predilection for nonlinearity. Right now the Web is the prime hypertext, quickly evolving into an approximation of Jorge Luis Borges's library that would contain all of the world's books.

Hypertext can be an individuating medium. It allows the reader to click on a single word, an image, part of an image, or an entire section and then continue to read or peruse according to these choices. Reading becomes a sometimes frustrating, sometimes illuminating adventure in which the authorial intentions are often suspect. How can an author create a hypertext that offers sufficiently satisfying choices? How can the author maintain a voice or a vision when the reader is filling in so many of the gaps, adding materials, making connections that the author may never have envisioned or even known

about? Can the hypertext, particularly a creative or fictional one that emerges from an authorial point of view, become a game of no consequence?

Hypertext would certainly undermine some of the great oratorical performances, depriving them of rhythm, rendering the speeches tentative and inconclusive. It is hard to image Dr. Martin Luther King Jr.'s "I Have a Dream" speech as anything but linear, told in his inimitable fashion. But hypertext also sustains and amplifies the Socratic method. And nonlinearity can be a more supple approach in the exploration of lives and situations that are themselves multifaceted.

Adrienne Rich's 1987 poem "Delta" poses a rationale:

> If you have taken this rubble for my past
> raking through it for fragments you could sell
> know that I long ago moved on
> deeper into the heart of the matter
>
> If you think you can grasp me, think again:
> my story flows in more than one direction
> a delta springing from the riverbed
> with its five fingers spread

The viewer might stop and look at an image, and then decide which of a variety of options to pursue. Pieces of the image can be potential links, as can the caption, the frame, or the entire photograph. When watching film or video, media in motion, it is more difficult to take advantage of nonlinear options, to digest what is occurring fast enough and then to change course, choosing a new and significant interest. In this sense it is the film and video viewer who may be the more passive, being led along, whereas viewers of still photography in a hypertext environment can choose to pursue their own curiosity in a variety of ways. They begin to bear some of the responsibility of collaborator and "coauthor."

There are interesting hybrids utilizing photography that were created in the analog environment, experiments that presaged some of the experimentation going on today. Chris Marker's 1962 short film *La Jetée* was a pioneer in the use of still photographs to create a film. Here past, present, and future are melded together as the film's protagonist voyages back into his

memories, and forward into time, to save the planet. Another French venture into the photo-roman, or photo novel, was a televised series of short films using still photographs. One in particular, *La Cicatrice* (The Scar) by Xavier Lambours, was interesting in its use of bits of motion inside the still—such as an image in which only a car can be seen moving, reflected in a small rearview mirror, or a man jumping onto a bed while everything else in the scene, including his girlfriend, remained still. It was, in effect, a hybrid film-photo-novel, a tentative foray from the late 1980s into what will be, on a digital platform, an increasingly hybridized media.

But what *La Jetée* and *La Cicatrice* lacked are connections that would allow the interested viewer to follow a different evolution of the story. Many of the critiques about photography's inability to attain complexity, as well as its aggressivity and objectification, could be partially answered by allowing an interested viewer to find out more. The photograph could still shock, mystify, intrigue but it also could be contextualized, articulated, and expanded.

There are other precedents worth revisiting. For example, in 1961 French writer Raymond Queneau "wrote" what might be called a metapoem, *Cent mille milliards de poèmes* (100,000 Billion Poems) that was impossible for him or anyone else to read in their lifetime. Starting with ten sonnets of fourteen lines each on ten pages, each line in a strip separated from the one above or below it by a cut in the paper, the reader was encouraged to reassemble the lines in any sequence desired. There were so many possible permutations, according to Queneau, that "counting forty-five seconds to read a sonnet and fifteen seconds to change the strips, for eight hours daily, two hundred days a year, there is enough for more than a million centuries of reading…" He cites the poet Lautréamont's argument that "poetry must be done by all, not by one"—a potential rallying cry for the collaborative content–generating sites of Web 2.0.

With the arrival of early software such as HyperCard, which approximated a deck of index cards, new possibilities emerged for nonlinear fictions. *Afternoon*, by Michael Joyce, a pioneering hypertext novel published in 1987, featured "the story of Peter, a technical writer who (in one reading) begins his afternoon with a terrible suspicion that the wrecked car he saw hours earlier might have belonged to his former wife: 'I want to say I may have seen my son die this morning.'" Then again he might not have. No two readers read

the same narrative; after experiencing the story, there may be little overlap of plot or even similarity of characters to discuss with others. Enormous tragedy may have befallen a character, or none at all. In hypertext fiction the reader may simply be urged to continue until he or she is exhausted, since there is no conventional ending.

Unlike reading the same book, or watching the same movie, the fictional hypertext isolates the reader in interesting ways—but in ways that also make it difficult to find common ground for discussion. It is as if the oral tradition of overlapping, complementary, and divergent tellings of the same story were transferred to print, but without the live, physical presence of any of the speakers. Gutenberg's mechanical type is credited with advancing the formation of the nation-state as people were newly able to read and discuss the same documents. Hypertext ideally supports a complementary individuality of less duplication and more self-propelled exploration and communal amplification.

Though hypertext can be author-driven, with intentional meanings to the multiple pathways that are offered to the reader, this is only one form. The current diary-like blogs, feeding off other texts with their enormous number of links, and the wikis, in which groups of people write together, correcting and editing one another, obscure a singular author's voice. Web 2.0, with its emphasis on the power of a virtual community, on the lateral, less hierarchical "we" that collaboratively produces information together, circumvents the professional or artist's voice as if it were an old-fashioned, aristocratic ploy.[16]

As Joel Achenbach wrote in the *Washington Post* in 2006, "The ultimate destination of this phenomenon is the complete transformation of any text into discrete 'bytes' of information, divorced from their original source, to be used democratically in whatever fashion the downstream manipulator wishes. The concept of 'copyright' will become extinct. So will 'the meaning' of a piece of writing. If you wish, you can reconfigure *Moby Dick* to become the story of an aging sea captain who is obsessed with a great white hamster." Particularly on the Web, the production of a singular, linear work by individuals or by professional organizations becomes more of an antiquated notion, as others riff off their content like jazz musicians improvise off the original melody. And, increasingly, nonprofessionals are producing the content themselves.

And so it could be with photography, where, if only due to proximity, amateurs increasingly cover the news more effectively than professionals, as was the case in the London bombing of 2005, the racist rant by actor Michael Richards, or the return of the American war dead in caskets. They also frequently make the news, such as soldiers' photographs made in the Abu Ghraib prison or the videos of captives either pleading for their lives or being murdered that are expressly made by insurgents to foment terror.

It is becoming the norm for reputable news organizations to publicly solicit imagery from the rapidly growing amateur pool. Jake Dobkin, of the online site Gothamist, asked at a recent panel discussion whether one thousand amateurs with cameras covering a political candidate wouldn't be a better source of information than having to rely upon only one or two professional photographers. After all, it was an amateur cameraman (albeit working for another candidate) who videotaped Republican Senator George Allen using a racist slur, helping to sway the 2006 Virginia election and turn the Senate over to the Democrats.

However, many strong photographs taken by professionals are excluded from publication due to editorial decisions. And if one or two experienced photographers were allowed to publish a much more complete version of their observations—an image-text diary, for example—they well might attain greater complexity and nuance with fewer images than would a group of less-experienced amateurs.

"We Are All Photographers Now!" announced a 2007 exhibition at the Musée de l'Elysée in Lausanne, Switzerland, and increasingly this is the case (or at least many more of us now walk around with cameras). The museum showcased work by nearly 50,000 amateurs that was e-mailed into the museum in a running slide show, with a computer that randomly selected one hundred photos weekly that were then printed and displayed as well. One of the surprises, according to Bill Ewing, the museum's director, was that not more pictures were sent in to one of the world's most prestigious photography museums; the answer, one of the museum's staff suggested, involves the fact that people no longer need the museum to display their work, given the competition from the online user-generated sites where audiences may be much greater. In fact, more than 800 of the photographs shown at the

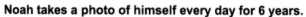

Noah takes a photo of himself every day for 6 years.

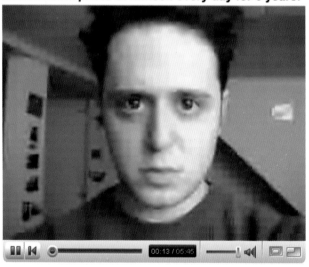

FIG. 24: Noah Kalina's photographic self-portraiture project on YouTube, which he had quickly compiled as a video, has drawn millions of viewers online and made him into something of a star.

museum were then put online at Flickr by their authors, who spontaneously created their own Web gallery. Also, a short video of self-portraits made daily over more than six years by photographer Noah Kalina, with a soundtrack by his girlfriend, already had more than 5.5 million visitors on YouTube by the time the museum exhibited it, easily dwarfing the museum's audience.

In this globalized world, however, the distinctive and admirable differences among specific kinds of regional photography, both in the nature of the societies that each represents as well as in their formalist strategies—a somewhat more metaphysical Mexican approach versus a cooler German formalism, for example—may be diminished in this Internet stew where speed is of the essence and subtleties are often obscured. It is here that the museum's curatorial function is sorely lacking, particularly its ability to highlight authorial intentions, in the warehouse-like accumulation of imagery that may be found on the Web.

Photography is not a universal language, but with billions of individual images floating in the ether with little context readers have a difficult time understanding many of their cultural references—we do not belong to a universalized *Family of Man*. Rather than adding more images to the mix, it would be helpful if people began to more effectively filter some of the work already online so that it is more reasonably accessible and pertinent. As the Web matures into its next incarnation as 3.0, a more discriminating use of contextualizing frames and filters will have to emerge to make sense of the masses of nearly undifferentiated content.

While there are many more venues online to show photographs for artists and documentary photographers alike (Reuters reported that there are more than 220 art galleries in Second Life, a virtual world, some of them with work for sale), there is significant concern that the splintering of media can create a potential downside for democracy. As a newspaper publisher asked over a decade ago at a Nieman Conference at Harvard focusing on the new challenges of digital media, "Where is the front page in cyberspace?" The lack of a standard front page or news broadcast can make it more difficult for citizens to focus on a similar social agenda, and as a result it may make it more difficult to muster a robust enough challenge to government so that it is forced to act. A report from the *Washington Post* or by CBS is now only one of a cacophony of voices and can often be more easily ignored.

Of course, on the other hand, the explosion in citizen journalism makes it impossible for many governments to avoid serious criticism. The hyperlinking of these many sources can create a sizable watchdog. It can also foster an equally sizable amount of trivial and repetitive posturing that can sideline its efficacy. Again, as with the myriad of photographs online, more effective filtering functions can help to create a livelier, more focused debate.

Perhaps unsurprisingly, given the tendency to have newer media copy older models, in the short history of the Web there have been remarkably few innovative attempts to extend photographic possibility. This should have been the golden age for the photo essay, given that until recently slow connections to the Internet had made it preferable to work with photographs and not with data-dense video and sound which required very lengthy download times. The still photograph, compressed, was much easier to transmit in the days of telephone modems. But in the first decade of the Web most uses gingerly imitated what was possible in print, "repurposing" content, reassured by the page metaphor, not trying to rethink the form. While a number of efforts resulted in distinguished photographic portfolios by artists and documentarians, such as Pedro Meyer's pioneering and inclusive ZoneZero, there were few who tried to reinvent strategies of exploration and presentation using the newer media.

There have been promising projects. For example, an early and ambitious project, 360degrees, focusing on the criminal justice system, allowed the viewer to look at and listen to a defendant, prosecutor, judge, victim, and parents, as seen through 360-degree panoramic rotating images. Created by Alison Cornyn and Sue Johnson of Picture Projects, the sense of being inside a prison cell was rendered claustrophobic and made the confinement more palpable.

Another site, akaKURDISTAN, is a virtual and evolving repository for a people who do not have their own country but now could review, identify, and add artifacts to help create a communal space for their culture. People were encouraged to contribute photographs that they had in their family's collection and ask others to identify them. The akaKURDISTAN project, directed by Susan Meiselas, became a way to foster kinship and to delineate

a more complex history through a virtual repository, a politically engaged antecedent to the more individualized identities that would later be promoted in sites such as MySpace.

A recent project published on Brian Storm's MediaStorm, Ed Kashi's essay on the relatively peaceful existence of the Kurds of northern Iraq, uses an old-fashioned flipbook approach set to music, a hybrid of photography and video. While photographers often discard their outtakes, in this case Kashi included hundreds to infuse movement in the stills. The results are intriguing, particularly the ability to modulate the movement of the photographs so that they become implicated in the musical rhythms. Once again, an abandoned media strategy is resuscitated in the digital environment.

Other sites have used media on the Web to create a sense of community, making connections explicit among people who otherwise might not have been thought to have that much in common. Yann-Arthus Bertrand's "6 Billion Others" is a massive visual display of people from around the world who are videotaped speaking intimately about subjects such as what happens after death, the meaning of life, their fears and their love. "LivesConnected," by the Peter A. Mayer advertising agency in New Orleans, is both an experiment in data visualization and a network of relationships that encourages the viewer to go from one post-Katrina testimony to another according to overlapping, linked subject matter such as "pets," "work as escape," and "flooded home" that employees individually speak about. And a searingly painful *New York Times* mapping of the "Faces of the Dead in Iraq" is heartbreaking in its use of a multitude of small squares on a soldier's face that each becomes, after the viewer places the cursor on it, yet another face of a soldier lost to the conflict.

Many small photo essays have also been created with sound or text, allowing some degree of choice to the reader, although often no more than the sequence in which the photographs are viewed. Sometimes simply hearing the voice of the photographer or of the subject amplifies the photographs' meanings in substantive and provocative ways—such as watching the *New York Times*'s Nicholas Kristof in Darfur describe the experience of a woman who had been raped as she stands there mutely (while Kristof's intentions were more than admirable, this viewer was relieved that the woman probably did not understand English). Similarly Marcus Bleasdale's recounting of the enormous devastation in the Democratic Republic of Congo in "Rape of a

FIG. 25: Nubar Alexanian's photographs of the beauty of Gloucester, Massachusetts, overlay the realities of the local working people. By placing the computer's cursor on any of the landscape photographs, underlying realities appear.

Nation" on MediaStorm is overwhelming. Quite a few such sites have had a HOW TO HELP button with the essay, so that the reader does not have to feel so much like a voyeur but can participate in potential solutions for some of the problems depicted.

On PixelPress, an online publication that I created with Carole Naggar in 1999, we have published many short essays, some attempting to use digital media in innovative or unconventional ways. The project "Democracy in America" includes a variety of documentaries on the state of the nation during the first Bush term, and "September 11: a remembrance," which went online a few days after the attacks, encouraged people from around the world to send in photographs, multimedia pieces, poems, and essays on the impact of the attacks and the future as contributors envisioned it. The Web site also featured, for example, a number of dream-related works by Wendy Ewald, Duane Michals, Alessandra Sanguinetti, Martin Weber, and others on the occasion of the centennial of the publication of Sigmund Freud's *Interpretation of Dreams.*

Many individual projects were published, including Joseph Rodriguez's "Juvenile Justice" on the California penal system with Rodriguez's moving audiovisual testimony of his own incarceration, as well as his image diary on dire economic conditions in Argentina where viewers, at one point, can select any image at random and then have to make sense of the story themselves. Dutch photographer Machiel Botman's playful portraits require that the viewer figure out from each unique image-text combination (each with different typographies) where to click in order to find out more about the ten different people. And Donna DeCesare's "Travelogue" allows the reader to click on her narrative text at certain points to replace the photograph with a more pertinent one.

Gloucester, Massachusetts, a magnet for tourists as well as a full-time fishing village, is shown so that by placing the cursor on Nubar Alexanian's photographs of the beautiful landscapes one can find a second layer revealing the workaday life of those for whom it is home—a giant fish eye, fishermen, local children. Tim Hetherington's "House of Pain," an animated series of still photographs that become movie-like to a strong musical soundtrack, deal with the combustible mixture of alcohol and violence in an emergency ward in Wales.

Portraits of Israeli and Palestinian victims of the second intifada, photographed by Bruno Stevens almost as if they were alive in the morgue, had trouble finding publication in print; they bring a more intimate and concrete sense of the people who have been lost in the raging violence. And Clarence Williams's pinhole photographs from New Orleans, made after he endured three days and two nights waiting for rescue from the rising floodwaters following Hurricane Katrina, represents a kind of family album that depicts his many cousins and expresses some of his rage as a black man about being stranded and nearly left for dead.[17]

There are endeavors by others that concentrate on technological means to amplify photographic possibility. For example, the Web site 10x10 uses software to analyze the text accompanying wire service photos. Then it continually updates the news visually with one hundred easily navigable keywords and photos, each connected to news stories that explain in greater depth the issues depicted. Given the compression of major events into a single image and keyword, it should be possible for such strategies to become more useful as people rely on small personal digital assistants to keep abreast of events—although the eventual cyborg citizen, continuously wired, should be able to view larger virtual areas through eyeglass-mounted devices and the like.

One newer strategy to organize and find photographs, now that cameras are increasingly equipped with GPS systems, is to search according to the automatically coded geographic, or date and time, identifiers on each image, independent of a more subjective tagging strategy. A researcher at Yahoo suggested that one would be able to search for photographs taken at different times of day, or only on weekends, or perhaps exclude the more superficial tourist photographs by specifying imagery made by people whose tagging indicated that they had been in a certain location for at least a week or a month, for example. This would override verbal tags that some people place on their photographs, some of which are wrong and others calculated to increase the number of viewers.

In fact, there is a program in development from Microsoft that could "make your photos smarter." It takes advantage of the billions of photographs already online in the user-generated sites. "Photosynth" processes a photograph, identifying "a DNA-like profile that describes the features that have been recognized in the image." Then Photosynth matches this "image

FIG. 26: The cathedral of San Marco in Venice, as visualized by "Photosynth," a software being developed by Microsoft that gathers a large number of photographs from among the billions available online to create a three-dimensional composition.

DNA" to other photos that have similar features. So, for example, if a person does not know what he or she photographed, the program could be used to take the informational tags from other images online of the same situation and add them to the initial photograph.

The much more compelling idea is that Photosynth could combine all these hundreds or thousands of images of a specific scene that it finds online (the demo I saw was of Paris's Notre-Dame cathedral, with photographs from Flickr), overlapping them according to the different points of view of the cameras and lenses used, combining imagery from disposable cameras and sophisticated SLRs or any others that were on the scene. This would allow the viewer to navigate the newly composed three-dimensional meta-image on the computer screen, zooming in and out, looking close-up at a painting or anyone or anything else someone might have photographed.

As more photographs of the same scene are uploaded to the Internet, Photosynth would add them to the 3-D composite so that the image would perpetually evolve. According to Blaise Aguera y Arcas, whose demonstration of Photosynth was met by a large ovation from technology leaders at the TED conference in California, the process involves transcending the photographer as individual author and "taking data from everybody, from the entire collective memory visually of what the earth looks like." Human consciousness as manifested in photographs then provides "a model that emerges of the entire earth." Photography becomes cubist.

The map becomes the same size as the territory, or maybe even larger. Even Borges might have been surprised.

FIG. 27: Gadi at the Market, photographed by Jacqueline, age eight.

7
The Social Photograph

Earlier much futile thought had been devoted to the question of
whether photography is an art. The primary question—whether the
very invention of photography had not transformed the entire
nature of art—was not raised.

—Walter Benjamin (1936)

———————————

The English critic John Berger, wondering why the *Times* of London could
publish a highly distressing, even searing 1968 photograph by Don McCullin
of a Vietnamese man clutching his bleeding child while the newspaper still
supported the war in Vietnam, was dismissive of the public, iconic photo-
graph. He had another idea: "The task of an alternative photography is to
incorporate photography into social and political memory, instead of using it
as a substitute which encourages the atrophy of any such memory.... For the
photographer this means thinking of her or himself not so much as a reporter
to the rest of the world but, rather, as a recorder for those involved in the
events photographed. The distinction is crucial."

A quarter-century later, new technologies make Berger's suggestion
ever more possible. Given its widespread dissemination and representational,
interactive, and activist potentials, the hypertextual photo essay is a significant
evolution from the linear, magazine-style photo essay. It is no longer just
about looking but can be more ongoing, engaged, and potentially even help-
ful, with work submitted by outsiders and insiders alike. The top-down Web
1.0 can combine with a more bottom-up Web 2.0 so that a dialogue is begun
between the authoritative professionals and the knowledgeable insiders.

The fact that many of the subjects of photographs can now see the
images—either immediately on the back of the photographer's digital camera
or as soon as they are published on the Web—means that the photographer
can have a new, sometimes problematic, collaborator. If a savvy subject asks
to see the images right after they are made, then it may be more difficult to

make exoticizing photographs as well as critical ones. Subjects may not like the ways in which they are being represented and can challenge the photographer, which may help to correct certain cultural misunderstandings. Those with access to a lawyer will probably still have more clout.

If the photographs can be seen on the Web from more and more places, then the privacy and safety of the people being photographed also become an issue. One cannot assume that people anywhere can be photographed with impunity because now they, or their local police or government, may see the images via computer. The growing worldwide reach of the Web is a source of both celebration and concern.

UNICEF, to cite one organization with which I have worked a great deal, in its role as children's advocate will not show the faces of child soldiers or children who are HIV-positive because the organization does not want to cause any further repercussions for those depicted. As Donna DeCesare, a photographer who often works in Central America and with UNICEF stated, "As children in Guatemala and Colombia know, showing your face while speaking honestly can get you killed." Any Web publisher has to be concerned not only for the reader but also for the subject. Even the most well-known images relate to particular people for whom, should the images be seen locally, they might cause very painful repercussions. A print publication, often unavailable outside of its immediate distribution area, posed less of a threat to revictimize those already victimized.

The outside photographer can now much more easily become "a recorder for those involved in the events photographed," as Berger suggested, but the increasingly widespread use of digital cameras also means that those involved in the events can become their own recorders. Point-and-shoot cameras present little technical challenge, even to those who have never photographed before. For children, young people, and others photographing their own environments, their imagery is usually not as stylized and self-censored as that of professionals, particularly because there is little attempt to imitate a "good" photograph, in part because they have limited experience of the photographic literature. The imagery frequently seems to revel in the excitement of seeing something for the first time through a lens, and the points that are made in the pictures are often, while perhaps obvious to those taking them, revealing for the outsider. There is spontaneity, intuitiveness,

and room for accidents of focus, framing, and flash in which odd and often telling components emerge. These amateurs evidently benefit from knowing intimately the language, culture, and neighbors they are photographing.

For example, while an outsider might frame young survivors of the genocide in Rwanda to emphasize their victimization (according to a 1996 UNICEF report, "When asked about the future, 60 percent of Rwandan children said they don't care whether they grow up or not"), the children's own photographs made on disposable cameras during a series of workshops at the Imbabazi orphanage in Gisenyi are much more lively, responding to color and light and their neighbors with considerable wonder.

They refuse to be the symbol of their people's tragic history. One eight-year-old Rwandan girl, Jacqueline (she had no last name), a student of visiting photographer David Jiranek, was awarded first prize in the 2001 *CameraArts* magazine contest in the portraiture category, open to adults. The picture she made, *Gadi at the Market,* was on her first-ever roll of film.[18] A series of these photographs was later shown at United Nations headquarters on the occasion of the tenth anniversary of the genocide.

Similarly, "Photographs by Iraqi Civilians," a project initiated by the Daylight Community Arts Foundation in 2004, also using disposable cameras, shows people going to the dentist, to the university, or playing, rather than images seen through the filter of bombs and fanaticism.[19] After it was shown at New York University, this small-scale exhibition was featured on CNN for its intimate and ordinary perspectives, showing how a marginal project can fill a void that mainstream media may overlook.

Or in a project called "Chasing the Dream," created for the United Nations (UNFPA) in connection with a campaign to achieve the Millennium Development Goals, photographs by marginalized young people from eight regions around the world on the subject of what they liked and disliked were more astute, thoughtful, and engaging than the great majority of professional work I had seen in over thirty years of picture editing.[20] It is the first time, for example, that I had ever seen a refugee camp as a place of joy and familial affection. Shown in the lobby of the United Nations during a 2005 international summit, the photographs by these young people resonated with a little seen sense of possibility and hope. (For example, of the ten Pulitzer Prizes awarded for photography published in conventional media

FIG. 28: *Al Hussein with his friends at recess*, Baghdad, 2004, photographed by Ahmed Dhiya.
Using disposable cameras, Iraqi civilians depicted their daily lives during
the year following the U.S. invasion in ways that were considerably more intimate
and humane than did the foreign press.

outlets after the Rwandan genocide in the second half of the last decade [1995–99], six were of dark-skinned people in trouble from Africa and Haiti and two were of firefighters rescuing children—the victimization of blacks and children dominated the visual imagery chosen. The prizes for text were not similarly skewed or, if anything, they were skewed the other way—there were few award-winning articles written on Africa.)

Perhaps then the trend to give cameras to people in marginalized situations should be extended to allow them the opportunity to photograph the more affluent sectors of their own societies, or even societies in the West. In an intensely critical debate about the September, 2005, *National Geographic* issue on Africa ("Africa: Whatever You Thought, Think Again"), which was photographed primarily by white photographers from outside the continent, a suggestion was made to the magazine's editor that perhaps the *Geographic* could now publish an issue on the United States that would be photographed primarily by Africans. How does American-style affluence and spirituality appear to others? It would be even more productive if Africans could control much of the editing and presentation of their own photographs.

The emerging trend for many individuals and organizations is to bypass mainstream media for the Internet, where self-publishing is a comparatively easy option. Anyone with a digital camera and Internet access can immediately upload the images without requiring processing in labs where they can be censored. Not only is there a widespread perception that mainstream media is too filtered, too tired, too constrained by advertising and by governments and by its own need to survive, but that Internet sites may be at least as effective in attracting sizable and knowledgeable audiences. This is certainly the case for pornographic sites where pictures can be uploaded without having to be processed at the corner drugstore and perhaps turned over to the police; the hope is that more illuminating sites will proliferate.

A reader does not absolutely need to know what mainstream media are reporting. As has previously been argued, many people consult mainstream media not to know what is going on in the world but to know what major media think is going on. It is useful, for example, in playing the stock market or handicapping a political candidate. But such consultation is more diffuse when so many competing media outlets exist, none of them with overwhelming cachet. It is also easier to refer to the primary sources, circumventing the filters. If one looks at the U.S. Congress's site, for example, it may

be more illuminating than waiting for the news media to report on what Congress is doing.

At the moment, in this open-ended environment, amateur digital photographers and bloggers are often the ones who are managing to provoke the most surprises online, as professionals are frequently constrained by the limitations of their assignments. Their imagery is often less generic, more personal, and sometimes even more credible in its awkwardness. It may in fact be time for professionals to pay more attention to how amateurs envision the world. While the future in media for the amateur seems ensured, right now, other than using a press pass to gain access to the latest posed photo opportunity, the future for the professional is less evident.

————————

Photography, along with television, has been criticized relentlessly for its perceived negative impact on society. It has been viewed as too pedestrian to be an art (Baudelaire), as too mechanical to be true (Rodin), as "essentially an act of non-intervention" (Sontag). It has also been judged by myriad critics to be too aggressive, alienating, colonialist, ethnocentric, and inhuman. But few have posed the question of how to better utilize photography.

It is as if, in affluent countries, the failure of a credible media can be cause for a sense of guilty relief, allowing a disconnect from the problems of the world. Saving photography, or reinventing it, may not be worth the effort, given the larger media's failures. But once there was a fairly widespread belief that the photographer, publishing in magazines and newspapers, could serve as an eyewitness to alert society to major problems. The photographs were generally viewed as credible, and sometimes so viscerally searing that one's life was never again the same. Sontag wrote of her discovery of photographs of Bergen-Belsen and Dachau: "Nothing I have seen—in photographs or in real life—ever cut me as sharply, deeply, instantaneously. Indeed, it seems plausible to me to divide my life into two parts, before I saw those photographs (I was twelve) and after, though it was several years before I understood fully what they were about."

Despite governmental denial or indifference, the evidence of the camera has at times become a clarion call to trigger action. And something (although far from everything) often was done. Wars were supported or

protested, money was collected to help build clinics and orphanages, people marched for the rights of others and themselves, governments acted or faltered, new laws were sometimes passed. Two-dimensional rectangles acted as potent reminders that helped provide momentum toward change. The photographic document, while not always irrefutable, could be difficult to deny.

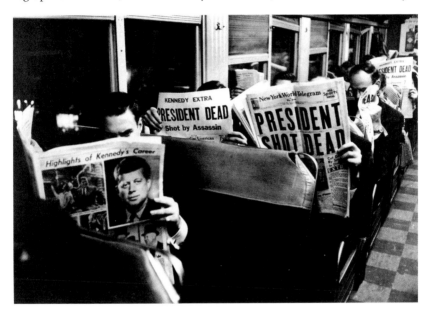

"I am sure I am right in my choice of work," documentary photographer Lewis Hine wrote in 1910. "My child labor photos have already set the authorities to work to see 'if such things can be possible.'" Hine's exposés stimulated legislatures to pass laws against child labor.

W. Eugene Smith's 1951 photographs in *Life* magazine of Maude Callen, a dedicated African-American nurse-midwife serving an impoverished rural community, led readers to donate so much money that a new clinic, which she said "looks like the Empire State Building to me," was built. A multitude of excoriating photographs from the Vietnam War effectively contested the American government's claims on the nature and progress of the war. And in recent years photographers have provided imagery of people suffering from conflict, famine and disease that has advanced the humani-

FIG. 29: There was a time when people in the United States were getting the news from the same or similar sources. Photograph by Carl Mydans / Time-Life Pictures / Getty Images, 1963.

tarian goals of nonprofit groups both morally and financially.

As these and other photographs served as landmarks shaping moral landscapes and delineating societal priorities, photography became a benchmark medium for those interested in social issues. Young people in the twentieth century turned to photography as a career, hoping to provide eyewitness testimony that might help better society. Paradoxically, as photographs gradually began to play a less pivotal political role in societies suffering from a surfeit of images and an increasingly confused moral compass, many of these photographers were then celebrated with monographs and prizes.

For even as much of the style and intensity of the photographs stayed the same, people's reactions to the images changed. Some, like author William Shawcross, called this diminution of response "compassion fatigue," the numbing that comes with seeing too many troubling photographs. As a cacophony of singular images of shock began to emerge, they drowned out the less sensationalized photographs that attempted to explore, to explain, to provide context. In the growing competition for readers, the trophy images became those that paraded the exotic and aestheticized the intolerable, making pain graphic and impenetrable—a form of violence tourism. Those that instigated new thinking that might aid in the search for even a partial solution were all too frequently marginalized.

Publications themselves were reconceived to privilege the consumer over the citizen. Undoubtedly, this is what advertisers, if not readers, preferred. Articles on personal health trumped those on world affairs, and politicians were downgraded to become merely one more consumer necessity, competing on the basis of appearance as much as functionality.

Paul Stookey of the singing group Peter, Paul, and Mary once reflected onstage that after the demise of *Life* the next popular magazine was *People,* a title that left out much of "life," which then was followed by *Us* magazine, excluding most "people," which in turn led to *Self,* a title that excluded in its focus anybody and anything else. Now we have Facebook, YouTube, MySpace.[21]

What then of the more serious, confrontational imagery that focuses on others who do not share our lifestyles? Our dilemma in empathizing with others includes our own pain at being complicit. The "other" is, whether acknowledged or not, part of our world in deeper ways than we usually think.

For example, the many photographers who haunted us with images of famine in the Sahel region of Africa more than two decades ago, inspiring "Hands Across America" and the gathering of musicians to record "We Are the World," were depicting not only the other, it turns out, but also ourselves:

> Nearly two decades after one of the world's most devastating famines in Africa, scientists are pointing a finger at pollution from industrial nations as one of the possible causes.
>
> The starvation brought on by the 1970–85 drought that stretched from Senegal to Ethiopia captured the world's attention with searing images: skeletal mothers staring vacantly, children with bloated bellies lying in the sand, vultures lurking nearby. Before rains finally returned, 1.2 million people had died.
>
> Now, a group of scientists in Australia and Canada say that drought may have been triggered by tiny particles of sulfur dioxide spewed by factories and power plants thousands of miles away in North America, Europe and Asia.
>
> —Associated Press, July 21, 2002

There were other important factors too, including political manipulation of food supplies, overgrazing, El Niño, poverty, bad planning, and climactic fluctuations. It is, however, particularly disturbing in hindsight to find that the spectral bodies that gave us nightmares just might have had something to do with the smoke pouring out of our chimneys. While one society had been manufacturing air conditioners and powering refrigerators, others could not even find a cup of warm water. Now the emerging impact of climate change makes it clear that those who have been least responsible for polluting the atmosphere, those with the most minimal of material possessions, are the ones who will suffer most.

The window is also a mirror, as Szarkowski pointed out. We exist in the other, and the other in us. The Web, with its growing complexity, allows us to better advance the media cycle so that it does not end with me, but can be conceived to include a larger conception of we. And with that amplified sense of ourselves comes new responsibilities.

Can the advent of the digital provide new and more profound possibilities for knowing, and for responding? Can we imagine an evolving, activist photography?

In 1984 and 1985, the Brazilian photographer Sebastião Salgado spent fifteen months photographing in the drought-stricken Sahel region of Africa in the countries of Chad, Ethiopia (and the disputed Tigre province), Mali, and the Sudan. Approximately one million people died from extreme malnutrition and related causes.

From Paris he sent me a box of these photographs. I took them around New York City, showing them to editorial and curatorial professionals. I was arrested by the images of people starving to death, by their extraordinary grace in the face of adversity, and by the responsibility of possessing these photographs. My goal was, I thought, simple—to have the work shown so that it might be shared with others. Together, I thought, we could decide what to do. Alone, the box was unbearable.

Only a few of these photographs I was carrying had been published in the United States in either newspapers or magazines. But the quest for a book to be published or an exhibition to be shown was short-lived and ultimately naive. While the young literary agent wept at his desk as he thumbed through the images, he ended up concluding that no one would publish such depressing images. One could not blame the publishers, he said, since they could not be expected to invest in a book that no one would buy. Then there was the museum director who, having also found them too depressing, phoned me a few years later, angry that another museum had been given these photographs as part of a major midlife retrospective of the photographer—a retrospective, apparently, was not too depressing. Then there was the World Hunger Year organization that determined not enough images had been published in the United States for the work even to be entered in their awards competition; many of those that had been published otherwise were of the journalistic shorthand for hunger in Africa: big-bellied children.

Meanwhile, in the larger culture, there was "Hands Across America," a massive if sentimental attempt to link bodies across this country in solidarity with those in Africa. (I stood next to a group of leather-jacketed Hell's Angels holding hands on New York's West Side Highway.) Popular musicians from Michael Jackson to Willie Nelson to Stevie Wonder were singing

in concert and selling hymns to global solidarity. The sentiments were empathetic even if the gloss was showbiz.

After a short BBC clip by Ethiopian cameraman Mohamed Amin aired on NBC evening news alerting Americans to Ethiopia's crisis, other camera crews descended on the region for a few days and were gone. The Sahel became a gaunt specter, a backdrop for a self-styled compassionate West. *People* magazine ran pictures of Senator Ted Kennedy visiting, holding up the requisite starving child.

When several years later I received a call from the San Francisco Museum of Modern Art to curate a midlife artist's retrospective of the work of Sebastião Salgado, it appeared that the photographs from the Sahel could finally be shown, but under the rubric of an art museum. It would have been important, both practically and spiritually, if the people in acute distress represented in the photographs had been the main reason for the acknowledgment. Salgado had been recognized as an artist, when he had always thought of himself as a documentary photographer. As a result, in 1990 people in California could belatedly see, in an art context, some of what had happened a half-decade before in Africa.[22]

A few years later, with the advent of the Web, I wondered whether there was a way to circumvent these various filters and show powerful documentary work in a timely fashion. What would be the new problems and possibilities? How would publishing work on the Internet change its meanings, its audiences, its impact?

So when in 1999 we began PixelPress to put such work online, it was with the idea of not being beholden to the vagaries of the publishing industry. We put many projects online. But one in particular seemed to demonstrate the shift.

A disc of scanned photographs arrived in my office from a Dutch photographer unknown to me, named Robert Knoth. The photographs were extraordinarily gripping, a multiyear project to document and explore the grim impact on the health of people, particularly children, caused by the nuclear accidents and aboveground testing that occurred in recent decades in eastern Europe. In 2006 PixelPress published "Nuclear Nightmares: Twenty Years after Chernobyl" as a conventionally linear nineteen-screen photo essay by Knoth and with reporting by Antoinette de Jong, but with a difference—

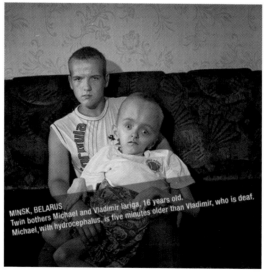

MINSK, BELARUS
Twin bothers Michael and Vladimir Iariga, 16 years old.
Michael, with hydrocephalus, is five minutes older than Vladimir, who is deaf.

FIG. 30: From the online essay "Nuclear Nightmares," photos by Robert Knoth and reporting
by Antoinette de Jong. A reader would first see the top photo without any
caption but could place the cursor over the image to reveal the caption identifying the
16-year-old twin brothers and their health problems.

the photographs would first be seen alone as images, and only by rolling over them with a cursor could the reader then summon a hidden caption.

Brain tumors and prostate cancer in teenagers, children with horribly enlarged heads suffering from hydrocephalus, a six-year-old girl who stopped growing at the age of three, the black-and-white photos catalogued a highly visible but generally unknown legacy. One photograph, of sixteen-year-old twins, one athletic-looking and the other with an enormously enlarged head, made perhaps the most telling visual comment of how far these young people's lives had deviated from the normal. In another image, a young girl, Annya Pesenko, was confined, in agony, to her bed, needing twenty-four-hour attention, too ill with a brain tumor to sit up or even turn over. Then there was the sixteen-year-old Russian boy who stated, "I hope I will not have children who look like me."

In the era of the Web it was relatively easy to get the work online (a group of students at Temple University in Philadelphia did much of the research and editing, and Zohar Nir-Amitin designed it from her home in Haifa, Israel). It was published on a newly incarnated Web 2.0, with readers playing a much more active role. In the age of the blog, where a living Web is not only constantly expanding but its components are being evaluated and linked, half a million people came to the site and looked at over three million screens; for a moment it became one of the 2,500 most visited sites on the Web. Bloggers sent their readers to see "Nuclear Nightmares," debating online among themselves the safety of nuclear power, citing the photographs to show the hugely deleterious effects possible. A student in one of my classes at Temple University saw the work projected during a lecture and e-mailed a blog, which in turn sent some 17,000 viewers to pixelpress.org. Perhaps never before in the history of media has a student in the back of the room had so much impact on readership.

These photographs and text reached a large, international, and apparently young audience; though depressing, the work could not be denied. On the margins of mass media, without any promotion or other publicity, those for whom conventional media might be less appealing were able to find a documentary recommended by their peers, both with this work and through projects by many others (Paul Fusco's photographs and voice online concern-

ing Chernobyl similarly attracted a massive readership). The community, virtual and abstract, could be engaged. If at least some people respected what was published, found it authentic, then they would spread the word until an ad hoc readership, and community, was born.

The responses to this project were moving. A retired assistant fire chief wrote: "There are no comments I can make to describe the depth of despair to which you have enlightened me and whoever sees this documentary." A woman in Moscow responded: "I just want to thank you for the job you're doing. My father was a scientist whose job it was to invent radiation measuring devices and other ecological control devices. He died in November of heart attack after radiation resulted in a heart mutation." Someone else commented: "I happened upon this feature in the middle of the night, somehow awoken from sleep. I couldn't get back to sleep for at least an hour afterward, and was haunted for days by what I had seen."

It was as if in a parallel universe the often-announced death of the photo essay had not happened. And, unlike with print periodicals, many of which shied away from publishing the photographs, the work remains accessible on the Internet long after its initial appearance.

According to Greenpeace, after an exhibition of this work in Kazan, Russia, received extensive media coverage, the provincial government of Tatarstan canceled plans to build a nuclear reactor. More recently, an agency of the federal government there launched a program to relocate families away from the banks of the Techa river, polluted by radiation. The publications of these images and text, in digital and analog forms (a book by Knoth and de Jong, *Certificate No. 000358*, was published in Europe), focused and stimulated debates on nuclear power in many countries and contested the points of view of certain international organizations as to its safety.

Serious documentary work, even now, can serve as a critical component in societal discussion and decision-making. "Purple Hearts," Nina Berman's sustained photographic project on the grievously wounded soldiers coming back from the war in Iraq, for example, coupled with her visits to high school students with a veteran of that conflict, has served as an important counterpoint to some of the mythology invoked by military recruiters. Michael "Nick" Nichols's beautiful photographs of Gabon, made on assignment for *National Geographic* magazine, were critical in inspiring that country's leader

to transform over 10 percent of his country into a network of natural preserves after he was shown the images in a New York hotel room.

Compassion fatigue is due in large part to media's repetitive obsession with shock and superficiality, not to an assumed lack of interest or compassion on the part of readers. Rather than engaging their viewers in serious conversation, media's response to a fear of being irrelevant has made their irrelevance a self-fulfilling prophecy.

Casting doubt on the credibility of the photograph and other media, the introduction of the digital may be the moment to argue for a more thoughtful, less automatic approach to establishing authenticity, including a more sustained collaboration with the reader.

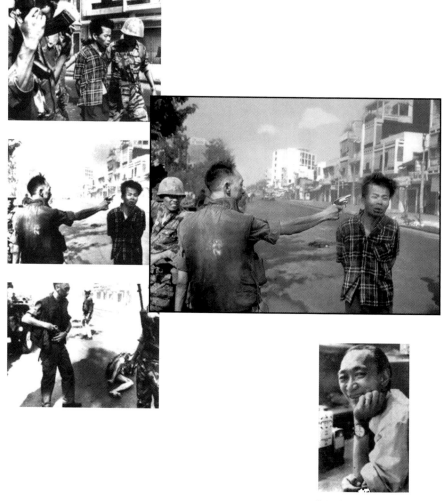

Brig. Gen. Nguyen Ngoc Loan in
his pizzeria in Dale City, Virginia.
Mr. Loan died in 1998

FIG. 31: If the reader clicked on the famous photograph of the execution of a member of the
Vietcong, he or she could see the images that preceded and followed it. If the reader
clicked on the man doing the shooting, he or she could find out that he later opened a pizzeria
in Dale City, Virginia. Photographs by Eddie Adams / Associated Press.

8
Toward a Hyperphotography

The moment of the meeting of media is a moment of freedom and release from the ordinary trance and numbness imposed by them on our senses.

—Marshall McLuhan, *Understanding Media* (1964)

Eventually, digital photography's relationship to space, to time, to light, to authorship, to other media will make it clear that it represents an essentially different approach than does analog photography. It will also become clear that to a large extent this emerging cluster of strategies will be forever linked with others as a component in the interactive, networked interplay of a larger metamedia. This new paradigm, which has yet to fully emerge, can be called "hyperphotography."

The digital photograph, unlike the analog, is based not on an initial static recording of continuous tones to be viewed as a whole, or teased out in the darkroom, but on creating discrete and malleable records of the visible that can and will be linked, transmitted, recontextualized, and fabricated. "The basic technical distinction between analog (continuous) and digital (discrete) representations is crucial here," wrote William J. Mitchell in *The Reconfigured Eye* in 1992. "Rolling down a ramp is continuous motion, but walking down stairs is a sequence of discrete steps—so you can count the number of steps, but not the number of levels on the ramp."

Most digitally constructed photographs depend, as does the analog, on the shutter's release. but they use rows of pixels, each one defined in its color and hue as an integer, rather than chemically processed grain. As such, the digital photograph can be conceived of as a meta-image, a map of squares, each capable of being individually modified and, on the screen, able to serve as a pathway elsewhere.

Temporally the analog photograph is also discrete, representing only a fractional second, responsible for slicing the world into segments that are nearly always rectangular. For example, a very large exhibition of work by

photographers from the Magnum photo agency that I once helped to curate, with four hundred images depicting four decades of world history, represented only four seconds of actual activity recorded—given the shutter speeds of the photographers' cameras. A critic for the French daily *Le Monde* remarked that it was like writing the history of opera by focusing only on the high notes.

The digital photograph also can be said to represent a single moment, but one that can be easily lengthened and amplified by joining it to many other moments through various forms of hyperlinks and hybrid media, including extending it as a movie. It becomes part of what Hugo von Hoffmansthal a century ago had described, arguing for an art in which "everything lives, everything acts, all things correspond to one another. It is a transparent network that covers the world."

It is also, unlike almost all of analog photography (with the exception of the Polaroid), nearly contemporaneous, producing imagery that can be seen almost immediately worldwide or on the camera (which becomes both a way to view one's environment in real time and a way to re-view it right away). Or the hyperphotographer can watch through a remote camera and "snap" her own pictures, taking screen shots via Webcam of a second cousin getting married, the babysitter at the refrigerator, or sunset over Mount Fuji. Rather than as a window or mirror, the digital photograph can also be thought of as an excerpt from a screen.

Reflecting the world of 0's and 1's from which it comes, the digital photograph may be also said to explicitly acknowledge time as integer, not resonant with the continuity of time as flow. As such, it can enable other temporal models, ready to incorporate a more contemporary post-Einsteinian space-time, where divisions between shutter speed and frame are less relevant and the relative position of the observer is key. Rather than a "decisive moment" selected from an advancing continuum, the digital photograph can acknowledge a more elastic sense of time, where future and past can intertwine and be as decisive as the present (the digital family portraits where parent and child are shown at the same age next to each other testify to this). Its Cartesian pixel grid may also eventually be reconceived, extended to limn the twenty-six dimensions of string theory or to explore the possibilities of parallel universes, so that as a result the two-dimensional photograph may seem rather basic.

The photograph's frame, heretofore simply a container for the image, can now store a variety of hidden information that can help to contextualize and amplify the image's meanings, accessible to the interested reader. And the digital camera will be further absorbed into other devices, first as telephones, refrigerators, walls, tables, jewelry, and ultimately our skin, allowing for non-stop recording, a panopticon without the warning shape of a conventional camera to alert potential subjects of what may be going on. The increasing cyborgization of people in which cell phones, iPods, and laptops reach near-appendage state will see photography extended into an all-day strategy, including images that are made according to involuntary stimuli such as brain waves and blood pressure. The camera will also be circulating within our bodies and stationed in our homes, acting proactively to warn us of and possibly attempt to correct any problems (disease, fire, an accident), even on the molecular level. Much of digital photography will not be, as it is now, reactive but will try to anticipate and deal with potential issues rather than waiting for them to happen and recording their existence.

In the digital environment the release of the shutter will be frequently considered only the first step in a process that includes altering the image and linking and contextualizing it with other media. As synthetic imagery tech-

FIG. 32: Reuters correspondent Adam Pasick, and his avatar, were assigned in 2006 to report full-time on the Internet world called "Second Life."

TOWARD A HYPERPHOTOGRAPHY

niques become more efficient, photographs will be increasingly synthesized from various codes, including DNA, creating realistic-looking imagery of beings and places that do not yet exist. Advertisers are already bypassing photography, light, and cameras to show some products according to the smoother, hyperrealistic look created from polygons that, for their purposes, transcend the photographic. The idea of a portrait will evolve to depict what may be a virtual being, not an actual one, taking into account our alter egos as avatars and the like. Recently, the news agency Reuters assigned a full-time correspondent with corresponding avatar to cover "Second Life," the virtual community populated by other avatars. The company also opened a virtual bureau there.

Both consciously and unconsciously, the emerging imagery will help people to understand the universe through strategies that were relatively inaccessible to analog photography, including multiple temporal and spatial perspectives, nonlinear and relativistic histories, contrasting cultural points of view, internal spaces such as the body, quantum mechanics, artificial life, and genetics. The new photograph will be read and understood differently as people comprehend that it does not descend from the same representational logic either of analog photography or of painting that preceded it.

The digital environment encourages new strategies and supports them with new efficiencies. For the moment, however, an older, more intuitive way of working yields to newer methods that are often still relatively simplistic. An analog photographer in the field, unsure whether the pictures on the undeveloped film are any good, who pushes herself to take more, possibly better photographs, is working in a more instinctive, exploratory, and probably more "present" way than the digital photographer who sees the results immediately and right away decides whether to reshoot or not influenced by the initial results. The image mediates the experience in the field. As photographer Paolo Woods told the *New York Times* about the digital: "You tend to be satisfied a lot more quickly but when you're shooting with film, you never know what you've got, and you push on and eventually it's the last image that's the good one." Or, as veteran photojournalist David Burnett put it less optimistically, the digital allows you to see immediately what you missed.

Many digital photographers may be erasing pictures they don't like, so there's no permanent record. And the storage of the images depends upon having available software decades later in order to be able to correctly recon-

stitute the 0's and 1's stored on a disc. Currently many camera companies encode digital information differently and refuse to share how they do it, making it more difficult for others to decode the photographic data. (Breaking into proprietary code is expressly forbidden by the Digital Millennium Copyright Act.)

Digital photographs, frequently made while peering at the camera's back, concretize the central paradigm of the screen. Veteran press photographers, for example, refer to digital colleagues as "chimping" (said to be derived from the actions of a chimpanzee), given that they can frequently be seen looking down at the screen and pressing lots of buttons, even in the middle of an event—although that may be preferable to what analog press photographers have long been called: shooters.

A digital camera can be part of a larger personal communicator that will keep appointments, make calls, take visual notes, check calendars, order from restaurants, find out about sales in neighboring stores, check blood pressure, and tune in to television, radio and personal playlists. The digital photographer potentially will be so thoroughly linked to a multiplicity of

FIG. 33: People used to hold up lighters at concerts;
now the cell phone serves this function. From an encore by the Killers at Street Scene,
San Diego, California, 2005. Photo by Mhyla Guillermo.

TOWARD A HYPERPHOTOGRAPHY

media, both as recipient and producer, that communication of whatever kind becomes more important than the singularity of the photographic vision. The pixelated photograph's ephemerality on the screen and its easy linkage, as well as the impression that it is just one communication strategy among many, reduce the individualized impact of the photograph as it appears on a piece of film or paper. Rather than as "photographers," for the most part these kinds of image-makers will be thought of simply as "communicators."

———————————————

There are those who have photographed the stone hitting the water and rejoiced in the camera's ability to freeze the pivotal event in a fractional second. These have been the conventional photojournalists.

Then there are those who focused on the ripples that the force of the stone hitting the water produces, distrusting the event itself but seeing its significance in its impact on people and place. These are more likely to have been the photo essayists, or, more broadly stated, the documentary photographers. When Henri Cartier-Bresson was offered an exclusive ticket to attend the coronation of King George VI in 1936, for example, he would have had a scoop. But by turning it down to focus on the reactions of poor people lining the streets outside, he made some of his most memorable photographs—and did so for *Ce Soir,* a Communist daily. He chose the ripples, not the stone.

There are others who profoundly mistrust the depiction of either stone or ripple as being no more than the camouflaging conventions of photography that conceal the medium's transformative effect. Such photographers may prefer to stage the scene while shouting "mediation" as loudly as possible. Like scientists who know that the presence of the observer may alter the results of the experiment, and like McLuhanites who believe that "the medium is the message," postmodernists and other interlocutors want to make sure that viewers don't fall into an easy complicity with the process. They may include within the image their cameras, microphones, even themselves, as ways of heightening our unease about our assumptions.

Now there will undoubtedly be a variety of new strategies as more practitioners, artists, documentarians—professionals and amateurs—choose to expand and harness an evolving medium that can respond to some of photography's frailties, its lies and limitations, with new methodologies. A few ideas:

Unmasking Photo Opportunities, Cubistically

In a 1994 photograph we see U.S. soldiers invading Haiti, lying on the airport tarmac pointing their rifles at unseen enemies. The heroic image supports the claim of the U.S. government that it is invading to support democracy, liberating a neighboring country from a dictatorship.

The curious reader, however, might want to place the computer cursor on the image. Another photograph appears from beneath it; it is of the same scene but from another vantage point. U.S. soldiers are pointing their guns not at any potential enemy but at about a dozen photographers who, lined up in front of them, are photographing them. In fact, the photographers are the only ones doing any shooting.

The contradictory "double image" is cubist; reality has no single truth. Perhaps these soldiers are heroes, and perhaps the U.S. government is justified in its invasion. Maybe they have to lie prone on the tarmac, anxious about an unseen enemy. The additional photograph asks the question "Is this for real?" Or is this a simulation of an invasion created for the cameras? As *Washington Post* editor Benjamin Bradlee described a similar situation, invoking quantum physics: "Readers—and especially television viewers—must understand the Heisenberg principle before they can understand the news. What is actually happening that is being described by the media? Is Somalia being assaulted in the predawn dark by crack U.S. troops? Or are bewildered GIs being photographed by freelance photographers who have been waiting for them for hours? The difference is often critical."

If politicians, actors, and other people in power knew that the staged event would be exposed by a second photograph, or by a panoramic image that similarly revealed the staging, then the subterfuge would be less worthwhile. Who would want again to spend $500,000 to air-condition an outdoor press conference of U.S., Egyptian, Israeli, and Palestinian politicians at Sharm Al-Sheikh simply so that they would not appear to be sweating if a smart photographer would expose the ruse? She could additionally explain that in fact little progress had been made, and perhaps the half-million dollars for the temporary cooling, done for the camera, could go toward building a few schools in the Middle East.

FIG. 34: The U.S. invasion of Haiti in 1994 as it was reported and the same scene viewed from the side. Perhaps in the future readers of Web-based publications will be able to place the cursor on the initial photo so that the contextualizing one emerges, providing a second interpretation as to what might have been going on. Bottom photograph by Alex Webb/Magnum.

People will better understand that a large percentage of photographs pretending to depict something significant are showing only its simulation, often created by the photograph's subjects themselves. The more powerful a subject is, the more he will control the simulation, while weaker and poorer people are often photographed to conform to generic but frequently less flattering imagery. A photograph that attempts to get at the complexity of individuals is considerably more rare. (A group of young Swiss photojournalists once told me that the goal of a portrait is to make the subject look nice.)

A multiperspectival strategy would help devalue spin. Every successor of the Teflon president could be unmasked. Photo opportunities could be continuously shown for what they are, until media managers grow tired of putting them on. Photographs made to consciously echo other photographs, borrowing from their impact, could be paired with the previous image, exposing the vacuity of the idea. The raising of the flag at the World Trade Center towers so soon after their destruction could be shown over the image that it tried to imitate, the flag being raised at Iwo Jima, allowing the reader to consciously compare the two events.

Or, as we did at PixelPress, the destruction of the Pentagon on September 11, 2001, could be presented next to a very similar photograph showing the destruction of the Chilean legislature on September 11, 1973, a result of the coup that brought down the Socialist government of Salvador Allende, another cataclysm and national tragedy. The Web site also showed a photograph of a devastated Kabul, an isolated figure in the foreground, next to one just like it of the destroyed World Trade Center towers *before* the United States began to bomb Afghanistan. Why bomb Afghanistan again when parts of it already had been devastated and looked like lower Manhattan?

Photographing the Future so a Version of It Does Not Happen

The photograph in the digital environment can envision the future with enough realism to elicit responses before the depicted future occurs. Whereas analog documentary photography shows what has already happened when it is often too late to help, a proactive photography might show the future, according to expert predictions, as a way of trying to prevent it from happen-

ing. For example, creating a photograph of Glacier National Park in the year 2070 or so without glaciers, made according to reputable scientific predictions that incorporate the impact of global warming, might give the public an opportunity to seriously envision, without sensationalism, the future that may await us unless we change certain behaviors.

Photography, rather than reacting to apocalypse, can now try to help us avoid them. Robert Capa's "If your pictures aren't good enough, you aren't close enough" becomes its opposite; the most distanced imagery, of events that have not yet happened, might be, in some cases, the best kind.

Of course, one would have to provide the reader with the contextualizing background, including the scientists who predicted the melting, links to their research, and a label making it clear that it is not a conventional photograph but an altered one (in this case dated 2070). It is similar to the commonly used photorealistic visualization of an architect's rendering of a future building. Certainly, this kind of "future photography" could become spurious, used for sensationalist purposes such as by unnecessarily scaring people as Hollywood has done. But it could also be quite valuable.

Another future rendering, to help the police track down missing children, has already been used for some twenty years. First devised by Nancy Burson, Richard Carling, and David Kramlich, the morphed photograph, combining available photographs of other family members, is used in the creation of an image of what the growing child might look like years later. The increased realism has helped in the recovery of some of the children.

There undoubtedly will be many other uses. As we saw earlier, *Newsday* could document a next-day encounter of two skating rivals; undoubtedly, the photographic community will be able to improve on that.

Enfranchising the Subject

Paradoxically, the subject of the photograph is often voiceless, unable to contest his or her depiction. Often the photographer barely knows the person, yet the image could be used to define the person or to represent a certain theme. For example, just before I came to work at the *New York Times Magazine* in 1978 one man had woken up on a Sunday morning to find himself on the cover for an article about the black middle class in which one

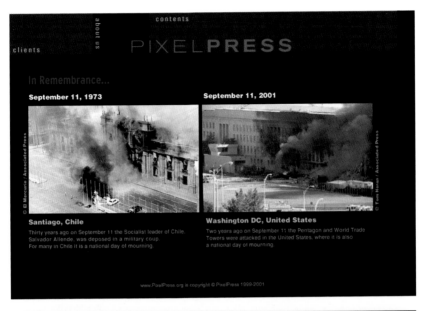

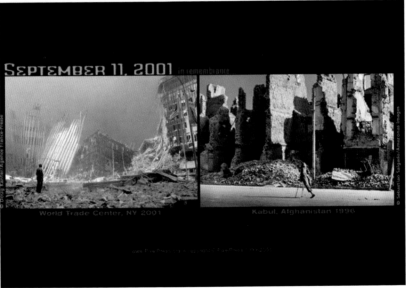

FIG. 35: PixelPress's Web site showed the similarities of the September 11th attacks in both Chile and Washington, D.C. (top), as well as the fact that Kabul, like the World Trade Center towers, had already been destroyed. At the time of publication the U.S. government was deciding whether to bomb Afghanistan.
Photographs by El Mercurio/AP (top left), Tom Horan/AP (top right), Doug Kanter/AFP (bottom left), Sebastião Salgado/Amazonas Images (bottom right).

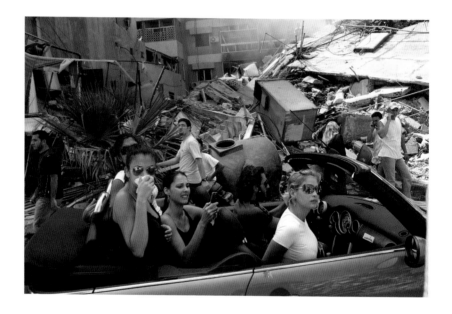

FIG. 36: The subjects of Spencer Platt's 2006 photograph were individually interviewed after
the image was widely distributed, selected as the World Press Photo of the Year.
They challenged the initial caption, "Affluent Lebanese drive down the street to look at
a destroyed neighborhood." Four of the five lived in the neighborhood and had come
back to survey the damage after the conflict with Israel had ended. Bissan Maroun, a bank
employee who is shown holding her cell phone, told the BBC, "We are not rich kids,
we are really middle class, so the impression the picture gives is wrong."
Photo by Spencer Platt / Getty Images.

of the major points was the neglect of the underclass by their better-off brethren. The photographer had simply snapped his picture on the street in passing without talking to him. He then became, much to his eventual dismay, the symbol of such neglect.

If this "interactive revolution" privileges the consumer by affording more choices—like a bank ATM machine, where the "user" can choose what amount of money to withdraw, or a Web site with a multiplicity of consumer choices—why not also give the photographic subject a voice? Now that the photograph is immediately viewable on a camera or a computer, the subject can in many cases be asked to react to the image, or be asked to describe her own situation. Imagine a daily newspaper in which the reader can expect to hear the subject commenting on the photograph, including its merits, or articulating opinions on his situation. Walker Evans's Alabama tenant farmers might have enjoyed the opportunity, as no doubt would a host of people depicted these past few years on the streets of Baghdad.

The subject could at times be engaged in a conversation—perhaps using a menu of questions as in Luc Courchesne's *Portrait One*—so that the portraits can speak to the point. A press conference where the viewer could question an interactive photo-video of the presidential candidates to find out more about issues of greater personal interest might lead to a deeper understanding of their various stances on specific issues. It would also be a way to hold candidates accountable once in office. (According to a study by the Project for Excellence in Journalism and the Shorenstein Center on the Press, Politics and Public Policy, during the first months of the 2008 presidential campaign 63 percent of the campaign stories focused on political and tactical aspects of the campaign while only 15 percent dealt with the candidates' ideas and policy proposals; a companion poll found that 77 percent of the public wanted more reporting on their positions on issues.)

The World Press Photo, based in Amsterdam, selected as its 2006 photo of the year an image by New York-based photographer Spencer Platt. The photograph shows young Lebanese driving through a partially destroyed area of Beirut after the conflict with Israel (a young woman in the car is making a cell phone video of her own).

Originally captioned, "Affluent Lebanese drive down the street to look at a destroyed neighborhood 15 August 2006 in southern Beirut, Lebanon,"

the image's contextualization was then challenged by the people in the photograph. Four of them, it turned out, lived nearby (Platt had not talked with them). While dressing stylishly, they were not affluent.

The BBC, among others, then interviewed and photographed the different people in the photograph and posted the results on their Web site —an early example of how the subjects of a photograph, in this case of a particularly emblematic one that is simultaneously misperceived, can talk back and will do so more in the future. Lana El Khalil, the owner of the Mini Cooper that is shown in the photograph, is uncomfortable with the picture's selection. As she told freelance journalist Gert Van Langendonck, "It confirms what many people in the West think already, that war only happens to people who don't look like them."

The fact that photographs can be evaluated not only by the photographers, editors, or readers but also by their subjects changes the power balance enormously. Now it is not only the professional outsiders depicting the insiders, but the insiders responding with their own points of view, which may amplify or contest images and captions that previously had considerable immunity from such criticism. In the case of this photograph from Beirut we might also have been able to see Bissan Maroun's cell phone videotape as a counterpoint.

Reporting as "Family Album"

Given the widening scope of the Web, Berger's ideal of "the photographer... thinking of her or himself not so much as a reporter to the rest of the world but, rather, as a recorder for those involved in the events photographed" can be concretized as a Web-based family album, available to the subjects of the photographs as well as to other viewers. On the Web, the photographic subjects could then recontextualize the imagery, working with or without the photographer, to provide other perspectives and to make the work their own, as was done with the Web site akaKURDISTAN. Photographs can then be made that are relevant to the context of those who appear in them.

Avoiding the typical approach, photographer Eric Gottesman depicted HIV-positive people in Ethiopia without showing their faces, since to do so

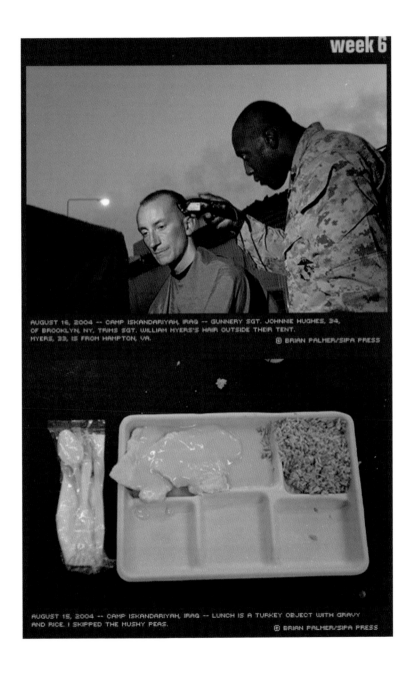

FIG. 37: From week six of Brian Palmer's 2004 "Digital Diary: Witnessing the War."

FIG. 38: Commuter Alexander Chadwick's cell phone photograph shows passengers in a tunnel near King's Cross Station where a bomb exploded at 8:56 am London time. The widespread coverage by amateurs of this tragedy is credited with jump-starting the "citizen journalism" movement.

would open them up to the scorn and rejection of their neighbors. The photographs were then transported by van to Ethiopian villages and informally exhibited to create a forum for residents to discuss their attitudes toward those with the disease and to recontextualize them. The photographer searching for the iconic image would almost certainly have concentrated on their faces and, in doing so, quite possibly revictimize them. Gottesman's preference was for the useful image.

The outsider-insider collaboration can be a productive conversation among profoundly different points of view, each seeing some of what the other misses. Swiss-born photographer Robert Frank's now classic 1950s essay *The Americans,* initially detested by almost every domestic critic, brought out issues of race and class that had barely been exposed before. If done today, it might have been turned into a highly contested Web-based "family album," a referendum on what the United States has become. The subjects of the photographs could have been asked to comment, adding layers of amplifications and contradictions to Frank's somewhat acerbic vision. The problem would be to figure out a way to add substantive comments without so many of the meaningless comments—"nice picture," "sexy smile"—that one finds today on many of the user-generated sites.

Photographer-writer Brian Palmer went to Iraq for six weeks in 2004 to follow the 24th Marine Expeditionary Unit. Published on the Web at pixelpress.org as "Digital Diary: Witnessing the War," he posted his observations weekly so that families in the United States could better understand the lives of their loved ones serving in Iraq. The chess game with a U.S. soldier and two translators, the "turkey object" that they were served so unlike the president's ceremonial turkey that he held up at Thanksgiving, the transformation from civilian Goth to institutional Marine, all brought back the war in ways that were intimate and useful. Linked to by "www.marinemoms.com," it was as if the photographer had become an extra set of eyes representing the families. This photography was not of strangers for strangers but of a community for those who did not make the trip.

When a young woman's boyfriend was killed in Iraq, the photograph became essential as the last testament to his existence. "I saw the article, 'Digital Diary Witnessing the War,' last week and was hoping to see it again. Is there any way I can get a copy of it? My daughter's boyfriend was with that

unit and she did not get an opportunity to see the diary. Unfortunately he was the young Marine who was mentioned in the 6th week because he was killed. We would be VERY interested in having a copy of the full six weeks if at all possible."

There were nearly simultaneous responses to Palmer's postings: "I want to thank you for being with the 24th MEU. My husband is with the MEU and it is so comforting to be able to read what they are going through there. Sometimes it is hard to read about them getting hit by mortars but at least I am able to somewhat know what is going on there. I was so upset to hear that the MEU had lost a fellow Marine (Vince Sullivan). I pray for his family as well as the guys there who were close to him. Again, thank you for keeping us family members back home who are worried updated on what our loved ones are doing while away."

Berger's sense of recording for those photographed has found at least a partial solution.

Now micropublishing is possible in an immediate, direct way. Photographing the tsunami in Banda Aceh, one can immediately transmit the photographs to Web sites available to those who have family and friends in the area, and to cell phones of people worldwide providing information on how they can help.

Or after the July 2005 bombing of London's transportation system, the pedestrians who were caught in the violence created "History's New First Draft," as *Newsweek* online put it. "Through photo sharing Web sites like flickr.com and individual and group blogs, the citizen journalist played as vital a role in disseminating information this week as any brand-name media outlet," the Internet journal reported in a "Web exclusive." (The words "photo sharing Web sites" were themselves linked to another *Newsweek* online article, "Photos for the Masses.") The protagonists, while their imagery is seen worldwide, are also recording for those involved — themselves.

For the professional photographer, providing photographs to the community being documented changes the conceptual stance. One cannot depict people as exotically different and expect to be welcomed. By showing their photographs to the troops on whom their lives depend, the embedded photographers working in Iraq find that the change in audience can make it more difficult to be critically distanced, even unconsciously. Imagine if Walker

Evans, for example, had shown the tenant farmers in Alabama the photographs he was making of them while there, perhaps even within minutes of having taken them: would that experience have changed the succeeding images? Certainly such collaboration would allow the photographer to understand and perhaps correct certain of his own cultural stereotypes.

It might also make it exceedingly difficult for the photographer to be honest and open. Showing the work immediately constrains a certain intuition, a freedom for the photographer to reflect in solitude on what is being seen and felt, and to privately discard the photographs that are less successful. One professional, Paolo Woods, explained the difference between analog and digital photography: "It's a bit like wine: you make the wine; then you wait a while for it to become good before you drink it. But digital images, you consume immediately."[23]

Constructive Interventions

Rather than be rendered passive and guilty from the latest shocking photograph or suffering from a terminal case of compassion fatigue, the reader could be given the chance to intervene. Clicking on the image, or a piece of the image, or a predetermined corner of its frame might open up avenues where one could learn more about the situation, volunteer, contribute, vote, articulate an opinion, or play some other kind of role. Certainly not all images lend themselves to quick, constructive responses by viewers, but providing the sense that the viewer's concern is shared can be helpful in diminishing its role purely as spectacle.

At the Georgia Institute of Technology, for example, an experiment called the Digital Family Portrait used icons on a frame containing a photograph of a family member living far away in order to update the relative's daily condition. The idea was that the digital frame communicates the kinds of information that one would naturally be aware of on a daily basis if the relative was living next door—did a grandfather pick up his mail or take his morning walk, did he watch his favorite television program, what is the weather like over there, etc. The goal is to support peace of mind for members of the family worried about aging parents who are living on their own.

FIG. 39: The lifeless body of an alleged collaborator is kicked and photographed in a public square in the Palestinian town of Jenin, August 13, 2006. Photo by Mohammed Ballas / AP.

In other ways, the instantaneous photography allowed by camera phones is becoming a form of self-defense for civilians in all kinds of situations, even as a strategy against exhibitionism. A recent *New York Daily News* front page read, "Caught in a Flash: High School Girls use Cell Phone Camera to Capture Subway Perv." If public opinion were still to have any moderating force, one way to resist an invasion by a superior military power might be to provide every civilian with a camera phone. These photographs of the inevitable horror of war could conceivably serve as a partial brake, assuming that the public had not already been bombarded endlessly by competing and trivializing imagery.

On the other hand, "happy slapping," an emerging phenomenon, employs the camera for its sadistic potentials, as does much of the "amateur" pornography that permeates the Web. As happened at the Abu Ghraib prison, in happy slapping a victim is bullied or beaten, even raped, the cell phone capturing the incident as part of the humiliation.

FIG. 40: Elizabeth Brown, born in 1979, with her avatar named Thalia, created in 2004.
Brown plays the game "Hero's Journey," in development. She describes Thalia's special ability as
having "Godlike powers." Photograph by Robbie Cooper from his book, *Alter Ego*.

9
Of Synthetics and Cyborgs

So all we have to do is wait for those "seeing machines" which
can see and perceive in our stead. — Paul Virilio

Rather than Garry Winogrand's "I photograph to see what things look like
when photographed," people may soon be saying, "I photograph to see what
things look like when I get excited...or depressed...or fall asleep." Or the
machine will do it for us, using face recognition to remind us with whom we
are talking at a party, or recording what we missed when inebriated.

It was unfathomable just a couple of decades ago that people would
carry around oversized boom boxes to listen to music. After that we were
astonished that others would wear earphones in the street, listening to
Walkmen. Now people are plugged into their telephones and their iPods. A
few years ago I walked into a café where each of the four tables had one
person seated, each in conversation with someone not present. The
newcomer had no place to sit, and no one with whom to talk. Then it was a
shock; now it is commonplace.

Vannevar Bush, author of the prophetic 1945 essay "As We May Think,"
speculated that picture making could become a nearly continuous activity by
"the camera hound of the future [who] wears on his forehead a lump a little
larger than a walnut." The issue would be the efficient retrieval of the extraor-
dinary amounts of data from such prolific image making, and then how to
make sense of it all. The potentials are extraordinary, and frightening.

Bush's suggested technique is reminiscent of Walker Evans's 1930s
subway photographs, taken incognito from a hidden camera by pushing on
a cable release in his sleeve. But there is also something of the twenty-first
century cyborg in his description.

> The cord which trips its shutter may reach down a man's sleeve within easy
> reach of his fingers. A quick squeeze, and the picture is taken. On a pair
> of ordinary glasses is a square of fine lines near the top of one lens, where it

is out of the way of ordinary vision. When an object appears in that square, it is lined up for its picture. As the scientist of the future moves about the laboratory or the field, every time he looks at something worthy of the record, he trips the shutter and in it goes, without even an audible click. Is this all fantastic? The only fantastic thing about it is the idea of making as many pictures as would result from its use.

In the 1980s Steve Mann, a media pioneer who may most deserve the cyborg label, built an interactive system into his dormitory room at MIT linked to his underwear. The thermostat there would modify the air-conditioning automatically.

Later on, he would walk around linked to a video camera that his wife could also see through on a Web site, which allowed her to help him decide which fruit to buy from the market. Or he could bicycle down the street looking through one eye at a video of what was behind him. In a memorable television interview for PBS, his head-mounted display appeared to let him know that he was talking to the actor Alan Alda who was just in front of him. He was also reported to have been strip-searched while trying to board a flight in Canada, his electronic gear removed, "disorienting him sufficiently to necessitate that he use a wheelchair."

He has argued that the computer could be trained to replace images via a head-mounted display. A poster of a semi-nude woman advertising a Caribbean vacation, for example, might be replaced by an image of a fountain or a tree for those who find nudity objectionable. While an intriguing idea given the contemporary image overload, the strategy of "diminished reality," as he calls it, theoretically might be then applied in other more objectionable ways: perhaps to homeless people or people whom one identifies as too thin or too fat. The computer could then create a kind of visual apartheid, selectively lightening or darkening skin colors, making the world conform to one's desires.

The fictional overlay would undoubtedly become a credible nonfiction for some for whom the screen already has such primacy. The puritan, the racist, the idealist would be able to remake much of the world in their own image. In a milder way, this is already done for televised sports events where advertising signage can be substituted for far-away viewers; even hospitals use simulated scenes of the outdoors that are supposed to speed up patient recovery in windowless rooms.

FIG. 41: At a 2007 "Second Life" book party. Image by Lesley A. Martin (her avatar is at left).

FIG. 42: Ultrasound "portraits" made of fetuses at the request of parents.
Images courtesy Baby Insight.

The images of buildings could be replaced by beaches, giving the visual sense of being on vacation without leaving one's hometown, seeing sand and waves instead of the local post office (the iPod would supply the sound of the ocean). Rather than urban renewal, a cynical government could give out such devices to make it appear as if all was well.

An even more detached tourism could emerge: imagine what could be done in New Orleans.

Similarly, a personalized camera could be linked to one's blood pressure, alpha wave emanations, or the amount of moisture on one's skin. Photographs, made without conscious volition, could keep a visual record of the camera wearer's day—this is what I photographed when my blood pressure went over 150, or when I was about to fall asleep, or when I was sexually aroused. Think of the surveillance possible if one were able to see, via wireless sensors, the Web, and a GPS system, what a person is looking at when angry or fearful? Criminals on probation, political nonbelievers, even children could be monitored by what essentially becomes a thought police.

Imagine applying it to a sex offender: then, of course, a computer could analyze the imagery and send an alarm when anything "inappropriate" is being looked at, punishing people for thoughts that not only are not acted upon, but may not have been consciously realized. Before, it was the other who was spied upon; now the gaze itself becomes a potential crime.

In fact, the veteran computer innovator Gordon Bell has been attempting to record much of his daily life wearing a SenseCam, being developed by Microsoft, which is a "black box about the size of a cigarette pack which contains an infrared system." As Bell told the *New Yorker* in 2007, "It senses heat—it takes a body a certain size to throw off enough heat to be recognized—and when it finds a person it takes a picture." The system also takes a photograph when the light changes or at various time intervals. There is now even a new term, CyborgLog, shortened to "glog," referring to a first-person recording ("glogging") of an activity in which the person doing the recording is a participant.

Given the extreme miniaturization possible, a constant surveillance of others, and of self, is possible. A new minicamera already in use, the PillCam, the size of a vitamin, takes about 2,600 images with "lights flashing from both ends" to screen for abnormalities in the esophagus, and then

is passed out of the body in eight to seventy-two hours. Similar cameras are being developed for other internal explorations. According to Sam Lubell in the *New York Times,* there is a new industry emerging called elective fetal photography: "While doctors typically conduct ultrasounds at 20 weeks (when the fetus is large enough to show abnormalities), nonmedical ultrasounds are generally performed later, when the fetus is more developed and more photogenic."

In the permanent so-called "war on terrorism" one may ask how extensively the camera will oppress its users, not only by the myriad images of destruction throughout the world to which we are immediately privy but also by a continuous and increasingly omnipresent surveillance. The London Underground has more than 6,000 cameras watching its riders. (Some of the accused terrorists in the recent British bombings were caught through cameras that recognize and record license plates.) As of May 2005, according to the Camera Surveillance Players, there were 604 detectable surveillance cameras in New York's Times Square. By the end of 2008 there are plans for 3,000 surveillance cameras below Canal Street, where New York City's financial district is located. Even Dillingham, Alaska, has 80—one for every thirty residents. And these statistics do not include people with Web-cams watching the babysitter.

Cameras connected to computers with face-recognition software scan people at stadiums or on the street without them knowing, and sound an alarm when someone with an allegedly suspicious background approaches. For some the fear of crime added to the fear of terrorism, compounded by the fear of the other, makes the camera a welcome intruder.

Recently, having lunch in a mostly empty café in New York's Greenwich Village with a colleague, we noticed a wall-mounted camera pointed right at us. When we summoned the young waitress she did not understand the problem. "It's for the manager to keep track of what's happening in the back of the restaurant," she said, amazed that we might be upset. The diminution of street photography in more affluent societies is evidently linked to the street's diminished role as social sphere. In the age of the computer, television and air conditioning, fewer spend much time on the streets except as a way to get somewhere else. On the other hand, risk-averse citizens, convinced of their imminent peril, hardly seem to mind the institutionalized photographing of these same streets and the resultant loss of privacy.[24]

Congress, in recent legislation known as the Video Voyeurism Prevention Act of 2004, has made it clear that certain kinds of privacy will be protected, at least on federal property.

> (a) Whoever, in the special maritime and territorial jurisdiction of the United States, has the intent to capture an image of a private area of an individual without their consent, and knowingly does so under circumstances in which the individual has a reasonable expectation of privacy, shall be fined under this title or imprisoned not more than one year, or both.
>
> (b) In this section—
> (1) the term "capture," with respect to an image, means to videotape, photograph, film, record by any means, or broadcast;
> (2) the term "broadcast" means to electronically transmit a visual image with the intent that it be viewed by a person or persons;
> (3) the term "a private area of the individual" means the naked or undergarment clad genitals, pubic area, buttocks, or female breast of that individual;
> (4) the term "female breast" means any portion of the female breast below the top of the areola...

The act goes on to explain the term "under circumstances in which that individual has a reasonable expectation of privacy," ending with the somewhat Orwellian phrase: "This section does not prohibit any law enforcement, correctional, or intelligence activity."

Why the Video Voyeurism Prevention Act? According to a 2004 report in internetnews.com: "As cell phone cameras exploded in popularity and practices such as image alteration where the face of one person is digitally edited to appear on the naked body of another became more widespread, the 108th Congress began steadily moving the legislation to the president's desk." As with the Child Pornography Act, with regards to sexuality Congress has been, more than most, attuned to the digital image revolution.

Another problem exaggerated by the pervasiveness of cameras, this time in Japan, focuses on the issue of privacy in death. "Japan's obsession with camera-equipped mobile phones has taken a bizarre twist, with mourners at funerals now using the devices to capture a final picture of the deceased," Reuters reported in early 2006. "'I'm sure the deceased would never want their faces photographed,' [a funeral director] said. But others called it a form of a memento in the modern age. 'Some can't grasp "reality"

FIG. 43: Mike Solo, *Obsessive/Compulsive,* 2007. "Spellbinder" allows the superimposition
of virtual art created for a particular scene on a cell phone photograph
of the same location. The initial image is first transmitted to a database and the
composite is then returned to the photographer.

unless they take a photo and share it with others.... It comes from a desire to keep a strong bond with the deceased,' commentator Toru Takeda told the [news]paper."

Neither the disrobed nor the dead are off-limits for the omnipresent cameras.

Given, then, the near inevitability of being photographed in public places in cities, either by cameras at an ATM, on the street by cameras put there by the police, or in restaurants and other public institutions, finding the ability to "disappear" may become as valuable a tool as the visibility so many currently strive for before the camera. Disappearance may become, as in cyberpunk movies such as *Total Recall,* the prerogative of the well connected, the completely marginalized, or the resistance.

As a result, some have embraced what they call *sousveillance,* or "watchful vigilance from underneath" (as opposed to surveillance, from above) in which people carry cameras to spy on the cameras spying on them. Paradoxically, this may be prohibited in institutions such as stores and government buildings that forbid photography while simultaneously photographing customers and visitors. In Japan "digital shoplifting," or the use of camera phones in bookstores to copy and send magazine spreads to friends that might show a new dress or hairstyle, is the object of a national campaign against information theft. A new photo-sharing site, strictlynophotography.com, is for "pictures taken where you are not allowed to take them." Their goal: "To organize the world's forbidden visual information and make it universally accessible and useful."

The Renaissance one-point perspective should become somewhat quaint in a world of multiple visions, where each eye views a world governed by different rules, and the viewer, in turn, will be watched by multiple machines. A former student-cyborg at MIT, Thad Starner, once explained that his professors allowed him to take his exams while attached to his computer hard drive, one eye immersed in the digital (his "private eye"), given that there is no separation between his body and the equipment that he wore at all times. The cyborg's double gaze recalls the double portrait suggested at an MIT seminar, where a person's portrait could be made and simultaneously supplemented by a second photograph made of her from a satellite in space. Local existence is contextualized by planetary location, and also by our cameo

FIG. 44: From Brian Eno's *Constellations (77 million paintings)*, 2006, a generative artwork
in which some three hundred of his paintings are mutated via algorithms to form images that
the artist has never seen before. According to Eno, a viewer would have to look for about
450 years to be sure of seeing an image twice.

roles on surveillance tapes. The irony, lost in the hype around user-generated Web sites with their billions of images, is that human awareness of proximate realities may be a minority strategy in the digital revolution.

"While this sudden distancing admittedly offers the possibility of embracing hitherto unimaginably vast geographic and planetary expanses," argued Virilio, "it is also risky, in that the absence of any immediate perception of concrete reality produces a terrible imbalance between the sensible and the intelligible, one which can only result in errors of interpretation." While celebrating the ascension of photography in the digital environment, we may have already, and unknowingly, given up the primacy of the human gaze to the machines. The cyborg, rather than an oddity, may be the one that has acknowledged the shift.

––––––––––

The human will also be rivaled and challenged in other ways. Artificial life, or the simulation and extension of "living" processes in the digital environment (a computer "virus," for example), approximates the sexual, but through recombinant algorithms. While it raises potentially frightening scenarios of machines with their own agendas, for an artist the possibilities are endless. People in their lifetime can produce very few pieces of art, but an algorithm can evolve, or mutate, or combine with others so that the artist never, even with death, stops producing.

For example, the influential musician and multimedia artist Brian Eno, known for his pioneering work in electronic and ambient music, a collaborator with David Bowie and U2, interviewed in *Wired* magazine by Kevin Kelly:

If I could give you a black box that could do anything, what would you have it do?
I would love to have a box onto which I could offload choice making. A thing that makes choices about its outputs, and says to itself: this is a good output, reinforce that, or replay it, or feed it back in. I would love to have this machine stand for me. I could program this box to be my particular taste and interest in things.

Why do you want to do that? You have you.
Yes, I have me. But I want to be able to sell systems for making my music as well as selling pieces of music. In the future, you won't buy artists'

works; you'll buy software that makes original pieces of "their" works, or that recreates their way of looking at things. You could buy a Shostakovich box, or you could buy a Brahms box. You might want some Shostakovich slow-movement-like music to be generated. So then you use that box. Or you could buy a Brian Eno box. So then I would need to put in this box a device that represents my taste for choosing pieces.

I guess the only thing weirder than hearing your own music being broadcast on the radios of strangers is hearing music that you might have written being broadcast!
Yes, music that I might have written but didn't!

Will you still like the idea of these surrogate Brian Enos when they start generating your best work?
Sure! Naturally, it's a modifiable box, you know. Say you like Brahms and Brian Eno. You could get the two of them to collaborate on something, see what happens if you allow them to hybridize. The possibilities for this are fabulous.

What's left for us to do then?
Cheat. And lie.

What would be the photographic equivalent? Finding the algorithm that somehow corresponds to an Ansel Adams image and marry it to a Cartier-Bresson decisive moment algorithm, adding a small affair with relativity theory for some seasoning?

Watching drawings and sculptures form as the algorithms evolve can be fascinating. One evolutionary artist named William Latham came up with a generative program in 1986 labeled Mutator that would allow him to watch the computer create multiple forms, select the ones he liked best, and these would then become the "parents" for other generations. This artificial life process creates 3-D virtual sculptures, a sort of organic art that uses a form of Darwinian selection and human aesthetic choice. "I had not anticipated the variety of sculpture types which my software could create," stated Latham. "There appears no limit to the wealth of different forms that can be created using this method."[25] It may also feel as if one is watching a history of sculpture unfold via algorithms.

Or it can be a history from a parallel universe, one not yet achieved here. The screen shot can itself become a photo-realistic record of unseen

worlds, accessed from the virtual. They may point to a Jungian archetype, maybe even to life-forms on other planets, perhaps potential terrestrial life. As such, the screen shots may be akin to a photography of the future.

"The evolutionary artist creates twice," writes Kevin Kelly in *Out of Control*. "First, the artist acts as god by concocting a world, or a system for generating beauty. Second, he is the gardener and curator of this made world, interpreting and presenting the chosen works he nurtures. He fathers rather than molds a creation into existence." The artist is promoted to be the visionary and founding parent of a radically new world.

And we, humans with one eye looking through a screen attached to an alternative digital universe, will have a true revolution to witness, one that breaks from previous forms of art. Photographs, video, and paintings may seem nostalgic in the evolving new universe of forms. In *Spore* by Will Wright, for example, a computer-based game that verges on a cosmology, each player will create his or her own synthetic universe and creatures that evolve, overlapping with worlds created by others. Players can explore, build, develop their species, and interact with organisms that others have spawned as if they were in a parallel world. These synthetic universes, seemingly so far-out and computer-like, begin to resemble our own genetically modified, environmentally challenged planet, however uncomfortable it may be to realize.

As we ourselves change, and change ourselves, we will have more difficulty in attaining the perspective to evaluate the significance of these changes. Gradually and unconsciously, we may eventually adopt a mind-set where we find that the synthetic universe better suits us, distancing ourselves from the problem-filled world that our media have tried, however unsuccessfully, to show us. We will require an enormously effective post-photography to deal with what it means to become post-human.

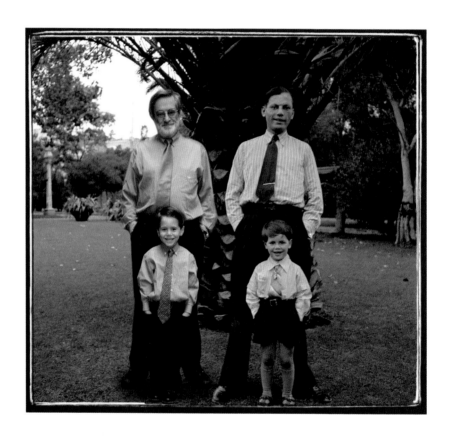

FIG. 45: Pedro Meyer's composite in which he appears twice:
as son (right) and as father (left).

IO
A Quantum Leap

Thus, for instance, he once saw his cat leap vertically where it fell, rigid. He clearly remembered placing the dead cat in a shoebox and burying it under the almond tree in the yard. Just as clearly, though, there was the cat at its bowl the next morning, looking up at him as if nothing had happened.

—W. G. Sebald, *The Emigrants* (1992)

———————

While almost never discussed, the movement from the continuity of the analog to the discrete integers of the digital parallels a similar evolution in physics. The reassuring continuity of a Newtonian universe was reconceptualized in the twentieth century into the discrete energy packets of a quantum world. These parallel transitions alone argue that we have immersed ourselves in the digital not only for its efficacy but to catch up to differing worldviews, even if only metaphorically. Just as cubism reflected an Einsteinian, relativistic world, so too the digital can better evoke the quantum, teasing out its probabilities and ambiguities, as well as other nonclassical theories.

A quantum worldview is not obvious: As physicist Niels Bohr put it, "Anyone that is not shocked by quantum theory doesn't understand it." Nobel Prize winner Richard Feynman may have gone further: "I think I can safely say that no one understands quantum physics." Digital media can begin to be receptive to the oddities described by newer theories, using the Internet as a conceptual playground and eventually introducing new logics (or lack of logic) to an information-age public that may now be more receptive to such reflection. The possible superimpositions of image as digital layers and the high-speed nonlocal links of a hypertext help to make explicit a more ethereal universe of intriguing overlaps and esoteric attractions.

Like a digitally based photography, quantum physics in many ways is counter-intuitive. One of the best-known experiments in physics, the "double-slit experiment," indicates that light is not just a wave, as was previously thought, but simultaneously has both wave and particle qualities.

Light, the stuff of photography, concurrently manifests both the wave-like continuity of the analog photograph and the particle-like discrete pixels of the digital image. Photography, analog and digital, plays with light but depicts the universe with differing assumptions.

According to Bohr, in the Copenhagen Interpretation, only the act of observation would make this essential duality collapse into a single state. Photography also has been taken to collapse multiple states into a singular state of affairs ("the camera never lies"). In fact a close reading would suggest that photographic observation is given too much credit for clarity, and instead often argues for multiple, overlapping states of being—not only physical, but also cultural and political. The image may appear to answer a question posed to it without noticing that it asks many more.

In photography's case ambiguity's collapse is usually aided—and often inappropriately forced—by captions that attempt to resolve the uncertainty by telling us, correctly or incorrectly, whether Schrödinger's cat is alive or dead. (Without such a caption, based upon the photographic evidence, the cat might easily be thought of as appearing, quantum-like, both asleep and/or dead.) The caption is made to constrain the photograph into a single state rather than open it up to amplification. If a photograph is said to be worth a thousand words, very few of those words generally come to mind after a caption tells the reader what the photo is supposed to be about.

There are other kinds of captions that can be appended and which provide some pertinent information (the date of the photograph, for example) to point the reader in a general direction without necessarily neutralizing the photograph's multiple states. For example, in working with Sebastião Salgado on his 1986 book *Other Americas,* he was adamant in not supplying captions beyond the name of the country and the year in which each photograph was made. The pictures concerned the double state of "otherness" of his subjects. They were Latin Americans in a hemisphere where "American" generally means someone from the United States, and they were also peasants who stayed behind on the land while so many millions migrated to cities. To concretize in captions what was happening in each image would have been to pierce a variety of overlapping possibilities, spiritual and otherwise, deflating the poetic and metaphoric into a more banal and ultimately less true singular state.

Rodin, as we have seen, argued that this collapse of possibility made photography a liar. The mechanical observation was not as things were in life. Photography, he believed, was artificial, whereas art, as in a sculpture, was truer to the way things are — a continuity of time and movement. Rodin was also arguing, even if not in these terms, that sculpture is emblematic of a Newtonian existence, continuous and rational, and photography's interruptions were foreign to him.

After all, even analog photography divides up the world into rectangular two-dimensional images that are recorded from a segment of the electromagnetic spectrum in fractional seconds — discrete segments. Each of these segments, the photograph, wrests a record of appearance out of what is only the tip of a complex and changing, multilayered set of physical and conceptual systems, many of them unknown. Its attempt to make sense of the underlying forces by their visible manifestation may be too facile; the territory covered may be insufficient. The emerging flexibilities of photography's digital incarnation, including the ability to link all kinds of data, to readily represent the conceptual as well as the perceptual, allow for more intense and productive explorations of the less visible, including that which on the surface seems illogical.

Proust, viewing his grandmother in *The Guermantes Way* from the temporary perspective of "the stranger who does not belong to the house, the photographer who has called to take a photograph of places which one will never see again," is finally able to see the decline of his grandmother sitting there. The collapse of possibilities, or the objectification brought on by viewing her in his eyes as a photograph, is both salutary and distancing: "I, for whom my grandmother was still myself, I who had never seen her save in my own soul, always in the same place in the past, through the transparency of contiguous and overlapping memories, suddenly, in our drawing-room which formed part of a new world, that of Time...saw, sitting on the sofa beneath the lamp, red-faced, heavy and common vulgar, sick, day-dreaming, letting her slightly crazed eyes wander over a book, an overburdened old woman whom I did not know."[26] The relationship moves from that of first- and second-person to the third, or in philosopher Martin Buber's terms from I-Thou to I-It.

The analog photograph can be as abrupt as Rodin suggested. Dualities may need to be acknowledged and restored. A digital photography, with its

various potential superimpositions and links, its ability to aggregate a multiplicity of perspectives (think of Photosynth), might be able to restore Proust's grandmother to the more complex and human stature of the one who is known and, evidently, unknown.

Similarly, in Michelangelo Antonioni's film *Blow-Up*, the hidden gun is revealed from within an enlarged photograph, but the photographer, unconvinced by the evidence that a murder had in fact taken place, no longer sure of what is real, goes on not only to watch people play tennis with an invisible ball but to join in. The dualities, one might suggest, are resurrected. In Cortázar's short story *Blow-Up*, upon which the movie was based, the photographer's quandary is somewhat different: "He tacked up the enlargement on one wall of the room, and the first day he spent some time looking at it and remembering, that gloomy operation of comparing the memory with the gone reality; a frozen memory, like any photo, where nothing is missing, not even, and especially, nothingness, the true solidifier of the scene." It is the missing nothingness, the ethereal, that would allude to other potentials and probabilities, making the scene more permeable.

After all, there may be no there there. In *The Quantum Self* Danah Zohar argues that "some quantum theorists, foremost among them Niels Bohr and Heisenberg himself, argued that fundamental reality itself is essentially indeterminate, that there is no clear, fixed, underlying 'something' to our daily existence that can ever be known. Everything about reality is and remains a matter of probabilities." We have tried to use the photograph to concretize the probabilities (isn't that what the "decisive moment" is all about?), reassuring us that reality is more solid than what our theories tell us. It is this profound anxiety that explains why we are so readily convinced that the photograph is credible. The alternative may be too disconcerting, if not terrifying.

In the quantum world, distance may be illusory, certain measurements are impossible, time may go backward, particles can be in two places simultaneously, and the only certainty may be probability. Digital photography, based upon segments, divorced from conventional temporality, from continuous tones and the interplay of film and chemistry, allows us to envision different cosmologies. Conventional photography may, in this new world, be judged insufficient, not just for reasons of efficacy but because it comes from a conceptual space that will seem increasingly remote and old-

fashioned. Just as a photograph taken in a fractional second of Moses with the two stone tablets might have been meaningless to his contemporaries, for whom temporal and spatial fragmentation into a two-dimensional photograph would probably have been illegible, so too the digital photograph may appear murky to us until our understanding of the universe advances.

Within a Newtonian worldview, the famed Cartier-Bresson photograph of a man jumping a puddle leaves the reader confident that he will land on the other side; in a subatomic quantum universe it remains a matter of probabilities. The implications of each photograph vary in different physical and conceptual universes, just as they differ in divergent cultural and political environments, although ethnocentric readings predominate.

The digital-quantum photograph reinstates some of the uncertainty that surrounded the first photographs. It's not that the photograph "never lies," but that in some ways it always does. Now the grandfather can be posed alongside the grandson, each the same age; the Martian gravitational force can be applied to the Lisbon street scene; the ambiguities of two lovers' relationship(s) can be resolved, tentatively, in parallel universes.

Image cannot be calcified from a quantum photograph when it is indeterminacy, not instant credibility, that is evoked. The staged press conference did—and did not—occur. The photograph, and its authority, cannot be taken for granted.

The photography of the future can explore and delineate universes where multiple principles are at work, and where existence is both solid and illusory. It will be able to evoke the concept of shared energy states that link people, animals, spirits, beings, objects, potentials—connections the Newtonian prism was less capable of considering. Photography will not so much stop or capture time as acknowledge its space-time plasticity and track its meandering evolution. It may fragment less and enlarge more, envisioning history, and the present, as nonlinear with a multilayered complexity.

This, finally, will be "digital photography," synthesizing and analyzing aspects of the universe in interesting and unusual ways, rather than beginning with a mythic wholeness and freezing small sections as two-dimensional rectangles—the problem of the blind man befuddled by the elephant.

The older mechanical photography will, to a certain extent, falter. It will be valued as historical documentation and for its singularity as object

that will more and more resemble that of painting. But its singularity may also be seen as a drawback, and the digital may appear, almost paradoxically, as more holistic. Argues Zohar: "The mechanical world view fails, ultimately, because it does not work towards a greater, ordered coherence. It reflects neither the intuitions nor the personal needs of most people, nor the simple, quite classical fact that we live in a shrinking world, a world where technology and mass communication, industrial pollution and the threat of global extinction have made us aware as never before that in some very important sense we are all interdependent and that our human lives are inseparably intertwined with the world of Nature. A worldview that leads to fragmentation, and that encourages the selfish exploitation of others and of our common world, violates the constraint of the natural."

A digitally based photography begins to be an adventure reminiscent of the one embarked upon by the early pioneers of analog photography — Fox Talbot's "sun pictures" in the 1845 *Pencil of Nature* or Nadar's aerial photographs from a balloon, for example, as well as the "spirit" photographs of the nineteenth and twentieth centuries with their attempted depictions of ghosts and souls. Vision can be reinhabited by magic and surprise; we may require it.

In the Bible, the graven image is forbidden. An interdiction against

FIG. 46: A sunset in "Second Life," 2007. Image by Michael Schmelling.

idolatry, a desire to keep a monotheistic God invisible, all-powerful, and ambiguous, invoked a multivalent reality that was variously interpreted, influenced by what could not be seen. The imagination was elevated; belief was required to inhabit the sacred, the separate, and the holy. Undefined visually, God cannot be compared to any other being. Nor do God's characteristics depend upon the perceptions of any human.

Photography that reflects a nonclassical view of the universe can invoke not only confusion but also the ineffable. Whether or not actually linked to other imagery, sounds, texts, smells, such photography may implicitly acknowledge their impact. A temporary collapse of possibilities, the photograph, malleable and resilient, can be reactivated. The digital environment is a capable host for dealing with probabilities, complementary and essential dualisms, and connections over great distances as well as into future and past. A productive "indecisive moment" can surface in a system much larger than we had previously imagined, a map for known and unknown territories, encouraging a quantum leap into unimagined possibilities.

None of this argues that we should deny photography's strengths as we have known them, just as we would be foolish and self-defeating to abandon the classically seen physical world to begin living our daily lives according only to quantum probabilities, string theory, black holes, and quarks. For the foreseeable future analog and digital should coexist, as will the photo and hyperphoto, complementing and challenging each other's biases and possibilities.

Donna J. Haraway concludes her seminal, much cited socialist-feminist essay "A Cyborg Manifesto" by commenting upon the ponderous societal constraints insinuated by the mythic and romantic, and contrasting them with the comparative freedom (and honesty) of the artificial and ironic: "Though both are bound in the spiral dance, I would rather be a cyborg than a goddess."

In the digital-quantum world, it might just be possible to be both, and more. To use an emerging post-photography to delineate, document, and explore the post-human. To dance with ambiguity. To introduce humility to the observer, as well as a sense of belonging. To say yes and, simultaneously, no.

Photography (or hyperphotography) may, as always, be seen as a confirmation. Or an exploration. A question or an answer.

Or not. Or both.

Afterword

The world, on multiple levels, is rapidly changing around us. It is happening so quickly and expansively that any missteps assume an enormous potential for damage. An irony, in democratic societies, is that so many feel so little influence over these changes. Another irony, in information societies, is how difficult it is to become cognizant of these changes so as to know how to respond.

The argument for reliable and meaningful media to help us navigate our future has never been more compelling. In the last few years alone the United States has been able to invade a country and start a major war citing weapons that did not exist. A major city was submerged and, whether due to complicity or incompetence, nearly abandoned and destroyed. Massive pollution has been overlooked worldwide to the point where the planet, belatedly, is now recognized as in severe peril. As humans we are diminished, at times nearly blinded, as we enter a new millennium.

What comes after photography, or any other medium, is not predestined. In a multimedia environment no medium need be monolithic but should emerge with enormous potentials for synergy. Sophisticated tools of media production are already in the hands of more people than ever before, even if their possible uses are still dimly understood. Media, in their accessibility, malleability and overlap, can provide opportunities for transcendent flights of experimentation. Presentation is less of a problem as distribution networks continually expand, carrying with them the potentials both for a more effective mass incarceration as well as for an escape from previous prisons of misunderstanding.

Critical questions at this fraught juncture, however, are often obscured by marketing slogans and a generalized fear of taking responsibility for fundamental change. Will we be able to utilize these new technologies to increase meaningful information and various kinds of comprehension? Will we be able to envision a more beneficent universe and create media to help us get there? Can we transform this moment into an age of enlightenment rather than a permanent war on terror?

Without an ability to pose these and related questions, answers to our growing dilemmas will remain scarce. Certainly it is easier to criticize the distorting power of contemporary media than to envision and build new strategies for communication, while floating ideas for others to modify and advance. Given the transnational stake in these outcomes, the pressures should be globally shared to help us create a more open-minded, inquisitive media platform. Students in schools worldwide should not only be asked how media work, but also asked how they should work.

Since the 19th century photography has been a means of self-expression and an ambiguous social construct, a strategy to illuminate and certify as well as to distort and calcify. But it is no longer the medium it once was. As Peter Plagens remarked in *Newsweek* at the end of 2007, "The next great photographers—if there are to be any—will have to find a way to reclaim photography's special link to reality. And they'll have to do it in a brand-new way."

What photography evolves into is, to a significant degree, up to those interested in abetting its transformation; the possibilities for change are freshly palpable. The stakes are momentous: our outlooks on life, both perceptual and conceptual, are sure to be deeply affected. What looms before us finally is not simply a question of media but one that, when answered, will help determine, to a degree greater than we now think, our own uncertain fates.

Endnotes

1. Recently Japanese researchers have come up with a prototype that captures a limited number of smells digitally and, once hooked up with a special gadget, can reproduce them for anyone else.

2. *Espresso*, September 30, 1994.

3. Ruth La Ferla, *The New York Times*, September 21, 2006.

4. Reported by this author in "Photography's New Bag of Tricks," the *New York Times Magazine*, November 4, 1984.

5. I described this early experience in a previous book, *In Our Own Image: The Coming Revolution in Photography*, first published in 1990.

6. Nicholas Wade, "It May Look Authentic; Here's How to Tell It Isn't," *The New York Times*, January 24, 2006.

7. "Photography's New Bag of Tricks," *The New York Times Magazine*, November 4, 1984.

8. Gigapan is being developed as part of the Global Connection Project, a collaboration among Carnegie Mellon University, NASA, Google and National Geographic.

9. Douglas Davis, "The Work of Art in the Age of Digital Reproduction (An Evolving Thesis: 1991–1995)."

10. In May of 2008 the United States Supreme Court ruled that the pandering of imagery as child pornography, whether or not actual children were depicted, is punishable by law. While virtual child pornography is still protected by the First Amendment, its marketing as actual pornography is not.

11. Robert Capa's famous 1936 photo of the "Falling Soldier," considered perhaps the greatest war photograph of the twentieth century, was recently discovered by Capa's official biographer Richard Whelan to have been made when the soldier, who was playing around for Capa's camera, fired a shot and then was killed by the enemy. As such it was both a spontaneous documentary photograph and a tragically staged image.

12. Quoted by Jacques Clayssen in his essay, "digital (R)evolution," in *Photography After Photography*, 1996

13. "It looks like a painting," the Sarah Miles character said in the 1966 movie *Blow-Up* while looking at a grainy enlargement of a 35 mm photograph that was made by the photographer searching for evidence of a murder. It was a statement concerning origins that would be difficult to repeat for the pixelated blow-ups of a digital photograph.

14. Peter Plagens, "Is Photography Dead?" *Newsweek*, December 10, 2007.

15. The enthusiastic, open response by Kevin McKenna, the all-around support and insights of Mark Bussell, then a senior editor, and the enlarging of the project by Martin Nisenholtz, president of the New York Times Electronic Media Company, were crucial in making this foray possible. Many others contributed in important ways, most especially *Times* forum moderator and senior editor Bernard Gwertzman, design director Ron Louie, content development editor Elizabeth Osder and online news editor Jean-Claude Bouis who did the audio interviews, international forum producer Alison Cornyn (IBM

For updated information, please consult www.afterphotography.org.

helped installing computer terminals in the Hague and the UN), and Indigo Information Design's Lucy Kneebone, Melissa Tardiff and Amnon Dekel—the latter's early input was essential to the interactive design.

16. It is interesting as well how verbal language is being changed, from the use of smileys to predictive text messaging in which the word "book" has replaced, for some, "cool."

17. PixelPress is at www.pixel press.org. It maintains both an online publication and has worked extensively with human rights organizations on campaigns such as one with photographer Sebastião Salgado to end polio globally, with the Crimes of War organization on international humanitarian law, and with UNFPA on the Millennium Development Goals. Carole Naggar and I founded it in 1999, Zohar Nir-Amitin is the senior designer, Aviva Michaelov and Anna Norris previously also worked as designers; Jessica Ingram is the managing editor, succeeding Alicia Kuri Alamillo and Ambreen Qureshi; and Matisse Bustos served as outreach coordinator. Many others have supported and guided the organization, no one more than Joseph Rodriguez, one of the contributing photographers with Donna DeCesare and Brian Palmer.

18. See www.rwandaproject.org.

19. See www.pixelpress.org/ index_iraqi.html.

20. The young people were taught in two-hour workshops by photographer Diego Goldberg and reporter Roberto Guareschi, both Argentineans, whose own adroit documentation from the outside,

focusing on a single child in each situation, contextualized and explored their living situations with broader strokes. I served as the curator. See www.chasingdream.org.

21. On June 2, 2007, a short article ran in the *New York Times* reporting on a televised interview with a Polish railworker who had just woken up from a coma that he had been in since 1988: "'What amazes me today is all these people who walk around with their mobile phones and never stop moaning,' he said in the interview. 'I've got nothing to complain about.'"

22. A longer discussion by this author can be found in *Sahel: The End of the Road*, by Sebastião Salgado, also with an essay by Eduardo Galeano, published by UC Berkeley Press, 2004.

23. Douglas Heingartner, *The New York Times*, May 3, 2005.

24. A man in Dallas recently called police in England while watching a Beatles-related Webcam showing a part of Liverpool that the musicians frequented. He noticed people who seemed to be breaking into a sports store; three suspects were arrested.

25. Quoted in *Out of Control* by Kevin Kelly, 1994.

26. Marcel Proust, *In Search of Lost Time: The Guermantes Way*, translated by C. K. Scott Moncrieff and Terence Kilmartin, The Modern Library, 2003.

Bibliography

Amelunxen, Hubertus v., Iglhaut, Stefan, Rotzer, Flörian, *Photography After Photography: Memory and Representation in the Digital Age*, G+B Arts, 1996

Baudelaire, Charles, *Selected Writings on Art and Artists*, 1981

Baudrillard, Jean, *Simulations*, Semiotext(e), 1983

————, *Fragments*, Routledge, 2004

Benjamin, Walter, *Illuminations*, Schocken, 1969

Berger, John, *About Looking*, Pantheon Books, 1980

Boorstin, Daniel J., *The Image: A Guide to Pseudo-Events in America*, Vintage, 1992

Borges, Jorge Luis, *Labyrinths: Selected Stories and Other Writings*, New Directions, 1964

Buber, Martin, *I and Thou*, Charles Scribner's Sons, 1958

Bush, Vannevar, "As We May Think," *Atlantic*, July 1945

Cortázar, Julio, *Blow-Up and Other Stories*, Pantheon, 1985

Crary, Jonathan, *Techniques of the Observer: On Vision and Modernity in the Nineteenth Century*, MIT Press, 1990

Debord, Guy, *Society of the Spectacle*, Zone Books, 1995

DeLillo, Don, *White Noise*, Viking Penguin, 1985

Druckrey, Timothy (ed.), *Iterations: The New Image*, MIT Press, 1993

Eco, Umberto, *Travels in Hyperreality*, Harvest Books, 1990

Friend, David, *Watching the World Change: The Stories Behind the Images of 9/11*, Farrar, Straus and Giroux, 2006

Garnett, Joy, and Meiselas, Susan, "The Rights of Molotov Man," *Harper's* magazine, February 2007

Goldberg, Vicki, *The Power of Photography: How Photographs Changed Our Lives*, Abbeville, 1991

Gray, Chris Hables, *Cyborg Citizen: Politics in the Posthuman Age*, Routledge, 2001

Gribbin, John, *Schrödinger's Kittens and the Search for Reality: Solving the Quantum Mysteries*, Back Bay Books, 1995

Haraway, Donna J., *Simians, Cyborgs and Women: The Reinvention of Nature*, Routledge, 1991

Kelly, Kevin, *Out of Control: The New Biology of Machines, Social Systems, and the Economic World*, Addison Wesley, 1994

————, "Gossip is Philosophy: Interview with Brian Eno," *Wired*, issue 3.05 May 1995

Kelly, Michael, "David Gergen, Master of THE GAME," *The New York Times Magazine*, October 31, 1993

Kern, Stephen, *The Culture of Time and Space: 1880–1918*, Harvard University Press, 1983

Knoth, Robert, de Jong, Antoinette, *Certificate No. 000358: Nuclear devastation in Kazakhstan, Ukraine, Belarus, the Urals and Siberia*, Mets & Schilt, Amsterdam, 2006

Lanham, Richard, *The Electronic Word: Democracy, Technology, and the Arts*, University of Chicago Press, 1995

Landow, George P., *Hypertext: The Convergence of Contemporary Critical Theory and Technology*, Johns Hopkins University Press, 1991

Lipkin, Jonathan, *Photography Reborn: Image Making in the Digital Era*, Abrams Studio, 2005

Mann, Steve, and Niedzviecki, Hal, *Cyborg: Digital Destiny and Human Possibility in the Age of the Wearable Computer*, Doubleday, 2001

McCullin, Don, *Unreasonable Behavior: An Autobiography*, Knopf, 1992

McKibben, Bill, *The End of Nature*, Anchor Books, 1990

———, *Enough: Staying Human in an Engineered Age*, Henry Holt and Company, 2003

McLuhan, Marshall, *Understanding Media: The Extensions of Man*, McGraw-Hill, 1964

Mitchell, William, *The Reconfigured Eye: Visual Truth in the Post-Photographic Era*, MIT Press, 1992

Mirzoeff, Nicholas (ed.), *The Visual Culture Reader*, Routledge, 1998

Nelson, Theodor H., *Literary Machines*, Mindful Press, 1988

Pagels, Heinz, *The Cosmic Code: Quantum Physics as the Language of Nature*, Simon & Schuster, 1982

Paglia, Camille, Postman, Neal, "She wants her TV! He wants his book!" *Harper's* magazine, March 1991

Postman, Neal, *Amusing Ourselves to Death: Public Discourse in the Age of Show Business*, Viking, 1985

Proust, Marcel, *In Search of Lost Time: The Guermantes Way*, Modern Library, 2003

Queneau, Raymond, *Cent Mille Milliards de Poèmes*, Editions Gallimard, 1961

Ritchin, Fred, *In Our Own Image: The Coming Revolution in Photography*, Aperture, 1990, 1999

———, "Photography's New Bag of Tricks," *The New York Times Magazine*, November 4, 1984

Salgado, Sebastião, *Sahel: The End of the Road*, with essays by Eduardo Galeano and Fred Ritchin, University of California Press, 2004

Sontag, Susan, *On Photography*, Farrar, Straus and Giroux, 1977

———, *Regarding the Pain of Others*, Farrar, Straus and Giroux, 2002

Stephenson, Neal, *Snow Crash*, Bantam, 1992

Suskind, Ron, "Faith, Certainty and the Presidency of George W. Bush," *The New York Times Magazine*, October 17, 2004

Szarkowki, John, *Mirrors and Windows: American Photography Since 1960*, Little Brown and Company, 1978

Traub, Charles H., Lipkin, Jonathan, *In the Realm of the Circuit: Computers, Art, and Culture*, Pearson Prentice Hall, 2004

Turkle, Sherry, *Life on the Screen: Identity in the Age of the Internet*, Simon & Schuster, 1995

———, *The Second Self: Computers and the Human Spirit*, Simon & Schuster, 1984

Virilio, Paul, *Art and Fear*, Continuum, 2003

———, *The Information Bomb*, Verso, 2000

———, *The Vision Machine*, Indiana University Press, 1994

Wardrip-Fruin, Noah, Montfort, Nick, *The New Media Reader*, MIT Press, 2003

Wheeler, Thomas H., *Phototruth or Photofiction? Ethics and Media Imagery in the Digital Age*, Lawrence Erlbaum Associates, 2002

Zohar, Danah, *The Quantum Self: Human Nature and Consciousness Defined by the New Physics*, William Morrow and Company, 1990

Image Credits

Additional information as follows:
Frontispiece: Anonymous, c. 1938. **Fig. 1:**
Sunbathers is 3.2 x 2.3 meters and was exhibited
as part of "Paradise Now," Exit Art, New York.
The image is imprinted through photosynthesis.
Fig. 2: *The Drummer* copyright © Loretta Lux,
Ilfochrome print. Courtesy Yossi Milo Gallery.
Fig. 3: *Nepal* is 170 x 120 cm. Courtesy Raster
Gallery, Warsaw. **Fig. 4:** magazine cover copy-
right © 1982 National Geographic Society. **Fig. 5:**
newspaper front page copyright © 1994 New
York Newsday. **Fig. 6:** *Newsweek* cover copyright
© 1994 Newsweek, Inc. *Time* cover copyright ©
1994 Time, Inc. **Fig. 7:** image of Tydings/Browder
was originally published in *From the Record*,
1950. **Fig. 10:** courtesy My Twinn. **Fig. 11:**
courtesy of University of Washington. **Fig. 12:**
courtesy Carnegie Mellon University. **Fig. 13:**
Linienstrasse 137 is an on-location installation as
well as a 33 x 40 in. chromogenic photograph.
Courtesy Jack Shainman Gallery. **Fig. 16:** maga-
zine spread copyright © 2006 *Vogue Italia /*
Condé Nast Publications. **Figs. 22–23:** photo-
graphs and diary text copyright © Gilles Peress /
Magnum; screens copyright © 1996 The New
York Times Company. **Fig. 25:** photographs
copyright © Nubar Alexanian; screens copyright
© PixelPress LLC. **Fig. 27:** photograph courtesy
"The Rwanda Project: Through the Eyes of
Children." **Fig. 28:** photograph courtesy
of the Daylight Community Arts Foundation;
published at www.pixelpress.org. **Fig. 30:**
photograph copyright © Robert Knoth; screens
copyright © PixelPress LLC. **Fig. 32:** courtesy
Reuters. **Fig. 35:** screens copyright © PixelPress
LLC. **Fig. 37:** photographs copyright © Brian
Palmer; screen copyright © PixelPress LLC.
Fig. 43: Courtesy of the artist/highThree Media.
Fig. 44: design: Brian Eno & Lumen London;
photography: Wordsalad.

Unless otherwise noted all images reproduced
are copyright © by their authors.

Web Sites

akaKURDISTAN: akakurdistan.com
Bosnia: Uncertain Paths to Peace:
 nytimes.com/specials/bosnia/
Digital Journalist: digitaljournalist.org
"everyday" by Noah Kalina: youtube.com
Flickr: flickr.com
Fotolog: fotolog.com
Gigapan: gigapan.org
Girlpower: demo.fb.se/e/girlpower/retouch/
 retouch/index.html
gothamist: gothamist.com
LivesConnected: livesconnected.com
MediaStorm: mediastorm.org
New York Times Multimedia:
 nytimes.com/pages/multimedia/
Photobucket: photobucket.com
Photographs by Iraqi Civilians: pixelpress.org/
 index_iraqi.html
Photosynth: labs.live.com/photosynth/
PixelPress: pixelpress.org
"Portrait One" by Luc Courchesne: fondation-
 langlois.org/Artintact2/
Rwanda Project: Through the Eyes of Children:
 rwandaproject.org
Scene Completion Using Millions of
 Photographs: graphics.cs.cmu.edu/projects/
 scene-completion/
Spellbinder: blue.caad.ed.ac.uk/branded/
 stageone/invisibleArt.htm
ZoneZero: zonezero.com
6 Billion Others: 6billionothers.org
10 x 10: tenbyten.org/10x10.html
360 degrees: Perspectives on the U.S. Criminal
 Justice System: 360degrees.org

Among many other useful sites:
picturephoning.com:
 textually.org/picturephoning/
Rhizome: rhizome.org
VisualComplexity: visualcomplexity.com

For more sites and discussion, see
 afterphotography.org

Acknowledgments

Over the years many people have contributed to the thinking that has gone into this book. My students at New York University's Department of Photography & Imaging and, previously, the Interactive Telecommunications Program, were pivotal in helping me to understand and thread together disparate ideas, as were my NYU colleagues. My co-workers at PixelPress continually demonstrated, with extraordinary talent and dedication, that it is possible to create useful and experimental media projects with very limited funds and still keep a sense of humor. The many photographers with whom I have worked and from whom I have learned over more than three decades continue to be a source of inspiration; they play crucial roles in media that are both highly visible to the public and nearly unknown. And, of course, I am always indebted to the many writers and thinkers who confront the thorny issues surrounding media.

In particular I would like to thank the following for their support: Alicia Kuri Alamillo and Ambreen Qureshi for their help in researching photographs, and Lucy Helton for her help in obtaining permissions; Zohar Nir-Amitin for her design ideas; Mark Bussell, Anne Cronin, Jeremy Lehrer, and Carole Naggar for their thoughtful commentaries on the drafts of the text; Kent Klich, Ken Light, and Joseph Rodriguez for their steadfast commitment as colleagues in the documentary field; Mara Bodis-Wollner and Jessica Ingram for their dedicated and sensitive collaboration as teachers; Deborah Willis for her own unique brand of leadership both within New York University and outside; Bennett Ashley, Melissa Harris, Lesley Martin and my brother Steve Ritchin for their advice; Faith Hampton Childs for being the astute literary agent who cares deeply about ideas; and Jim Mairs, my longtime W. W. Norton editor, for allowing me to join him on many adventures, including this one. I am also grateful to Norton's editorial staff, particularly John Bernstein and Austin O'Driscoll. There are so many others to thank; I hope that you know who you are.

My wife and colleague, Carole Naggar, and our two sons, Ariel and Ezra, have made the going richer than I could have possibly hoped. This book is dedicated to them.

Index

Page numbers in **bold italics** refer to illustrations.